2.4 759.952 TER

D0320297

10.0

63

TREASURES OF ASIA

JAPANESE PAINTING

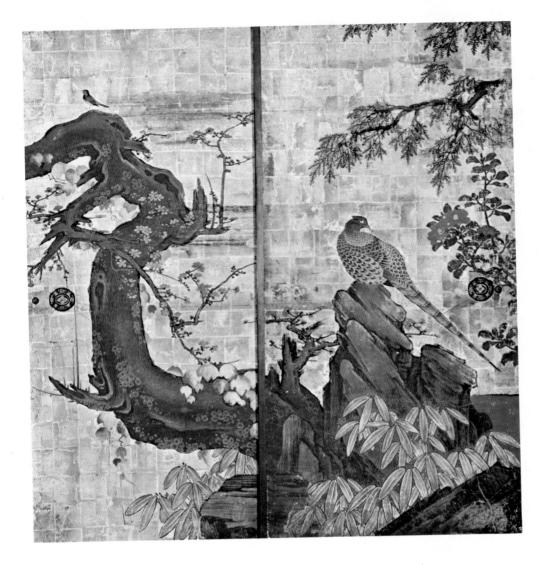

TEXT BY AKIYAMA TERUKAZU

Member of the National Institute of Art Researches in Tokyo

Colour plate on the title page :

Kanō Sanraku (1559-1635) and his adoptive son Sansetsu (1590-1651): Plum Tree and Pheasant. About 1631-1635. Detail of a painting on the sliding doors of the Tenkyū-in temple (west room). Myōshin-ji, Kyōto.

© 1977 by Editions d'Art Albert Skira S.A., Geneva First edition © 1961 by Editions d'Art Albert Skira, Geneva

All rights reserved No part of this publication may be reproduced or transmitted, in any form or by any means, without permission.

ISBN 0 333 23375 1

This edition published in Great Britain in 1977 by MACMILLAN LONDON LTD London and Basingstoke Associated companies in New York, Toronto, Dublin, Melbourne, Johannesburg and Delhi

PRINTED AND BOUND IN SWITZERLAND

BARNFELD CULLEGE LID LON ACCESSION 30523 CLASS NO 2055 159,952 TER

5

VER a century has passed since the West discovered Japanese art. To begin with, it was the beauty of Japanese prints and the exquisite delicacy of Japanese lacquerware, ceramics and ivories that caught the attention of the first European connoisseurs. The attitude of the Goncourt brothers, for example, is significant: struck by the quite unlooked-for affinities between two countries so far apart, they thought to find in Japanese art the same type of elegance and grace that so much delighted them in eighteenth-century French art. Japanese prints also came as a revelation to the Impressionists and their enthusiasm promoted this art form, in the eyes of Europeans, to an eminence it had never reached in Japan itself, where it was regarded as a minor art catering for popular tastes. There thus developed by the end of the nineteenth century a widespread vogue for a refined but dainty and affected style of Japanese art -a vogue that has lasted to the present day and in France, where its effect has been strongest, goes by the name of japonisme or japonaiserie. Japanese prints, however, for all their charm, are but the end-product of a thousand-year evolution, in the course of which Japanese painting has renewed itself again and again, imparting to each successive style a striking vividness of expression. This rich and varied heritage, of which for a long time nothing more was known in the West than what could be gleaned from curios and woodblock prints, was at last revealed to some extent thanks to the work of such fine scholars as Ernest Fenollosa, Okakura Tenshin, Laurence Binyon, Langdon Warner, Georges Buhot and Yashiro Yukio, among others. Even so, it is still difficult for Westerners to arrive at a just and adequate appraisal of Japanese art; this is due to the scarcity of first-rate works of the early periods in foreign collections (in Europe in particular) and to the language barrier which makes Japanese art publications inaccessible to the majority of foreigners.

The aim of the present work, then, is to trace and illustrate the long development of Japanese painting in the light of the latest results of art scholarship in Japan itself an aim more difficult to achieve than it might seem at first sight. For it is very rarely that a truly synoptic treatment of the subject has been attempted, despite the undeniable progress made by recent art-historical research on many points of detail. We cannot pretend to have made our way unerringly through the devious, highly complicated maze of Japanese art history. But at least we have enjoyed the attempt to acquaint the reader with the main lines along which Japanese painting has developed, and to gather together some of its finest flowers.

It is not our intention to embark in this brief introduction on an analysis of the essential characteristics of Japanese painting or the historical background conditioning its progress through the ages. The pictures reproduced here speak for themselves, and as he follows the course of their evolution the reader will do best to trust to his own sensibility for a proper appreciation of them. By doing so he cannot fail to gain an understanding of the efforts made by Japanese painters to assimilate, each in accordance with his own temperament, the persistent influences coming from the Chinese mainland.

In order to respect the unity of each of the different types of painting dealt with here, we have deliberately ignored the divisions of time customarily used in the study of Japanese history (Nara Period, Heian Period, Kamakura Period, etc.). But the distinctive features of these periods are studied in the text, and at the end of the book the reader will find a general chronological table, together with detailed maps of Japan as a whole and of the Kyōto-Nara region.

Since the treasures of Japanese painting are so widely dispersed in different museums, monasteries and private collections, the photographer's task was particularly difficult and exacting. Never before, not even in Japan, has the attempt been made to bring together so large and representative a selection of high-quality color reproductions, covering every period in the long history of Japanese painting. The work has been brought to a successful conclusion thanks to the friendly cooperation of curators and collectors, and to the skill and resourcefulness of our photographer, Mr Henry B. Beville, of Washington, who traveled through Japan with the author in the autumn of 1959.

We take pleasure in recording our deep and respectful gratitude to Mr Tanaka Ichimatsu, Director of the National Institute of Art Researches, Tokyo, who has given us the benefit of his advice and encouragement at every stage of the work. We extend our grateful thanks to the Commission for Protection of Cultural Properties, Tokyo, and to Mr Matsushita Takaaki in particular; to the curators of the national and private museums of Tokyo, Kyōto, Nara, Atami, Nagoya, the Kōya-san and the Seikadō Foundation; also to private collectors and the superiors of the different monasteries. All, without exception, have been cooperative and helpful in allowing us to photograph the works of art in their keeping. We are especially grateful to Mr Wada Gun-ichi of the Shōsō-in Office for kindly procuring us color transparencies of paintings in the Imperial Collections. Our thanks also go to M. Jean-Pierre Diény of the Maison Franco-japonaise, Tokyo, and M. Maurice Pinguet of Tokyo University, for their help in preparing the original French text of this book; and to Mr James Emmons for undertaking the English translation.

A book of this kind necessarily owes a great deal—far more than can be conveyed in a few words—to the work of our predecessors and colleagues in the field of Japanese scholarship, to all those dedicated scholars who have made it their task to raise the study of painting to the level of a scientific discipline.

AKIYAMA TERUKAZU.

Contents

INTRODUCTION	5
Pre-Buddhist Painting	I
The Introduction of Buddhist Painting and the Assimilation of the T'ang Style from China (7th and 8th centuries)	9
Buddhist Painting of Japanese Inspiration (9th to 13th century)	7
The Formation of the National Style in Secular Art (9th to 12th century)	5
The Great Age of Scroll Painting (12th to 14th century)	9
The Renewed Influence of Chinese Art and the Development of Monochrome Painting (13th to	
i6th century)	3
The Golden Age of Mural Painting (16th and 17th centuries)	3
Decorative Painting of the Sōtatsu-Kōrin School (17th to 19th century)	I
Genre Painting and the Masters of the Japanese Print (17th to 19th century)	9
Trends of Modern Painting (17th to 19th century)	I
CHRONOLOGICAL TABLE	5
MAP OF JAPAN	8
MAP OF THE KYŌTO-NARA REGION	9
SELECTED BIBLIOGRAPHY	0
GENERAL INDEX	I
LIST OF COLORPLATES	3

NOTE ON THE TRANSLITERATION OF JAPANESE AND CHINESE WORDS

- 1. In transliterating Japanese words we have followed the international Hepburn system.
- 2. Japanese names have in all cases been written in the Japanese order, i.e. the family name first, followed by the given name or the artist's pseudonym. Although today, when writing their names in Latin characters, the Japanese as a rule reverse the traditional order and write the family name last in the Western manner, we think it best to keep consistently to the same principle for both historical and modern names.
- 3. In transliterating Chinese words we have followed the Wade-Giles system.

JAPANESE PAINTING

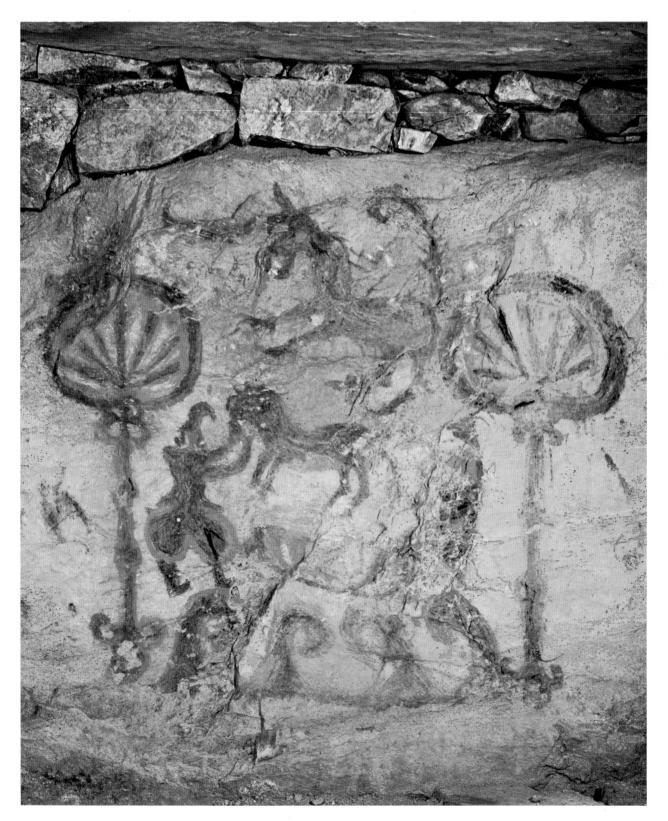

Wall Painting in the Takehara-kofun Tomb: Composition on the Back Wall of the Funerary Chamber. Fifth or sixth century. Wakamiya-machi, Fukuoka Prefecture (Kyūshū).

1

In the past decade or so a fresh interest has been taken in the earliest forms of Japanese art, and the beauty of the primitive arts of prehistoric times, before the introduction of Buddhism into Japan, is being discovered and appreciated. The $dog\bar{u}$ (clay figurines) of the Jōmon culture (seventh to first millennium B.C.), with their dynamic expression and highly modern stylization, have begun to arouse the enthusiasm of all who have a taste for the arts. The *haniwa* (terracotta funerary statuettes) of the Tumulus period (third to sixth century A.D.) have an even greater charm, owing to a naïve naturalism in which we may divine one of the sources of the Japanese artistic temperament. To the little known pre-Buddhist paintings which form the background to the history of Japanese art, the opening chapter of our book will be devoted.

The unceasing efforts of field archeologists in recent years have at last succeeded in confirming the existence of a Paleolithic age in Japan. From the north to the south of the country, chipped flint implements (unaccompanied by pottery) have been discovered in different diluvial strata, the earliest of which may go back to about 100,000 B.C. On the basis of radio-carbon tests, moreover, the Jōmon culture of Neolithic Japan may now be said to have begun nine thousand years ago—a much earlier date than hitherto supposed. This early culture of hunters and fishermen, characterized by pottery decorated with rope designs (jōmon), lasted until the third or second century B.C. in the west and center of the Japanese archipelago, and a little longer in the east and north. In the course of a long stylistic evolution, this Jōmon pottery maintained a plastic power which distinguishes it from the Neolithic ware of the rest of the world. The same power and dynamism characterize the anthropomorphic figurines ($dog\bar{u}$) which no doubt had some magic significance attaching to them in the primitive society of those early times.

No trace of painting survives from the long ages spanned by the Paleolithic and Neolithic periods. The plastic genius of the Jōmon men found its sole expression in modeling and sculpture. Not until the advent of the Bronze Age, the Yayoi culture, do we find the first manifestations of the art of painting. About the third century B.C., in northern Kyūshū, Japanese civilization entered a new phase with the introduction from the Asiatic mainland of agriculture (chiefly rice-growing) and of metal-working. With the transition from hunting and gathering to settled life, a change gradually came over all the products of human industry, affecting pottery in particular, which provides the surest evidence we have for an evaluation of the prehistoric cultures.

There now appeared a new type of pottery, called Yayoi (from the district of Tokyo where it was first identified), which differs markedly from vases of the Jōmon type. Between the Jōmon and Yayoi cultures, however, archeologists can discern no gap or discontinuity, while anthropologists incline to the view that no foreign invasion or any important racial change took place. How then are we to account for the striking differences of form and expression between Jōmon and Yayoi ware?

Instead of the grotesque and animated designs in high relief of the earlier period, the dominant features of Yayoi pottery are simplicity, serenity and equilibrium. These qualities reflect a different mode of life: the calm and confidence of a settled people, who must have been more responsive to nature and the cycle of the seasons and accordingly resorted to pictorial techniques to represent what they observed around them.

The earliest known examples of "pictorial art" in Japan occur in the so-called Middle Yayoi period (first century A.D.) and take two forms: designs engraved on vases and line reliefs on *dotaku* (bronze bells).

The ceramics decorated with these primitive line drawings come chiefly from Karako, south of Nara, where a large Bronze Age village was discovered. The stratigraphic excavations of 1936-1937 established the fact that these designs appear only on Type IV pottery of the late Middle Yayoi period. The most frequent themes are animals, chiefly stags, rendered with a liveliness that shows clearly how familiar these animals were to the inhabitants of the village. Anthropomorphic figures, very primitive and crudely drawn, are always shown with uplifted arms. There is also a boating scene, with three men rowing and some water birds near by; another shows a house on piles, with two men mounting the ladder. But on the whole the very notion of composition is absent; the design comes as the fanciful outpouring of a naïve and spontaneous spirit.

The line reliefs on the $d\bar{o}taku$ are more sharply designed and show a well-defined stylization. This difference seems to be due above all to the exigencies of casting. Incising the designs in the mold called for greater precision of line, and greater simplicity of form. The word $d\bar{o}taku$ designates a kind of bronze bell—the most characteristic type of prehistoric Japanese bronzes. Though its origin is still an open question, the $d\bar{o}taku$ certainly derives from some continental musical instrument, the small flat bell of ancient China or more probably the horse-bell of southern Korea. The oldest specimens of the $d\bar{o}taku$ are quite small (7 or 8 inches high), with a clapper, and may have been used as a sort of instrument. But the most highly developed types, the largest one measuring 51 inches in height, were no doubt used solely for ritual purposes.

Figures of men and animals appear for the most part on *dotaku* of the Middle Yayoi period, and are more varied than those of the incised designs on pottery. Among the animals represented, the preference always goes to stags, often laid out in rhythmically patterned rows producing a fine decorative effect. We often find water birds, long-legged waders such as cranes and a few palmipeds, and also fish, turtles, dragon-flies, praying mantises and spiders.

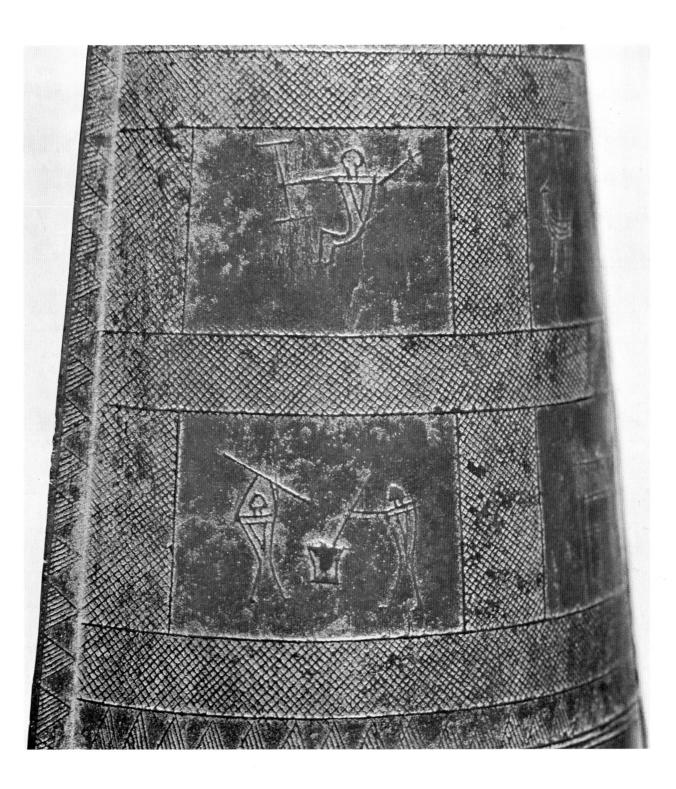

Line Relief on a Bronze Bell (dōtaku): Man winding Thread and Two Men husking Rice. First century A.D. (Height of the bell 167%") From the Kagawa Prefecture (Shikoku). Ōhashi Hachirō Collection, Tokyo.

Painting in the Otsuka Tomb: Decoration of the so-called "Lamp Stone." Fifth or sixth century. Keisen-machi, Fukuoka Prefecture (Kyūshū).

Illustration page 13

Among the decorated *dotaku*, one in particular calls for comment: that in the Ohashi Collection, Tokyo, which apparently comes from the Kagawa prefecture in Shikoku. This is an extremely rare work, over 16 inches high; each of the two sides is divided into six panels by horizontal and vertical bands. Each panel has a different subject, treated in a more or less elaborate design. On one side we have (I) a dragon-fly, (2) a tortoise, (3) a salamander and a tortoise, (4) two praying mantises, (5) two herons and (6) a boar hunt; on the other, (7) a salamander, (8) a man winding thread, (9) two men husking rice, (10) a dragon-fly, (11) a stag hunt and (12) a storehouse of rice. Our plate illustrates scenes 8 and 9. The upper panel was long interpreted as a dance; but the man actually seems to be holding a primitive reel for winding thread. The lower panel represents a method of husking rice, with a kind of pestle, still in use today in the islands of southern Japan. A Japanese archeologist, Kobayashi Yukio, a specialist in prehistoric painting, has proposed a general interpretation of the themes on this *dotaku*. He has pointed out that each of the animals represented on it lives by capturing other animals; and that some of them (the tortoises and herons, for example), are shown with their prey in their beak or jaws. The animals, in turn, are hunted and killed by man. These panels are thus intended to evoke the struggle for survival in nature, or the precarious life led by hunters and fishermen. The scenes of husking rice and winding thread, on the other hand, together with the storehouse of rice, evoke a different mode of life, a more peaceful, more secure existence. In any case, it is safe to say that these scenes were not chosen at random or for a purely decorative effect; everything points to their having been expressly designed to glorify a settled, agricultural way of life.

In the villages, at the period of the Yayoi culture, power tended to concentrate in the hands of the strongest, and tribal chieftains rapidly gained an increasing measure of authority. These social changes and the formation of a ruling class are symbolized by the construction of huge tumuli for the burial of the dead, the earliest of which go back to the third century A.D. Hence the name by which this protohistoric era is known: the Tumulus Period, or Period of the Great Burial Mounds. Terracotta statuettes (haniwa) were placed all around these tumuli. The burial mounds of the fifth and sixth centuries were also decorated with paintings and bas-reliefs; these, however, are confined almost exclusively to northern Kyūshū, the province nearest to Korea.

Seventy-two such tombs have been discovered. The paintings usually cover the stone walls of the funerary chamber and the antechamber. They contain both geometric designs (concentric circles, triangles, etc.) and figurative forms (armor, boats, men and animals). The most representative of these many tombs are those of Otsuka (Royal Tomb) and Takehara-kofun (Ancient Tomb in the village of Takehara).

The Otsuka paintings entirely cover the inner walls of the funerary chamber (13½ feet long, 10 feet wide, 12¼ feet high), the antechamber, and the funerary niche. The rough surface of the stone slabs was first coated with a thin layer of clay, and to this support the paints were applied. Chemical analyses carried out by Professor Yamazaki Kazuo of Nagoya University revealed five different colors: red ochre, yellow ochre, green (powdered green rock), white (clay) and black (pyrolusite, or mineral manganese).

Opposite the entrance of the tomb stands the wall, pierced by a door, that separates the antechamber from the funerary chamber. Painted on either side of the door are horses, guardians of the inner chamber: three on the left, superimposed one above the other (two black horses separated by a red one), and two on the right (a black horse above a red one). A rider, much too small for his mount, is barely distinguishable on the back of each horse, all five of which are treated with a naïve naturalism. All the rest of this wall is covered with decorative designs: triangles, fern patterns and two-stemmed rosettes. A short passage leads into the richly decorated funerary chamber. Here, on the inner wall (to right and left of the door), figure two rows of quivers and swords treated as purely decorative motifs; on the side walls, quivers (on the right) and shields (on the left) are aligned in two rows. These motifs give place on the back wall of the chamber to geometric designs. The niche at the back, which held two coffins, is lavishly decorated with polychrome triangles. The two slabs of stone flanking this niche—known as "lamp stones" on account of the hole in the top which probably contained lamp-oil-are decorated with fern patterns and rosettes. The walls are surmounted by a domed ceiling painted red and sprinkled with with yellow dots; this is presumably intended to represent the starry night sky. On the whole, the decoration of this tomb has a unity and harmony suggestive of a peaceful way of life in which beautiful and costly things were appreciated for their own sake.

Illustration page 14

Illustration page 10

With these decorations of the Otsuka tomb, which extend over the entire walls pace and perhaps reflect a *horror vacui*, the single painting at Takehara-kofun forms a striking contrast. Discovered in 1956, this tomb of average size (the funerary chamber is not quite 9 feet long, 7 feet wide, 9½ feet high) contains on the back wall the most successful composition of all pre-Buddhist painting. It consists of but two colors, red ochre and black (this time a carbon black), applied directly to the rock face with no intervening support. The pigments are so thick that brushstrokes are clearly visible. This composition is the sole ornament of the funerary chamber; the other walls and the vault are quite bare. So the decorative technique employed here is totally different from that of the Otsuka tomb.

In the center of the Takehara painting stands a helmeted man in baggy trousers holding back an animal which, though relatively small, seems to be a horse. The man's face and the edge of his trousers are painted in red to striking effect. Above this group rears a large mythical animal with talons, a long spiny tail and a red tongue, which brings to mind the dragons in early Chinese paintings, though its body is rather like that of a horse. In the wall paintings of ancient Korea (Koguryō kingdom)—those for example in the tombs of the Chi-an region, such as the Tomb of the Four Divinities—we often find a dragon of similar shape, shown flying through the air with a divinity on its back. The Takehara animal, then, may be taken to represent a horse-dragon flying across the sky. Below the groom holding the horse, an object resembling an overturned "C", painted red and outlined in black, represents a boat. Another, smaller boat can be made out above, to the left of the dragon. The boat which conveys the dead man's soul to the Other World is a common theme in funerary paintings. Mori Teijirō, who first published the precious Takehara painting, has proposed an interesting interpretation of these motifs: the horse travels by land, the boat plies the sea, and the dragon flies through the air; the conjunction of these three figures expresses the wish that the dead man's soul may find smooth and ready passage to the next world.

To the right of the large boat, five red and black triangles linked by a stem seem to represent a standard symbolizing the power or authority held by the dead man. Four large fern-like motifs form the lower part of the composition. They may be purely decorative or they may stand for waves, i.e. the sea crossed by the ship of the dead. Two disks at the top of decorated stems flank the composition on either side. This significant motif can be identified with the large sunshade-fans held over noblemen by their attendants in the ceremonies of ancient China. These ritual fans, modeled in the round, are also found among the clay sculptures known as *haniwa*. In this tomb they symbolize the dignity of the deceased.

It should be added that in the antechamber Mr Mori discovered the figures of two fabulous animals, one on either side of the passage-way leading to the inner chamber. On the right is a fabulous bird, all but effaced, yet reminiscent of the "divine bird" (red sparrow, guardian of the south) of ancient Chinese tradition. Distinguishable on the left is a large tortoise which brings to mind the tortoise with two snake-heads (black tortoise, symbol of the north). It is interesting to note several elements in the decoration of this tomb which clearly point to an influence from the mainland, from Korea. Nevertheless, as compared with the Koguryō wall paintings of Korea, the Japanese composition is seen to be especially remarkable for the same naïveté and clarity of expression which lend so much charm to the *haniwa*.

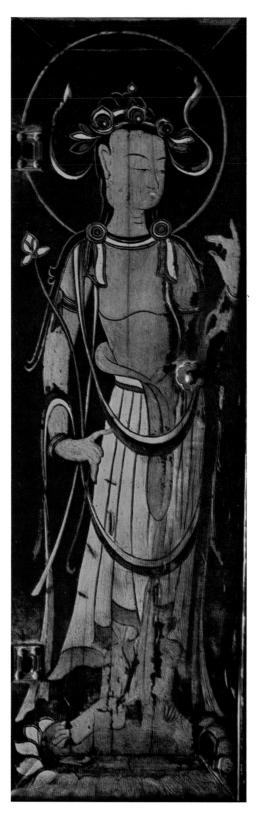

Tamamushi-no-zushi (Buddhist Shrine): Bosatsu (Bodhisattva). Decoration of a door panel, painting on lacquered wood. Mid-seventh century. (Height 12%") Hōryū-ji, Nara.

The Introduction of Buddhist Painting and the Assimilation

of the T'ang Style from China (7th and 8th Centuries)

2

MONG the tribes of the protohistoric period there was one family in particular, established in southern Yamato (the present-day prefecture of Nara), which steadily increased its power from the third century on and came to dominate all the neighboring tribes. By the fifth century it had extended its sphere of influence over a large part of Honshū, the main island of the Japanese archipelago. These early rulers, who are considered to be the ancestors of the Japanese "imperial family," had relations with the Sung and Ch'i dynasties of southern China and even established a protectorate, called Mimana, in southern Korea. Once their last-remaining adversaries, the large tribes of Kyūshū, had been subjugated in the sixth century, the court of Yamato took steps to complete the unification of the country and encouraged the introduction of ideas and techniques from the continent. Among these outside influences, it was Buddhism that had the strongest, most enduring impact on the cultural and social life of Japan. In 552 or (more probably) in 538 the emperor Syöng-myöng (Seimei) of Pekche (Kudara) presented the emperor Kimmei with some $s\bar{u}tras$ and a Buddhist statue, and this gift is usually regarded as marking the official introduction of Buddhism into Japan. The new religion, which, though originating in India, had already spread to China and been thoroughly sinicized, gradually penetrated into the country during the sixth century of our era, its progress and growth no doubt being fostered by the large numbers of Chinese and Korean intellectuals and technicians then emigrating to Japan. It was also owing to the activity of these foreign artisans that a sudden change came over Japanese art, as it adopted the most highly developed styles and techniques of the continent.

During the regency of Prince Shōtoku (592-622), a fervent advocate of Buddhism, many temples were built. According to the *Nihonshoki*, the earliest official annals (written in 720), by the year 624 there were forty-six temples grouping eight hundred and sixteen monks and five hundred and sixty-nine nuns. One of the largest of these temples is the Hōryū-ji, at Nara, which has almost miraculously survived to the present day and preserves many examples of early Buddhist art in Japan.

In the sanctuary of this temple stands the famous bronze triad of Shaka-nyorai (Sākyamuni), erected in 623 to the memory of Prince Shōtoku. This monumental statue rests on a large wooden base whose panels were originally decorated with paintings.

Today, unfortunately, they are so badly defaced that it is just possible to distinguish the figures of four celestial guardians on the two sides and of divinities in a mountain setting on the front and back panels. Another work of art dedicated to the same prince, known as the Tenjukoku Mandara, is a pair of large embroideries (each over sixteen feet square), representing the paradise (called Tenjukoku) to which the dead prince's soul was presumed to have migrated. According to the inscription on it, this large composition was designed by three painters whose names are all of Chinese or Korean origin: Yamato-aya-no-maken, Komano-kaseichi and Aya-no-nu-kakori. Only fragments of the embroidery survive, the major portion of it being preserved (since 1274) in the Chūgū-ji, a nunnery near the Hōryū-ji. Certain parts were rewoven in the thirteenth century. The patterns of the original fragments were embroidered with light-colored threads (red, yellow, blue, green, white, etc.) on a ground of purple damask. Among the original figures in the paradise scene and in the episodes of the prince's earthly life, there is one that wears a skirt in the Japanese style. But the lunar disk in which a rabbit and a tree are represented vouches for the persistence of age-old Chinese themes, which often occur in the wall paintings of ancient Korea.

These two examples of pictorial art of the early seventh century, both surviving in a fragmentary state, suggest that early Buddhist painting in Japan, like the sculpture of the same period, reflected the archaic style of the late Six Dynasties period in China, transmitted to Japan by way of Korea about a century afterward.

It so happens that the Hōryū-ji temple also contains a kind of Buddhist household shrine, or *zushi*, a work of great beauty and astonishingly well preserved, which testifies to the remarkable rise of painting in the mid-seventh century. Shaped like a miniature sanctuary, the shrine stands on a high base. It is called Tamamushi-no-zushi ("beetlewing" shrine) because the painted panels stand in open-work bronze frames which were once inset with the iridescent wings of a kind of beetle called *tamamushi*.

Illustration page 18

On the front door-panels of this shrine are the figures of two celestial guardians, carrying a long spear and a sword; and on the panels of the side doors, four slender bosatsu (Bodhisattvas). Though archaic, the style is graceful and elegant. The peculiar technique of this painting was long a matter of controversy, but a recent scientific examination has proved it to be an oil painting in four colors (red, light brown, yellow and green) on lacquered wood; it has been called in modern times mitsuda-e, owing to the litharge or oxide of lead (mitsudaso, from the Persian murdasang) which must have been employed as a siccative in the oil paints. The artist has thoroughly mastered this rather sticky medium and succeeded in playing off his four colors against the dark ground with an effect of the utmost charm. On the back panel of the shrine figures a mountain whose three peaks in the form of birds' heads support three pagodas, each sheltering a seated Buddha. This scene represents the Eagle-headed Mount where the Shaka-muni Buddha dwelt. The decoration of the four panels on the base is still more remarkable: in front, the worshipping of Shaka-muni's relic; behind, Mount Sumeru, symbolic image of the world. The two side panels represent two scenes from the *Jataka* stories, describing the Buddha's previous lives: on the left, the legend of a young ascetic in the Himalayas,

Tamamushi-no-zushi (Buddhist Shrine): Legend of the Starving Tigress, detail of a Jataka scene. Decoration of the base, painting on lacquered wood. Mid-seventh century. (25½×14″) Hōryū-ji, Nara.

Illustration page 21

who unhesitatingly sacrifices his life in order to hear, from a divinity disguised as a demon, the end of a revelation of human existence; on the right, the legend of the "starving tigress." This story runs as follows. Hunting in the mountains one day with his two brothers, Prince Mahasattva came upon a starving tigress and her seven cubs; his brothers turned and fled, but Mahasattva was courageous and selfless enough to lay down his life and be devoured. For this act of sublime charity, the prince became a Buddha in his future life. This legend was often represented in Central Asia (Kyzil Shorchuq), at Tun-huang (Caves A254 and A428) and at Lung-men (central cave of Pin-yang-tung) in the course of the fifth and sixth centuries. But the artist of the Hōryū-ji shrine ingeniously superimposed the three different scenes: the prince doffs his robe on the mountain top, leaps into the valley, and below the starving tigress and her seven cubs devour his body.

The Mahasattva of this scene has the same elegance as the Bodhisattvas on the door panels, but more movement. It brings to mind the figures in the Tun-huang paintings of the mid-sixth century (Western Wei and Sui), though the suppleness of forms is indebted rather to the art of the Eastern Wei and the Northern Ch'i. But what particularly compels attention is the curiously stylized mountain. The C-shaped cliff seems to be built up with straight and curving ribbons of several colors. This arrangement harks back to a long-standing tradition of Han art. So the style of the Tamamushi shrine shows a combination of very archaic elements with an advanced sense of expression. This shrine of Japanese cypress wood (*hinoki*) is unquestionably of Japanese make. A *Nihonshoki* text and comparison of the shrine with the wooden statues of four celestial guardians in the Hōryū-ji enable us to date it to the mid-seventh century.

It was just at this time that ancient Japan was reaching its early maturity. After the year 645 an economic and administrative reorganization, modeled on the Chinese system, tended to concentrate power in the hands of the imperial government. Closer relations with China opened the eyes of the Japanese to the latest creations of the great T'ang empire, and these they gradually adapted to their own needs. In the domain of art, the stylistic backwardness due to the roundabout transmission of Chinese influence through Korea was now to be overcome, and amply made up for. The Hōryū-ji wall paintings at Nara are an impressive testimony to the rapid growth and early fruition of Japanese painting.

According to the *Nihonshoki*, the main buildings of the Hōryū-ji were burnt down in 670. The work of reconstruction apparently went on for nearly half a century, not being completed until 711. But the decoration of the sanctuary, antedating the completion of the other buildings (the pagoda, etc.), can be assigned to the end of the seventh century. The inner walls of the sanctuary (measuring some 32 by 42 feet) were decorated with brilliant paintings whose subject matter conforms to a strict theological system. The four largest wall surfaces (a little over 10 feet high and 8½ feet wide) represent the four paradise scenes: the paradise of Shaka (Sākyamuni) on the east wall; the paradise of Amida (Amitābhā) on the west wall; the paradise of Miroku (Maitreya) on the left side of the north wall; the paradise of Yakushi (Bhaisajya-guru) on the right side of the north wall. In the center of each paradise stands the throne of the principal divinity, surrounded by the different Bodhisattvas and celestial guardians, and surmounted by a large baldachin with a flying angel on either side. In the foreground, below, are an offering table and two lions. This layout, however, by no means imposes a monotonous convention on the composition. Each wall has distinctive features of its own thanks to the varied handling of the figures and backgrounds. The eight corner walls ($10\frac{1}{2}$ feet high by a little over 5 feet wide) represent eight standing or seated Bodhisattvas, facing each other two by two, each pair acting as attendants for one of the paradise scenes. The upper part of the entire wall space is occupied with the figures of hermits (*arhats*), shown meditating in the mountains. The same subject figures in the wall paintings of Central Asia (Karashar) and Tun-huang (Cave A285; Pelliot 120N). Each of the small areas just under the ceiling, between the shafts of the inner columns, is decorated in identical fashion with two flying angels (*apsaras*).

The Horyū-ji murals, which mark one of the culminating points of the art of painting in the Far East, unfortunately met with a disastrous accident in January 1949. In the course of repair work then being carried out in the sanctuary, fire broke out and ravaged the whole interior of the building. Today, on the scorched and smoke-blackened walls, we can distinguish no more than faint outlines, the mere ghost of a departed masterpiece. The flying angels escaped destruction by an extraordinary chance, the upper wall surfaces having been dismantled and removed just before the fire. One of the most famous of the Höryū-ji paintings represents Avalokitesvara in the paradise of Amida. For their tension and sharpness, the red outlines have been described as "wire lines"; they give the body a self-contained volume further emphasized by reddish-brown shading. Colors are simple and unsophisticated-red, purple, yellow, green, blue, black and white-but so skillfully combined as to produce a variety of vivid and serene effects. The Bodhisattvas are richly bedecked with diadem, necklets, earrings and bracelets; their many-patterned costumes recall the luxurious brocades of the early T'ang period. The flying angels, sole survivors of the disastrous fire, have much of the charm of the Bodhisattvas; but stereotyped as they are, all drawn alike by means of a pouncing pattern, they admittedly have the conventional character of prentice work.

All too often these wall paintings are cited as an instance of "Indian" influence, with reference to the paintings in the Ajanta caves, particularly those in Caves I and II. Granting that the sensual *tribhanga* posture of bodies (i.e. with triple curves) and the profusion of ornaments derive from Indian art, the fact remains that the firm linework and vivid coloring contrast strongly with the Ajanta style. The art of Hōryū-ji reflects rather the early T'ang style, in which we see the Chinese tradition assimilating not only the influence of Indian painting, but other elements from Central Asia (chiefly from Khotan) and even from the Sassanians in Iran. Compare, for example, the Tun-huang paintings in Cave A220 (Pelliot 64), which date from 642, or those in Cave A332 (Pelliot 146), which date from 698.

Scientific examination by Professor Yamazaki Kazuo has shown the pigments employed to be cinnabar, red ochre and red lead for the red; yellow ochre and litharge

Illustration page 24

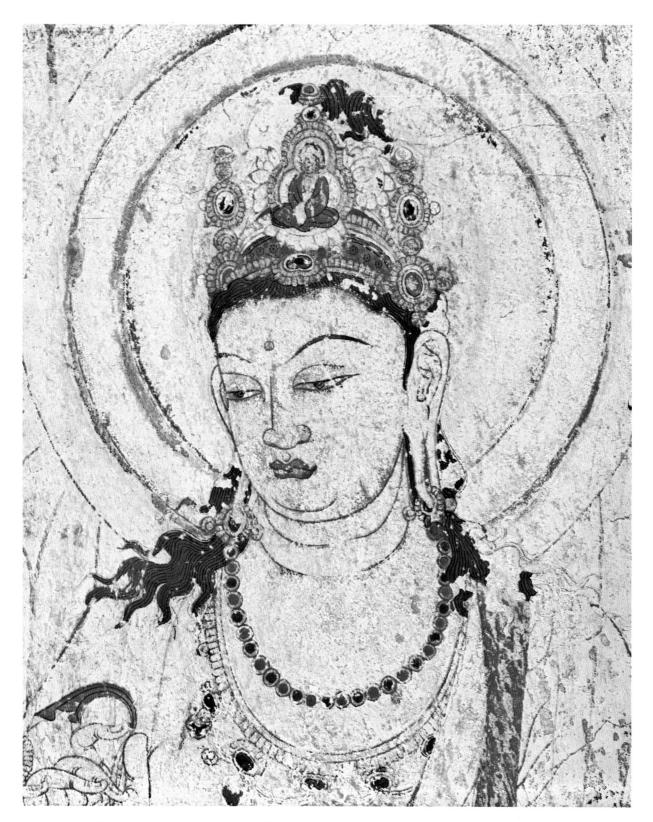

The Paradise of Amida, detail: Head of the Bodhisattva Kannon (Avalokitesvara). Late seventh century. Wall painting. (Entire wall 123×104%") Sixth wall of the Höryū-ji sanctuary, Nara.

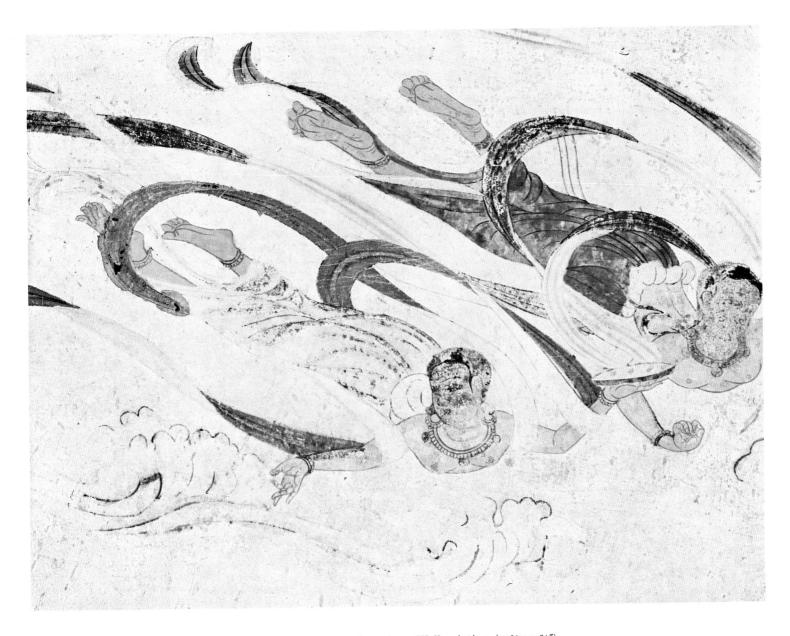

Flying Angels (apsaras). Late seventh century. Wall painting. (29¾×54¾") Upper wall panel of the Hōryū-ji sanctuary, Nara.

for the yellow; malachite for the green; azurite for the blue; white clay (kaolin) for the white; and India ink for the black. After coating the wall surface with fine white clay and transferring his design to this ground by means of a pouncing pattern, the artist laid in his outlines in black and red and added the colors *a secco*. (So it is a mistake to refer to the Hōryū-ji paintings as "frescos.") It should be noted that these mineral pigments, still in use today, are altogether different from those employed in protohistoric tomb paintings. The introduction of Buddhist art brought with it the new technique and new materials on which Japanese painting has been based ever since.

When the Hōryū-ji decorations were executed late in the seventh century, this new technique had already been mastered by Japanese artists—most of whom no doubt came of families of Chinese or Korean origin, but established in Japan for several generations. As early as 588 a painter from Kudara (Pekche), named Hakuka, had come to Japan with a group of monks and architects and settled there; while in 610 a painter-monk from Kōkuri (Koguryō), named Donchō, had introduced into Japan the technique of preparing pigments and painting materials. In 603 Prince Shōtoku accorded official status to several families of painters, all originally hailing from China or Korea, entrusting

Shaka-muni Preaching in the Mountains (Hokkedō-kompon-mandara). Late eighth century. Painting on hemp cloth, mounted on a frame. $(42\frac{1}{8} \times 56\frac{5}{8}")$ Museum of Fine Arts, Boston.

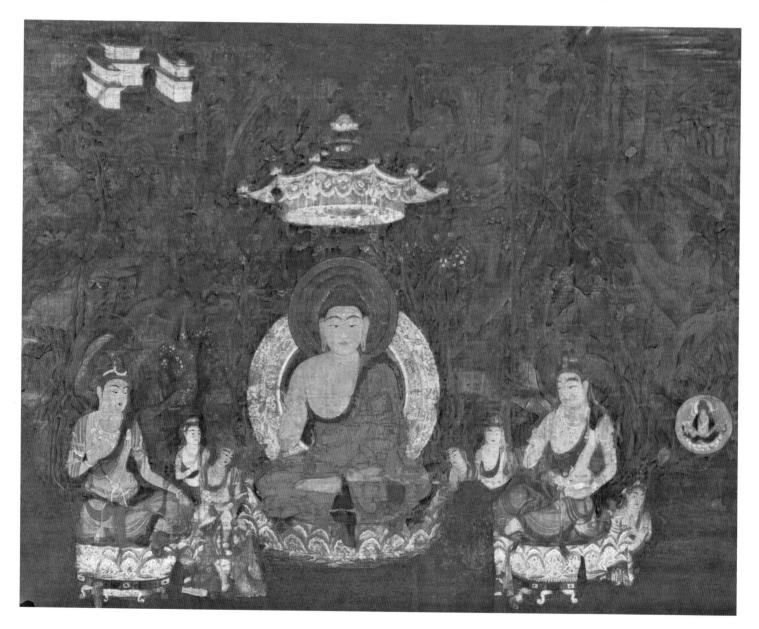

them with the decoration of Buddhist temples. The ink graffiti discovered on the ceiling panels of the Hōryū-ji, when repairs were recently made there, prove that even the artisan decorators of those early times were tolerably good draftsmen with an eye for realistic effects. Certainly these qualities are already an earnest of that mastery of brushwork which, in the Far East, is the first requisite of the painter's art.

After the founding in 710 of the great capital of Heijō (present-day Nara), the assimilation of the latest trends of T'ang painting went on apace, stimulated by a considerable program of "public works." The building of palaces and great temples called for a large number of artists and craftsmen. By virtue of the new Taihō-ryō law promulgated in 701, a Painters' Bureau (*Edakumi-no-tsukasa*) was set up in the Ministry of Internal Affairs. Presided over by three officials, this bureau was composed of four master painters (*eshi*) and sixty ordinary painters (*edakumi*). The archives of the period further prove that, besides these official painters, there also existed several groups of private painters (*sato-eshi*), in different provinces, who were called into the capital whenever works on a particularly large scale were being undertaken.

The interior of the great temples of Nara was lavishly decorated with paintings, embroideries and tapestries. Though untold numbers of such works were produced, and are often described in the texts, only a fraction of them now remains. Mysteriously preserved in the Taima-dera, an ancient temple south of Nara, is the famous Taimamandara which, according to the temple tradition, the blessed princess Chūjō-hime wove in 763 with lotus fibers, with the supernatural aid of Avalokitesvara. Actually, as we have it today, the work is a tapestry (tsuzure-ori) of silk thread. It represents the paradise of Amida on a large scale, bordered on three sides by small scenes illustrating anecdotes from the Kan-muryōjukyō sūtra. The original tapestry was already falling to pieces in the Middle Ages, and the surviving fragments, chiefly of the central part, have been pasted on a painting representing the same subject on the same scale. Although in these conditions it is difficult to appraise the style of the work, it is safe to say that it was directly inspired by the large compositions of the middle T'ang period. Amida is shown seated in a great palace amid innumerable Bodhisattvas, flying angels, celestial musicians and dancers; this is altogether reminiscent of the Buddhist paradise scenes so often represented in the Tun-huang paintings of the eighth and ninth centuries.

Another paradise scene, the paradise of Shaka-muni, is preserved in the Museum of Fine Arts, Boston. Painted on hemp cloth and now measuring 42¼ by 56% inches (originally somewhat larger but for some reason cut down), this picture numbered among the treasures of the Tōdai-ji, the Temple of the Great Buddha at Nara, until the end of the nineteenth century; there it was known as the Hokkedō-kompon-mandara. It represents Shaka-muni preaching in the mountains surrounded by Bodhisattvas. While the museum authorities still classify it as a Chinese painting, Professor Yashiro Yukio has made out a convincing case for regarding it as a Japanese work. Judging by the slightly mannered treatment of trees and rocks, and by the quality of the hemp cloth, we too consider it to be a Japanese production of the late eighth century. Though retouched in 1148 by the painter-monk Chinkai, this precious work still testifies to the high quality

of eighth-century Buddhist painting, in which the Japanese sensibility finds expression through a Chinese technique. In Chapter 4, when dealing with the evolution of Japanese landscape painting, we shall have more to say of the highly characteristic design of the mountain surrounding this assembly of divinities.

Illustration page 30

Illustration page 29

The native delicacy and sensitive touch of the Japanese artist come out more clearly in the exquisite image of Kichijō-ten (Mahasri), goddess of fecundity and beauty, a work preserved in the Yakushi-ji since 771 or 772. But for her aureole and the jewel in her hand, the usual symbols of the goddess, the picture might be taken for the portrait of a fashionable court lady in T'ang dress. On this strip of hemp cloth, the artist went about his work with great care. With unerring skill, on the thick layer of colors which entirely covers the preliminary design, he drew the very fine black lines of facial features and hair. The easy grace and poise of the goddess as she moves through the air is quite in keeping with the well-balanced color scheme enhanced with gold leaf. It was this highly refined technique, much cultivated from the tenth to the twelfth century, and catering preeminently for aristocratic tastes, which was to underlie classical Japanese painting.

Another form of Buddhist painting in this period calls for special mention: the illustration of the sūtras. The art of the e-makimono (scroll painting), whose greatest development came in the Heian period, is also represented by an extensive work of the eighth century. This is the illustrated sūtra of Causes and Effects (E-ingakyō), of which five entire scrolls and a few fragments, belonging to different copies, have come down to us. Translated into Chinese by Gunabhadra in the mid-fifth century, under the title "Kako genzai inga kyo" (Kuo-ch'ü hsien-tsai yin-kuo ching), this sūtra sets forth a mythical genealogy of the Shaka-muni Buddha and tells the story of his life, from his birth as a royal prince, his flight to the mountains, his solitary meditation and his illumination, down to the conversion of his leading disciples. It originally consisted of four text scrolls, but in the late sixth and early seventh century illustrated versions of the work in eight scrolls were presumably produced in China. This illustrated sūtra must have been copied in Japan at several different times, for the official archives attest the existence in 753 and 756 of at least three copies of the work. Four of the surviving scrolls are preserved as follows: (I) in the Hoon-in temple of the Daigo-ji; (2) in the Jobonrendai-ji temple; (3) in the Fine Arts University of Tokyo; (4) in the former Masuda Collection. These four, judging by their style, seem to have been made one after the other between 730 and 770; a fifth scroll, also in the former Masuda Collection, must be a copy of the early ninth century.

Illustration page 29

These scrolls are divided horizontally into two sections; the upper frieze from right to left illustrates the story of the text which occupies the lower part. While the Hōon-in scroll seems to copy faithfully the archaic style of the original Chinese $s\bar{u}tra$, the Jōbonrendai-ji copy shows a greater freedom of expression, both in the painting and the calligraphy. Despite the persistence of certain archaic features, like the stylization of rocks and mountains, and the disproportionate size of figures with respect to buildings and landscape, faces and attitudes betray the Japanese tendency toward naturalism. Though keeping to a few bright colors, the artist contrived to give his work a harmony

100

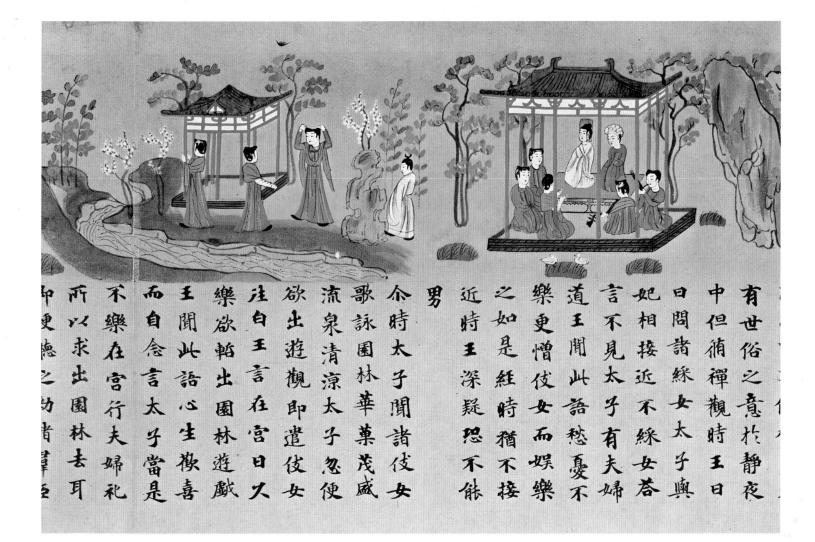

Sūtra of Causes and Effects (E-ingakyō): Miniature of the Second Scroll (first part). Eighth century. Painting on paper. (Height 10⁵/₁₆") Jōbon-rendai-ji, Kyōto.

and delicacy very far removed from anything primitive or uncouth. Conspicuous in the scene reproduced above is the melancholy figure of the young prince, impervious to earthly pleasures, indifferent to his charming wife, to the young women making music, to the fragrant paths of the flowering garden.

With such scenes as these, the art of sacred illumination gradually approaches the threshold of secular painting. For the luxurious life of the Nara court had refined all the secular arts, after the example of the aristocratic life led at Ch'ang-an, the T'ang capital. By great good fortune a precious testimony of this golden age has come down to us: the famous imperial collection of the Shōsō-in.

Originally the Shōsō-in was the central storehouse of the Tōdai-ji temple. In 756, on the forty-ninth day after the death of the emperor Shōmu, his widow, the empress Kōmyō, presented the treasures of his court to the Great Buddha of the Tōdai-ji;

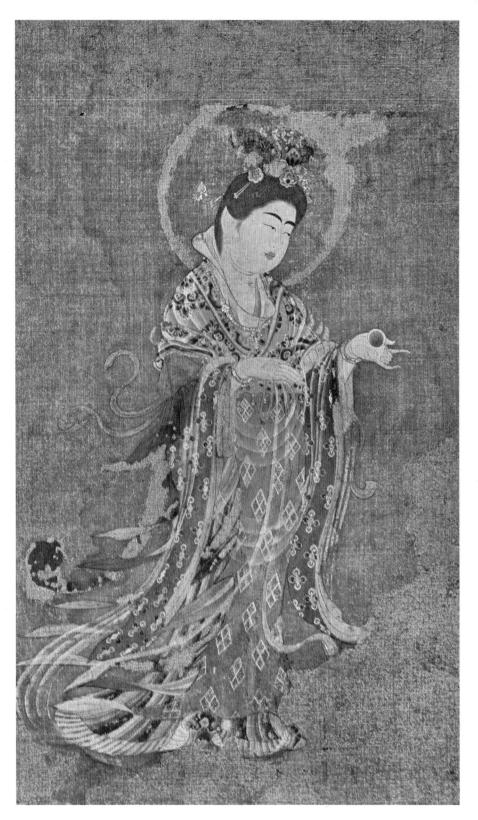

Kichijō-ten (Mahasri), Goddess of Beauty and Fecundity. Eighth century. Painting on hemp cloth, mounted on a frame. $(21 \times 12\frac{1}{4}")$ Yakushi-ji, Nara.

Beauty beneath a Tree (Chōmōryūjo-byōbu), detail of a screen painting. Eighth century. Colors and overlaid plumes on paper. (Entire panel 53½×22") Imperial Collection of the Shōsō-in, Nara.

Musicians riding on a White Elephant (Kizō-kogaku-zu). Eighth century. Painting on leather decorating a biwa (musical instrument). (16×6½") Imperial Collection of the Shōsō-in, Nara.

this temple had been erected by her husband in 752. To these gifts, other treasures of the court and temple were later added. No less than ten thousand works of eighth-century art have thus come down to us in an astonishingly fine state of preservation.

An inventory of the initial donation of 756 was drawn up and signed by the empress. Listed in it are "one hundred screens," twenty-one of them decorated with a variety of paintings described as representing landscapes, palaces, banquet scenes, young ladies, horses, birds, plants and more besides, all of Chinese inspiration. Apart from screens of tinted textiles, only a single other screen has survived, with six decorated panels commonly called Beauties beneath the Tree. Portrayed on each panel is a fine lady in Chinese costume, either standing beneath a tree or seated on a stone. The theme of Beauty beneath the Tree, probably of Indian or Iranian origin, was very popular in China in the T'ang period (e.g. the paintings excavated in the Astana cemetery at Turfan and the wall paintings found in T'ang tombs near Ch'ang-an). The robe, the coiffure and especially the make-up, with the green beauty spots on the face, follow the fashion of the Chinese capital. Face and hands are neatly drawn and carefully colored. Costume and headdress were once overlaid with polychrome plumes barely visible today (only the ink underdrawing remains). The screen in fact is listed in the Shōsō-in inventory under the following title: "Screen of the standing ladies with bird feathers," thus alluding to this peculiar decorative process and recalling the "feather dress" worn by fashionable ladies of the T'ang period. Despite these Chinese influences, the screen was certainly painted in Japan; witness the fragment of a paper from the administrative archives bearing the Japanese date of 752, which was discovered on the back of the painting. And even apart from this evidence, a scrutiny of the work only makes us increasingly aware of that freedom of expression, that supple linework, that serenity of countenance in which the originality of the Japanese painters lay when, having mastered T'ang painting, they set out to express the innermost feelings of the Japanese themselves.

Among the works of painting preserved in the Shōsō-in, particular importance attaches to the miniatures decorating stringed instruments. There now remain four biwa (a kind of lute) and two genkan (lute with a round body) whose soundbox is fitted with a leather plaque (kanbachi) decorated with paintings. These six paintings, handled with extreme finesse, treat subjects that are typically Chinese: young ladies making music in a park in springtime; hermits playing go (a game similar to checkers) under the pines; scholars gazing at beautiful clouds in the mountains; a tiger hunt; and musicians riding on a white elephant. The last-named scene surpasses the others thanks to its fine workmanship and impeccable state of preservation. The leather plaque-which served to protect the soundbox against the impact of the plectrum—was first coated with a layer of white pigment, on which the artist blocked out his composition in ink and painted in the rest, down to the smallest details, with bright colors. The painted surface was then covered in its entirety with a coat of oil producing the same effect that varnish does on Western paintings. This use of oil, which was current practice in the Nara period (but was abandoned a century later), protected the painting and at the same time gave it an agreeable effect of transparency.

Illustration page 31

Illustration page 32

In the foreground three musicians and a dancer are riding on a large white elephant beside a stream. Two of the musicians, playing flutes, are dressed in Chinese costume; the third, beating a tabor, is a bearded man with occidental features, wearing Iranian dress. A boy with a tall, broad-brimmed hat—like that of the tabor player—is dancing with his arms flung out. This group closely resembles the musicians of an Iranian type represented riding on a camel on a piece of "three-color" pottery discovered in 1957 in the tomb of Hsien-yü-t'ing-hui (died in 723) at Ch'ang-an, and now in the Peking Museum. Into the background extends a distant landscape, showing a deep valley with a river winding through it. From a crag, with a few red trees clinging to it, falls a cascade. In the distance a flight of birds wheels toward a horizon tinted with the setting sun. By means of deep perspective the artist has succeeded in compressing into his narrow frame the far-flung vista of an immense landscape. Though there is no telling whether this work was made in Japan or imported from China, it must be regarded as forming one of the standard models of Japanese landscape painting.

Innumerable treasures of the Shōsō-in collection, boxes and offering plates among others, are decorated with paintings in various techniques: in colors, gold and silver outlines, monochrome designs in yellow, etc. Outstanding, however, are the ink drawings on hemp cloth which, in contrast with the finesse of the miniatures, command attention by the emphatic vigor of their linework. The best example of the kind is the *Bodhisattva* seated on a Cloud. The sweeping gestures of the hands, the long scarf floating in the air, the billowing clouds below, all suggest the movement of a god hastening down from the heavens. Lines seem to have been drawn in freely and quickly, almost off-hand, but they have an agreeable rhythmic accent reminiscent of the "ink monochrome painting" (*pai-hua*) developed in China in the eighth century, above all by Wu Tao-tzu. This large Buddhist image no doubt served as a banner in the ceremonies held at the Tōdai-ji.

The mastery they soon acquired in the handling of the brush enabled Japanese artists to extend their repertory beyond the motifs inspired by Chinese art, and to tackle more familiar subjects, such as the Japanese landscape and the life and people they saw around them. The only vestiges of these early efforts to nationalize the T'ang style are the landscapes accompanying various maps preserved in the Shōsō-in and the human figures treated in a humorous vein which occasionally turn up in the margin of a document, on the back of the base of a Buddhist statue, or in nooks and corners of the timberwork in temples. The tendency toward decorative stylization, in a lyrical key, which characterized Japanese painting in the Middle Ages, had already declared itself in the landscapes on hemp cloth, of which two complete specimens are preserved in the Shōsō-in and a fragment in the Gotō Museum, Tokyo. These works represent marine landscapes with scattered islets, water birds, grass and pines, fishermen and horses, all treated with the same schematization and the same concern for decorative effects.

Few vestiges of painting in the Nara period remain, but they are enough to make it clear that the technical foundations of Japanese painting had been solidly laid in the eighth century thanks to the program of large-scale building and decoration carried out by the government.

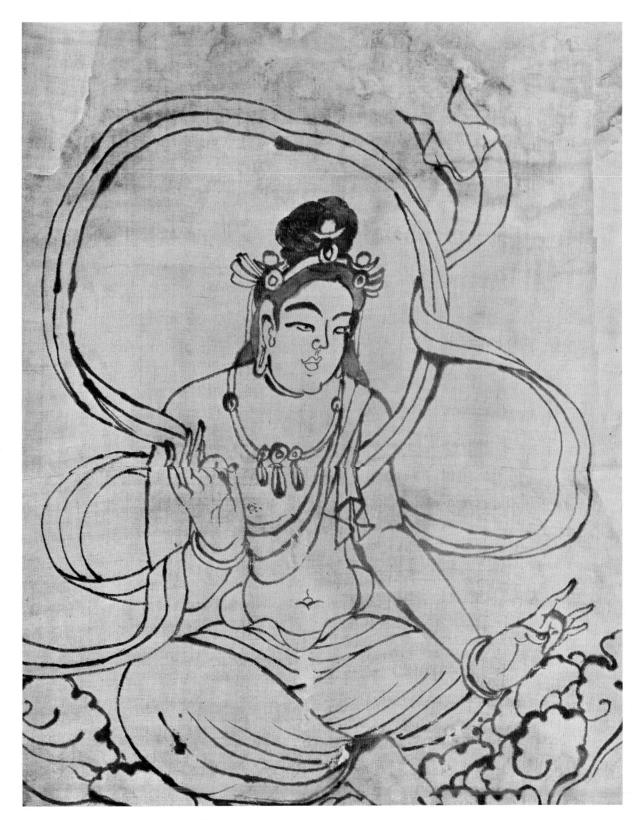

Bodhisattva seated on a Cloud, detail. Eighth century. Ink drawing on hemp cloth. $(54\%\times52\%'')$ Imperial Collection of the Shōsō-in, Nara.

Buddhist Painting of Japanese Inspiration (9th to 13th Century)

3

D ESPITE the wonderful flowering of art that took place there, Nara did not long remain the capital of Japan. In 794 the emperor Kammu transferred the seat of government to Heian-kyō (the "Peace Capital"), present-day Kyōto, some twenty miles north of Nara. His reason for moving the capital was to escape the domineering influence of the monasteries and the political interference of the powerful Nara clergy. This change of capital is regarded as ushering in a new era in the history of Japan, the so-called Heian period, which lasted to the end of the twelfth century.

The better to consolidate the imperial power, it was the policy of the early emperors in the new capital to foster cultural relations with China. This led to the introduction into Japan of the two Buddhist sects, Tendai and Shingon, which exerted a shaping influence on art. In 804 two monks, Saichō (767-822) and Kūkai (774-835), accompanied a Japanese embassy to China. Saichō, who had never been fully satisfied with the formalism of the old Nara doctrines, had spent twelve years in a hermitage on Mount Hiei, north of Kyōto, and at the end of a long spiritual quest it was brought home to him that the source of Buddhist truth lay in the *Hokkekyō*, or *Lotus Sūtra of the Good Law*. He pursued his studies in China, and upon his return to Japan in 805 he founded the monastery of Enryaku-ji on Mount Hiei, which became the center of the new Tendai sect. His doctrine, which proclaimed the equality of all living beings before the Buddha, was bitterly opposed by the established clergy. But thanks to the support of the imperial family and to the unremitting efforts of Saichō himself, his monastery was in time officially empowered to confer ordination on new monks and it unquestionably gave a new lease of life to Japanese Buddhism.

The other great religious teacher, Kūkai, had studied in the T'ang capital Ch'ang-an, where he initiated himself into the purely esoteric Shingon sect (*Chên-yen* in Chinese, *mantra* in Sanskrit). He returned to Japan in 806 and in 816 founded the Kongōbū-ji monastery in the fastnesses of Mount Kōya, far from the capital. In 823 he was put in charge of the official Tō-ji temple (or more correctly, Kyōōgokoku-ji) at Kyōto and it became another center of Shingon Buddhism. The mystical theology of this sect, which held every being in the universe to be a manifestation of the *bodhi*, the Wisdom of Buddha, attached great importance to plastic representations of divinities, whose numbers were

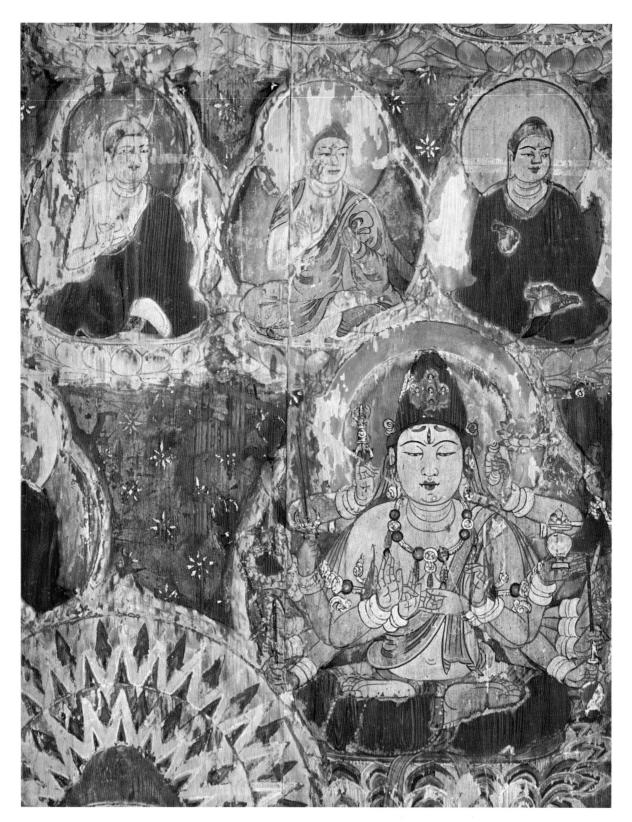

Large Composition of the World of Reason (Taizō-kai), detail: Shichigutei and Other Divinities. 951. Wall painting on a wooden panel. (Entire panel 102¾×27⅔") Pagoda of the Daigo-ji, Kyōto.

vastly increased in the doctrines of esoteric Buddhism. This hieratic world of divinities grouped around the central deity Dainichi-Nyorai (Vairocana) is represented by pantheons (mandara, in Sanskrit mandala), in which the gods are arranged in concentric circles (*Taizō-kai*, in Sanskrit *Garbha-dhatu*, world of reason) or in a rectangle with nine subdivisions (Kongō-kai, in Sanskrit Vajra-dhatu, world of wisdom). While studying at Ch'ang-an, Kūkai received from his master Hui-kuo two large polychrome mandara painted by several artists of the imperial court, among them Li-chên. Brought back from China by Kūkai together with many other esoteric pictures, these mandara were copied several times in the To-ji and other Shingon monasteries; on them was based the esoteric iconography of the sect. At the Jingo-ji in Kyōto there still exist a pair of large mandara executed between 824 and 833, not in colors but in gold outlines on dark violet damask. The equilibrium of forms and the well-knit design show that the Japanese artists had promptly mastered the new Chinese style. Among the polychrome paintings, the Jūni-ten images (the twelve *deva*) in the Saidai-ji at Nara most clearly reflect the style of esoteric painting adopted in the ninth century. Each picture is wholly taken up with the bulky figure of the deity flanked by two attendants. Colors are unsophisticated but forcible. Modeling is done in pink, and these effects of volume are carried to the point of chiaroscuro. The whole technique conspires to impart a sense of mystic vigor to the twelve *deva*, which are only incarnations of the principal elements of nature: sun, moon, fire, water, etc.

Since the Shingon sect regarded images as embodying the actual deities, painters working for it had to be more than mere craftsmen; they themselves had to be adepts, with a thorough knowledge of Shingon doctrines. In the Nara period, sacred images had been executed by artists attached to the official studios of painting. Now, in the Heian period, they were executed by the monks of each monastery. This was also true of the Tendai sect which, under the immediate successors of Saichō, tended to absorb the esoteric doctrines of the Shingon school of thought.

From the tenth century on, a change came over the aristocratic life of Kyōto. The political triumph of the Fujiwara family and the suspension of diplomatic relations with China left the nobles of the period free to lead an elegant life of peace and pleasure. In dealing with secular painting in the next chapter, we shall have more to say of this evolution of taste in the direction of a more genuinely Japanese style.

The same trend toward a more indigenous art also occurs in Buddhist painting. The decoration of the five-storey pagoda of the Daigo-ji, near Kyōto, built in 951 at the behest of the emperor Murakami, well exemplifies the transitional style. On the first floor of the pagoda, which occupies an area of five hundred and thirty square feet, the eye is caught at once by a large, colorful composition full of deities arranged in four vertical panels (each about 102 by 27 inches) around the central pillar. These are the main elements of the two fundamental mandara of the Shingon sect: the Taizō-kai on the west, north and south panels, the Kongō-kai on the east panel. Seen against a dark blue background spangled with golden stars, their size varying in accordance with their position in the celestial hierarchy, the gods are portrayed on lotus seats with unfaltering

Illustration page 38

technical skill, surrounded by aureoles of different colors. The most highly refined expression is reserved for the sixteen-armed Shichigutei Bodhisattva (Cundibhagavati); and this figure, as it so happens, is also the best preserved. The main outlines, in black, of the god's body were filled in with light yellow; then contours and features were drawn in red. The rather heavy modeling of the ninth century has disappeared, and colors are brighter and more harmonious. The lightness of the red outlines contributes to the effect of clarity which so sharply distinguishes this work from the esoteric paintings of the previous century, imbued as they were with the late T'ang style. The decoration of costumes, however, remains very simple and the prevailing patterns (the S-shape on the scarf, for example) still resemble those which decorate the polychrome statues of the ninth century. The secondary gods of the two mandara are continued on the four inner columns (two of which no longer exist) and on the upper half of the eight side panels—the Taizō-kai arrangement always remaining on the west side, the Kongō-kai arrangement on the east. The small divinities on the side panels are handled in a very free style. The Sanshuku (Ārdrā), one of the seven stars, has a particular grace born of serene colors and linear rhythms. Here we feel that the esoteric gods of Indian origin must by now have been thoroughly assimilated for the Japanese artists to be able to represent them in so familiar a way.

On the lower part of the side panels figure the portraits of the eight patriarchs of the Shingon sect, from Ryūmō (Nāgārjuna), its Hindu founder, to Kūkai. Comparing the portraits of the five monks active in China with the works which were brought back from China by Kūkai and which probably served as models for the Daigo-ji wall paintings, we detect in the more intimate, more serene expression of the copy the same trend toward a more genuinely Japanese style.

Early in the eleventh century, with the rise to power of Fujiwara Michinaga, head of the ministerial family, the aristocratic culture of the age reached its apogee. Noblemen vied with each other in building Buddhist temples as a means of ensuring their personal salvation. Ceasing now to play its national role as a bulwark of defense against moral and material evils, Buddhism became a private religion, a pledge of happiness and long life for believers. Buddhist painting accordingly changed character, passing from austerity to intimacy, from power to delicacy.

What contributed most to this evolution of sacred art was the transformation of Amidism (the cult of Amida) and the hold it gained over the Japanese mind. The Amida Buddha (Amitābhā) had been worshipped since the seventh or eighth century as one of the leading gods of Buddhism, and the dogma of rebirth in his paradise, Saihō Jōdo (the Pure Land of the West), took form in the course of the tenth century in the Tendai doctrine. But it was Genshin (better known under the name of Eshin-sōzu), a learned monk of the Enryaku-ji monastery, who in his book $\overline{O}j\bar{o}$ -yōshū, published in 985, worked out a theological system of salvation through Amida, based on the Kan-muryōju-kyō sūtra. Exhorting the faithful to despise earthly life and aspire to the Pure Land of Amida, his doctrine first attracted the attention of the educated middle class, which was debarred from the affluence enjoyed by the great nobility and could find no consolation in the

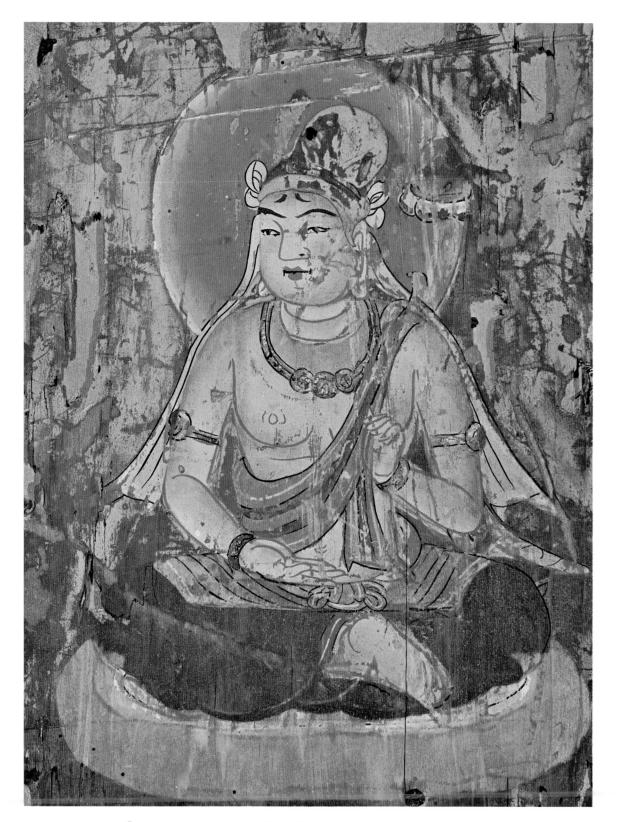

Sanshuku (Ārdrā), One of the Seven Stars (Secondary Divinity), detail of the side wall. 951. Wall painting on a wooden panel. (Height of the figure 9") Pagoda of the Daigo-ji, Kyōto.

current esoteric doctrines, too much vulgarized now to appeal to them. The worship of Amida spread to the entire nobility in the eleventh century. In hopes of prolonging their luxurious way of life in the next world, the nobles addressed their prayers to this merciful savior and commissioned paradise scenes picturing the beatitudes of the life to come. The image of Amida descending from heaven with his divine retinue to receive the believer's soul became the subject most frequently represented, under the name of *raigō-zu*.

The most complete monument we have of the cult of Amida is the Phoenix Hall (Hōō-dō) in the Byōdō-in temple at Uji, seven miles south of Kyōto. The building was commissioned in 1053 by Fujiwara Yorimichi who, having succeeded his father Michinaga in the office of prime minister, founded a temple for the salvation of his soul in the grounds of his palace at Uji, famous for the beauty of its landscape.

One of the gems of Japanese architecture, the Phoenix Hall miraculously survived the devastation of the civil wars, which played havoc with the other buildings of the temple area. From the central sanctuary housing a large, gilded wooden statue of Amida, two-storey galleries extend on either side; projecting behind the central sanctuary is yet a third gallery. Purely decorative elements determine a layout, intricate but always symmetrical, which recalls the figure of a phoenix with wings and tail. On the topmost ridge of the main roof, moreover, two bronze phoenixes dominate the whole structure, whose graceful lines are reflected in the waters of a pool.

The interior of the central building is entirely decorated with paintings. On the panels of the five doors and on the inner walls figure nine versions of the Descent of Amida (raigo), corresponding to the nine degrees of salvation to which the dead may accede, depending on their good or bad behavior. Best preserved are the scenes on the two side doors and those on the two doors on either side of the façade; these paintings show the style of this golden age at its most authentic. Take, for example, the divine procession on the south door. Instead of the hieratic representations of deities in the esoteric paintings, devoid of any indication of space or time, Amida surrounded by music-making Bodhisattvas here approaches the dying believer, hovering over a landscape typical of the Kyōto region. Though the panel is damaged and the colors have faded, we can still appreciate the supple linework suggesting the rhythmic movement of the divine procession. A recent restoration brought to light, beneath the wooden frame, the unexposed borders of the paintings which had preserved the original colors in all their pristine freshness, thus giving some idea of the sterling beauty of the work when first produced nine hundred years ago. The bodies of the gods were painted bright yellow; the deft outlines, which have now blackened, were originally red. Their robes and floating scarves were purple, orange, blue and light green. On the aureole there still remains a decoration of floral arabesques cut out of gold leaf—a technique which the Japanese call kirikane. Though it goes back to the eighth century, this technique played no very important part before the end of the tenth century; thereafter it enjoyed a remarkable development and became an indispensable decorative element in Japanese Buddhist painting.

Something more will be said of the $H\bar{o}\bar{o}-d\bar{o}$ paintings in the following chapter, when we come to deal with the landscape backgrounds of these divine processions.

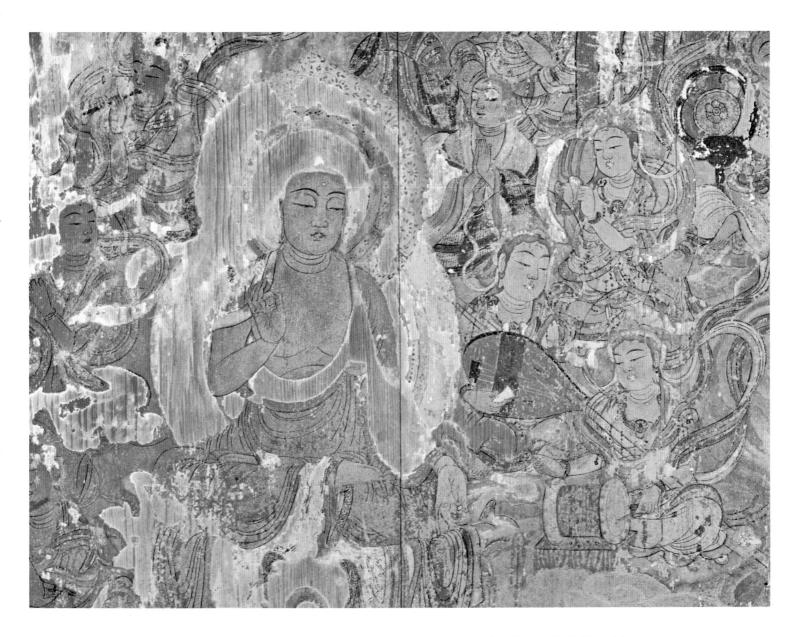

Descent of Amida with Divine Attendants (Raigō), detail of the south door of the Phoenix Hall (Hōō-dō). 1053. Painting on a wooden panel. (Entire panel $89 \times 26\frac{1}{2}$ ") Byōdō-in, Uji (near Kyōto).

But it should be noted here that the combination of sacred images with natural beauty imbues Japanese Buddhist painting with a warmth of feeling that made even the mythical gods of esoteric art more appealing.

While the Descent of Amida at the Hōō-dō is treated objectively, like a scene taking place before our eyes, that of the large Hokke-ji triptych at Nara is composed in such a way as to convey the impression that, as they descend toward us, this imposing company of gods is coming to save our own soul. In the central scroll, seated in front view on a red lotus flower, Amida gazes directly into the spectator's eyes. In this well balanced,

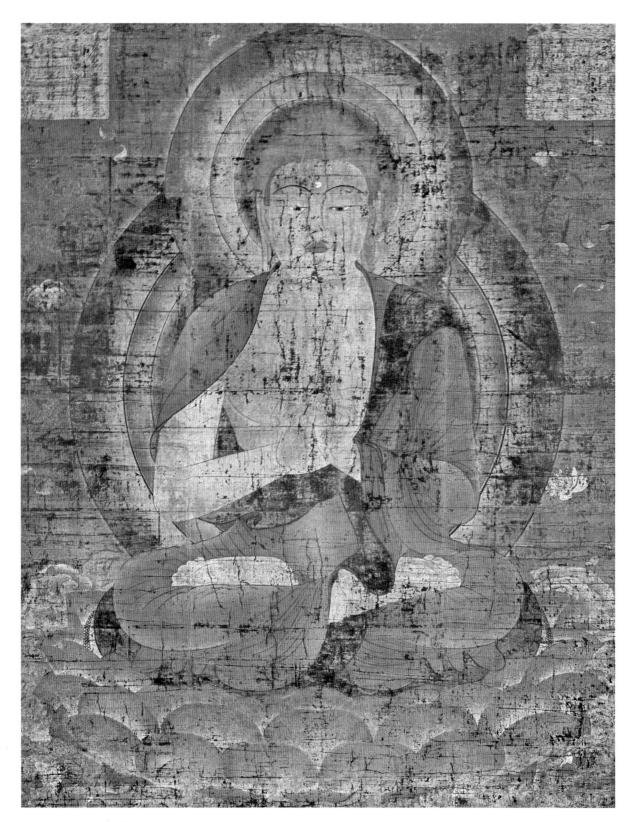

Amida on a Cloud, central part of a triptych composed of three hanging scrolls. First half of the eleventh century. Colors on silk. $(73 \times 575\%)$ Hokke-ji, Nara.

Illustration page 44

Illustration pages 46-47

almost symmetrical composition, only the white clouds surmounted by the deity serve to indicate the motion of Amida. Colors are simple and the red robe is undecorated except for the inconspicuous pattern of swastikas drawn in dark red. All these elements together lend the god a majestic dignity and bring to mind the more traditional style of the ninth and tenth centuries. Yet, when we scrutinize details, like the delicate handling of robe and flowers, and the serene, quite unmystical expression of the face, we cannot help noticing a nicety and discrimination which definitely point to a date within the first half of the eleventh century—a dating borne out, moreover, by the style of the calligraphy on the two cartouches. The two scrolls to right and left of the central deity represent a youth carrying the celestial banner and two Bodhisattvas, Kannon (Avalokitesvara) and Seishi (Mahāsthāmaprāpta); they were apparently added afterwards to give the dying man the impression of actually being received by the Great Savior.

Another important relic of Amidist art is the large composition preserved in the monastery on Mount Kōya. Originally executed on Mount Hiei, birthplace of the cult of Amida, it was transferred in 1571 to the center of the Shingon sect to safeguard it during the civil war. At the very heart of the composition appears the great figure of Amida, with gilded body, majestically descending toward us. His robe is also decorated with kirikane, and the gilding of the aureole is like a symbol of the light emanating from the Great Savior. He is accompanied by a stately procession of Bodhisattvas, with Kannon presenting the lotus seat for the dead man's soul and Seishi in the pose of an orant; both advance to the foreground, thus forming a triad with the central divinity. Seated in attitudes of devout prayer, the five Bodhisattvas flanking Amida-three of them dressed as monks-are well in keeping with the solemn composure of the god himself. Behind and to either side of the central group, celestial musicians grace the procession and announce the advent of salvation to the believer. The brilliant colors of the Bodhisattvas' costumes and the musical instruments, above all the bright purple and dark blue, contrasting with the gilding of the Buddha, add a felicitous touch to the composition. Now light brown, the clouds must originally have been colored mauve to imitate the "violet clouds" mentioned in the sūtras. Thanks to the spirited rendering of the clouds upholding the entire procession, the thirty-three deities form a harmonious whole and infuse a dramatic element into the scene of salvation. The procession passes over a lake, beside a mountain in autumn represented on the lower left; this landscape is not unlike the view of Lake Biwa from the top of Mount Hiei. The artist working in this mountain monastery no doubt took inspiration from the clouds drifting over the lake, tinged with the golden haze and mellowing colors of the setting sun. An old tradition attributes this picture to the monk Genshin (942-1017), who spread the cult of Amida in Japan. But the style and technique, above all the over-sharp outlines in red and the emphasis laid on colors, point rather to a date subsequent to that of the Phoenix Hall paintings (1053), perhaps the early twelfth century.

The eleventh century has bequeathed some other masterpieces of Buddhist painting, treating a variety of subjects. Both in the esoteric sects and the old Nara sects, the cult of Shaka-muni (Sākyamuni) as the founder of Buddhism had never lost its importance.

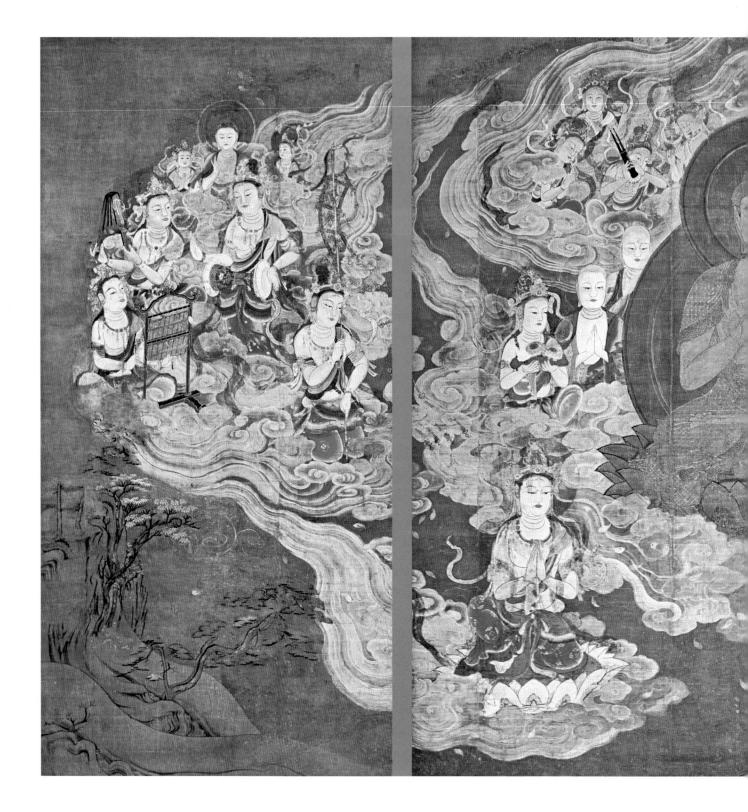

Descent of Amida with Divine Attendants (Raigō). Triptych of three hanging scrolls. Early twelfth century. Painting on silk.

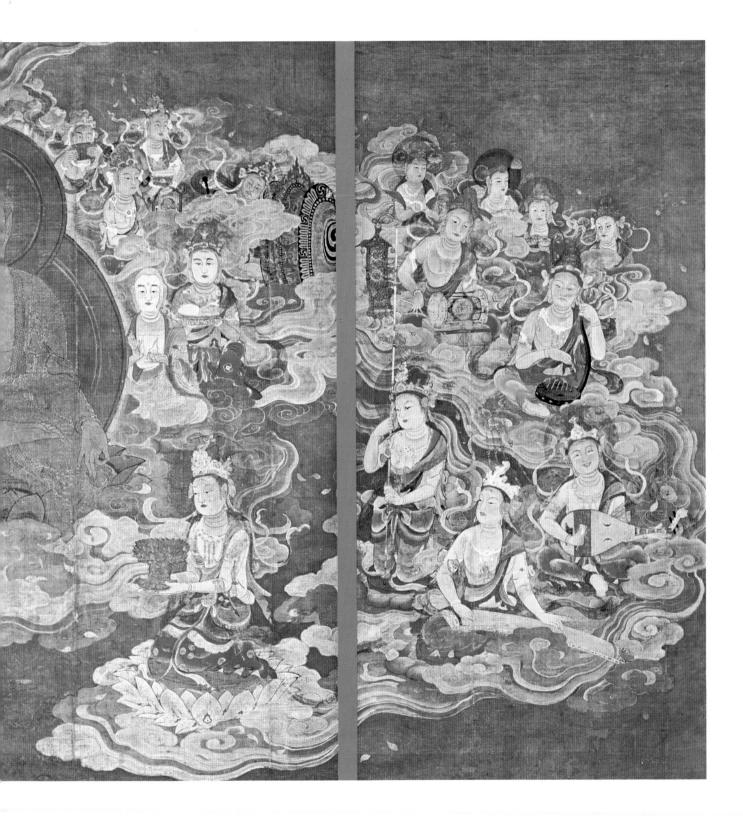

 $(Central \ scroll \ 8_3 \times 8_2 \ 7_8 \ ", \ side \ scrolls \ 8_3 \ 1_8 \times 4^{13} \ 4'' \ and \ 8_3 \times 4^{15} \ ") \ Eighteen \ Temples \ of \ Y \ ushi-Hachimanko, \ K \ vasan, \ Wakayama.$

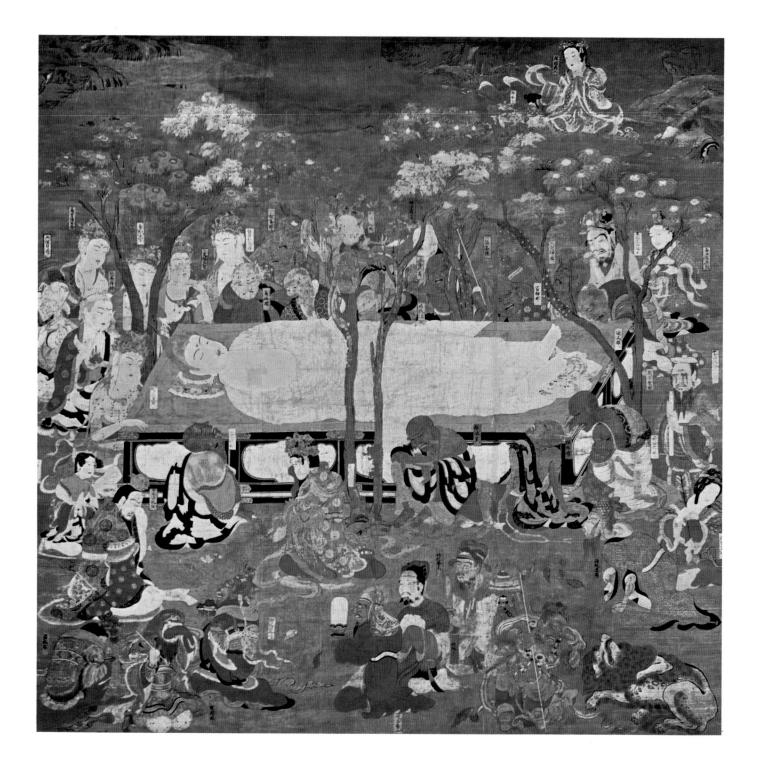

Death of the Buddha (Nirvana). 1086. Hanging scroll, painting on silk. (105¼×106¾″) Kongōbū-ji, Kōya-san, Wakayama. It was the custom to commemorate his death *(nirvana)* each year, on February 15, by presenting in the center of the sanctuary a large picture of the event, which was called *nehan-zu* (*nirvana* scene). Among many vestiges of this type of picture, a large *kakemono* (hanging scroll) in the Kongōbū-ji temple on Mount Kōya deserves special mention. In the opinion of the present writer, it represents the apogee of Japanese Buddhist painting in this period.

Illustration page 48

Lying on a richly decorated bed in the center of the composition is Shaka-muni, who has just died in a grove of sāla (the sacred tree). His body, colored bright yellow, is covered with a white robe delicately tinted with pink and patterned with cut gold leaf (kirikane). The effect of these light-hued colors is to make the Buddha seem aglow with a supernatural light which focuses attention on his transfigured face. The death-bed is surrounded by the denizens of the Buddhist world: Bodhisattvas, arhats (disciples), devas, kings, ministers and even animals. The Bodhisattvas seated around the head of the Buddha are represented with extreme elegance. A few are colored, like Shaka himself, in bright yellow with outlines in red, while the others have white faces drawn in black with delicate strokes. And the alternation of these color effects gives a peculiar intensity to this part of the composition. The Bodhisattvas preserve their serenity despite the sorrow of their great bereavement, while the arhats and devas give way to their grief. The sobbings of the latter are accompanied by an extravagant grimace; the somber colors dominating this group strike a contrast with the bright hues concentrated around the Buddha's head. On the lower right is a lion in an agony of grief. The Nirvana pictures of later periods contain animals of many different kinds; but by confining his allusion to the animal kingdom to a single lion, the author of this *kakemono* sensibly safeguards the unity of his composition. At the top of the picture, above the flowering trees, appears Lady Maya, Shaka-muni's mother, coming down to the scene. In the background is the valley of Kusinagara referred to in the sūtras; as described there, of course, it was an Indian landscape, but here it takes on an unmistakably Japanese character full of poetic charm. The fact of its being dated-to 1086, inscribed on the lower right-greatly enhances the value of this scroll. It proves that thirty years after the building of the Phoenix Hall, Japanese Buddhist painting had successfully achieved a style of its own, with delicately shaded colors and richly varied decorative patterning, while losing none of the dignity and grandeur of the past.

The warm feeling for nature pervading Japanese Buddhist painting is particularly apparent in the series of panels portraying the sixteen disciples of the Buddha (*rakan*, in Sanskrit *arhat*) from the Raigō-ji at Shiga, now in the National Museum in Tokyo. At the Buddha's request, the sixteen *rakan* consented to remain in the world in order to protect and uphold the Buddhist law. Nagasena (Nagassina), who symbolizes mercy, lived in the mountains in the company of birds and animals. In this charming picture of him seated amidst flowering trees, he is shown feeding a stag from his alms bowl. The composition, though no doubt of Chinese origin, is already very much in the Japanese manner; whereas in Chinese paintings the figure of the disciple often assumes strange shapes, here it is entirely natural and mild-mannered. Much more hieratic is the figure

Nagasena, One of the Sixteen Disciples of the Buddha (Jūroku-rakan). Late eleventh century. Hanging scroll, painting on silk. (37¾×20½") From the Raigō-ji, Shiga. National Museum, Tokyo.

Nakura, One of the Sixteen Disciples of the Buddha (Jūroku-rakan). Late eleventh century. Hanging scroll, painting on silk. (37¾×20½″) From the Raigō-ji, Shiga. National Museum, Tokyo.

Portrait of the Patriarch Jion-daishi (632-682), founder of the Hossō sect, detail. Eleventh century. Hanging scroll, colors on silk. $(64 \times 52 \frac{1}{4})$ Yakushi-ji, Nara.

Illustration page 51

of another arhat, Nakura (Nakula), symbol of divine power, shown with his two demonacolytes. Bamboos and a tree in bloom, however, add an appealing note of intimacy to the picture. Judging both by the style of the painting and the writing in the cartouches, this series of works can plausibly be assigned to the late eleventh century.

The faces of the disciples are treated in a naturalistic manner reminiscent of the portraits of the period. One of these, a monumental work also of the eleventh century, has come down to us: the portrait of Jion-daishi (Kuei-chi) in the Yakushi-ji at Nara. He was a Chinese monk (632-682) highly venerated in the T'ang and Sung periods as the founder of the Hossō sect. In Japan, from the tenth century on, homage was paid to his memory each year in a ceremony held in the great temples of the sect at Nara. The portrait, whose composition is probably based on a Chinese original, well conveys the spiritual vigor of the great monk, whose attitude suggests that he is engaged in some theological discussion. The sumptuous patriarchal costume, the handling of the body with its pink modeling, the beautifully decorated ink-stone beside him—all these are details characteristic of the T'ang tradition. At the same time, the harmonious, light-toned colors reflect the Japanese taste of the eleventh century.

The same stylistic change came over esoteric painting in the eleventh century. With its complex and mystical iconography, it had introduced in the ninth century the ponderous, powerful expression of the late T'ang style; one hundred years later the wall paintings in the Daigo-ji pagoda already reveal a new tendency toward a lighter, more delicate vein of expression. But it was in the eleventh century, at the height of aristocratic culture, that images of various esoteric deities were produced in large numbers and given a greater refinement in keeping with the taste of the nobility.

The Shingon sect and even the Tendai sect had by then almost lost or forfeited their original philosophical character and their mystical ceremonies had been enlisted in the service of the earthly desires of the faithful. Monks of both esoteric sects were continually being called in by the imperial family and the nobility to heal the sick, to allay the epidemics that often ravaged the country, to bless women in childbirth, to intercede in favor of office-seekers, and even to pronounce anathemas against political opponents or rival lovers. In the esoteric pantheon, where each deity filled a particular function, it was chiefly the "angry gods" who played an important part in these ceremonies and mystical prayers. According to the Shingon doctrine, the Buddhas (Nyorai, in Sanskrit *Tathagata*), who generally have a kindly, peace-loving aspect, manifest their anger when they attack the enemies of the Good Law in the frightening and even diabolical shapes of the Myōo (Raja).

Two remarkable paintings of the eleventh century are extant which represent the most characteristic deities of esoteric Buddhism. The first is the Dai-itoku-myōō (Mahājetas) in the Boston Museum of Fine Arts. Brought to the United States by Tenshin Okakura (1862-1913), who gathered together the Japanese collection of the Boston museum, this picture is regarded as one of the most important Japanese paintings in a foreign collection. The god, with his dark blue body, three heads, six arms and six feet, is seen astride a green bull. The glowing eyes and open mouths of his three faces show

Illustration page 52

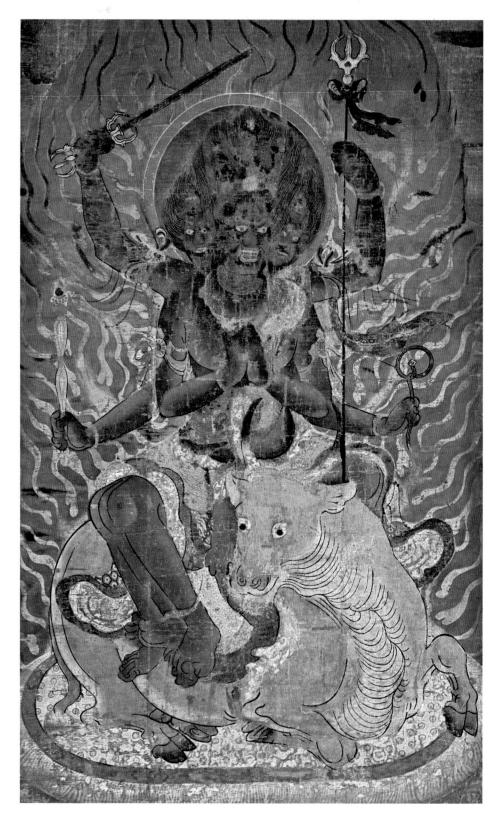

Dai-itoku-myöö (Mahājetas), Esoteric Divinity. Eleventh century. Painting on silk mounted on a frame. $(76\% \times 46\%'')$ Museum of Fine Arts, Boston.

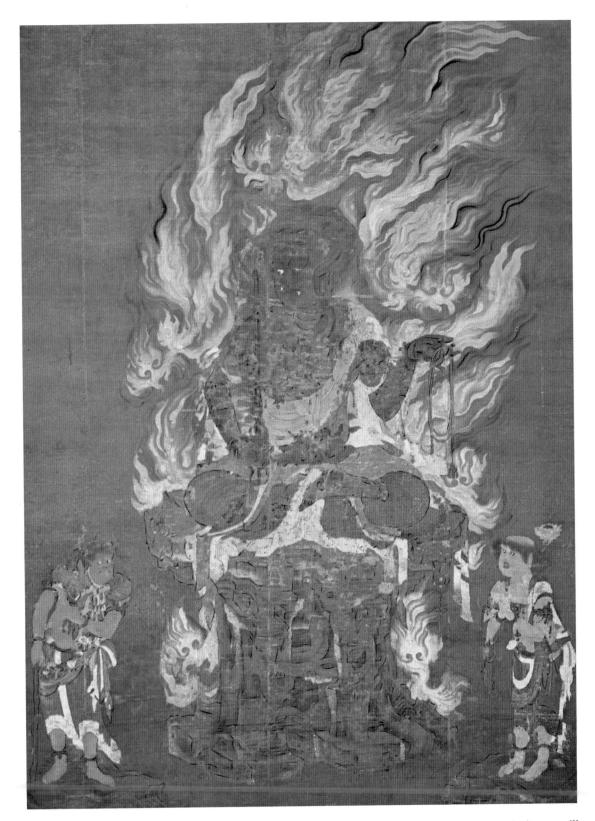

The God Fudō-myōō (Acala) and Two Attendants. Mid-eleventh century. Hanging scroll, painting on silk. $(81 \times 59\%'')$ Shōren-in, Kyōto.

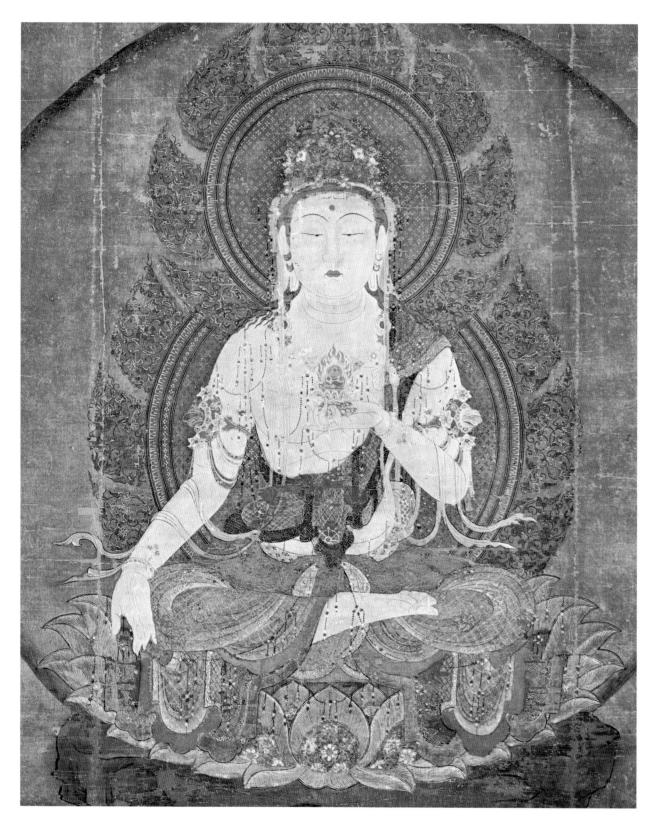

Kokuzō-bosatsu (Akasagarbha), God of Wisdom. Twelfth century. Central part of a hanging scroll, painting on silk. (Entire scroll 517%×331%") National Museum, Tokyo.

him to be in one of his angriest moods. Ringed with flame, he brandishes weapons in four of his hands to frighten away evil spirits, while the two clasped hands in the middle symbolize the divine dignity. In this well balanced composition, the artist convincingly expresses anger and dynamic power without lapsing into the ungoverned excesses of the early works of esoteric art. But it is above all in the details that we find the distinctive features of the eleventh century: the supple black outlines of the god's body and particularly that of the bull; the polychrome flower patterns on the costume and the rug; the use of fine cut gold leaf to represent hair and enhance the decorative designs.

These decorative methods are even more elaborately worked out in another masterpiece of the same type, the Fudō-myōō (Acala) in the Shōren-in temple at Kyōto. The god Fudō-myōō is a manifestation of the fury of Dainichi-nyorai (Vairocana), supreme god of the esoteric pantheon, and he has been deeply venerated in Japan since the ninth century. Though usually appearing in the midst of four other Myöö (Raja), he is also often represented singly both in painting and sculpture. In the ninth century a monk named Enchin (better known under the honorable title of Chishō-daishi), who introduced many esoteric elements into the Tendai doctrine, had images made of Fudō-myōō under the peculiar aspect in which he had seen the god in his mystical visions. One of these images is the Ki-fudo (yellow-bodied Fudo), still piously preserved in the Onjo-ji monastery. Unlike the mystical, exotic representation of the "yellow Fudo" standing in mid-air, the Shören-in painting conforms to the customary iconography of the god: his body is blue and he is seated on a rock between his two attendants, Kongara (Kinkarah) and Seitaka (Cetakah), who look like young boys. The triangular grouping of the three figures gives a classic stability to the composition, while the sublime power of the god is expressed by the swirling tongues of flame which, carefully studied, suggest the symbolic forms of the Karula (Garuda), the Buddhist mythical bird. But the beauty of this painting lies above all in its harmonious combination of pure and delicate colors. The dark blue silhouette of the god tells out against a background of red and orange flames; he wears a bright orange scarf and two skirts, a green one and a longer, purplish brown one. The pink figures of the two attendants, one light, one dark, re-echo the god's aureole and balance the base of the composition. Costumes are decorated with color patterns instead of *kirikane*. These various stylistic features, together with the extreme finesse and suppleness of the black outlines, enable us to date the picture to the mid-eleventh century.

The spiritual power and majesty which still imbue the Fudō-myōō, and which are so well in keeping with the decorative effect of the forms and colors, gradually disappeared in the twelfth century. By then, political power had passed from the Fujiwara family into the hands of the $j\bar{o}k\bar{o}$, the emperors who, though officially in retirement, were actually still the political masters of the country. Devout and even fanatical Buddhists, these ex-emperors erected large temples and commissioned a considerable number of Buddhist images, sometimes for use in a single ceremony. Buddhist art was at this period concerned above all with delicacy of execution, and compositional power was sacrificed to agreeable color effects enhanced with *kirikane*. A series of twelve *deva*

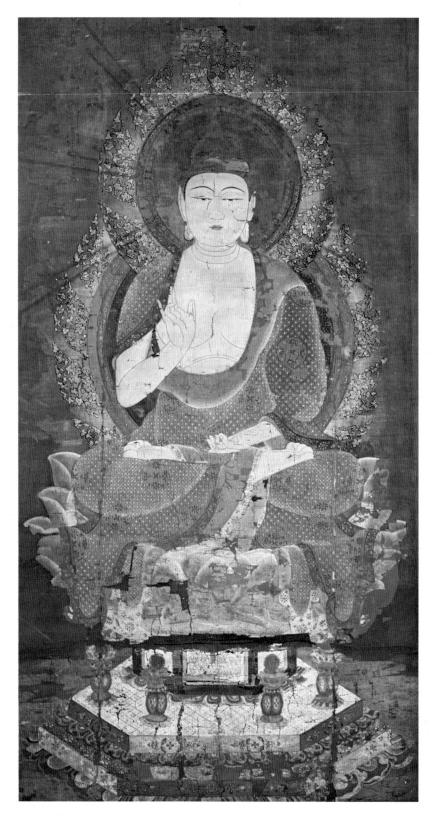

Shaka-nyorai in a Red Robe. Twelfth century. Hanging scroll, painting on silk. (62¾×335‰") Jingo-ji, Kyōto.

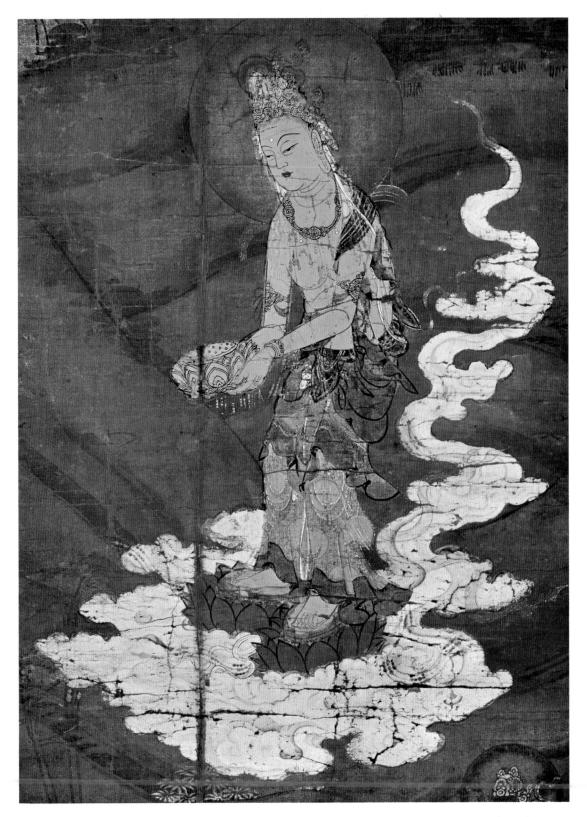

Descent of Amida across the Mountains (Yamagoshi-Amida), detail: Kannon-bosatsu presenting the Lotus Pedestal. First half of the thirteenth century. Hanging scroll, painting on silk. Zenrin-ji, Kyōto.

 $(J\bar{u}ni-ten)$ and five *raja* (Godaison), still preserved in the Tō-ji, can be dated to 1127 and provide an invaluable chronological landmark for the study of Buddhist painting in this period, of which we reproduce two signal examples.

Illustration page 58

The red-robed Shaka-nyorai (Shaka-muni) of the Jingo-ji at Kyōto is prized for the beauty of its colors, above all for the peculiar brightness of the red robe. Seated on a richly decorated, "seven-storey" pedestal, the Buddha makes the gesture of the preacher. The golden glow of his two aureoles is patterned with flower designs. In a more schematic form, executed in *kirikane*, flower designs sparkle on his robe. The bright yellow body shows no trace of modeling. The flat flesh-tints, which convey no sense of actual life, are harmoniously played off against the delicate colors of the costume and the pedestal; the effect they produce is that of an almost purely abstract beauty.

The National Museum in Tokyo owns two masterpieces of twelfth-century Buddhist painting: the Fugen-bosatsu (Samantabhadra) on a white elephant and the Kokuzōbosatsu (Akasagarbha) formerly in the Mitsui Collection. Kokuzō-bosatsu, dispenser of wisdom to mankind, appears here in a lunar disk supported by a rock. Very different from the warm coloring of the image of Shaka-muni, the cool tones that dominate this painting, together with the thin sheets of silver added here to the *kirikane* patterns of the costume and aureole, evoke the silvery gleams of moonlight. The lines marking the god's impassive features are of an extreme finesse. The subtlety of this work is highly characteristic of the aristocratic, effeminate taste of the late Heian period. Grandeur and dignity have been almost wholly sacrificed to a decorative effect whose evanescent beauty seems to symbolize the decline of the nobility at the end of the twelfth century.

As a result of the political and social changes of the second half of the twelfth century, the warrior class came to power in Japan. These men were originally no more than small landowners or local stewards of estates owned by the nobility, or even local tax collectors. But as they steadily increased their power in the provinces, they formed private armies of their own in each region, where in time their word became law. Their rise to power seriously jeopardized the economic resources of the nobles living in the capital. The leaders of this warrior class came from two great families, the Taira (Heike) and the Minamoto (Genji), whose members were then beginning to occupy more and more of the key posts at the imperial court. After the two civil wars of Hogen (1156) and Heiji (1159), it was the Taira family that made itself supreme at Kyoto and set the style of a luxurious way of life in keeping with aristocratic tastes. Its short-lived power (1167-1184) was broken by the opposing clan of the Minamoto, whose head, Minamoto Yoritomo, founded in 1184 a military government called *bakufu* (shogunate) at Kamakura, in eastern Japan. The official appointment in 1191 of Yoritomo as commander-inchief of the military establishment throughout Japan opened a new era, known as the Kamakura period (thirteenth and fourteenth centuries), during which a feudal society came into being. Nevertheless, the imperial court of Kyōto, supported by the traditional nobility, was still a cultural force to be reckoned with and the whole period was strongly marked by the parallel influence of the two intellectual centers, the Kyōto nobles on the one hand, the Kamakura military on the other.

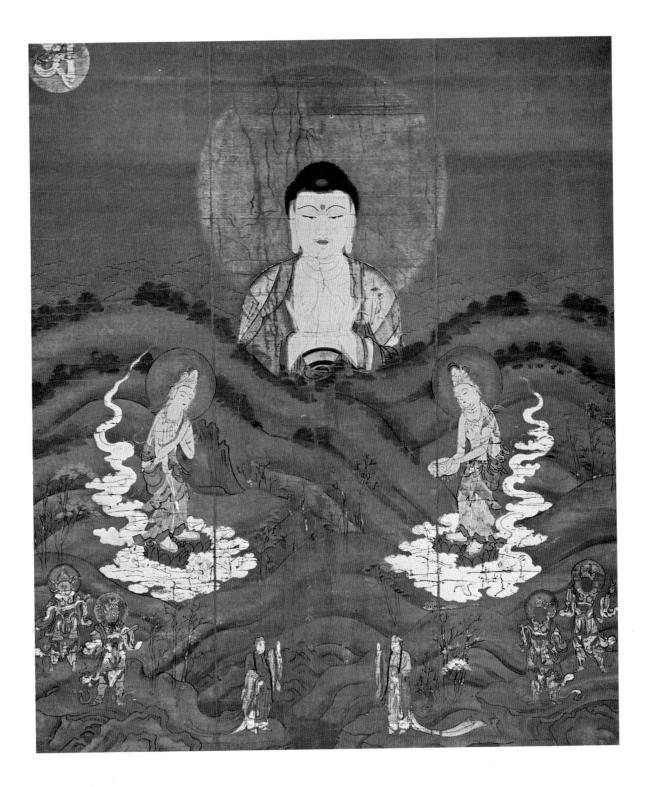

Descent of Amida across the Mountains (Yamagoshi-Amida). First half of the thirteenth century. Hanging scroll, painting on silk. (54%×46½") Zenrin-ji, Kyōto.

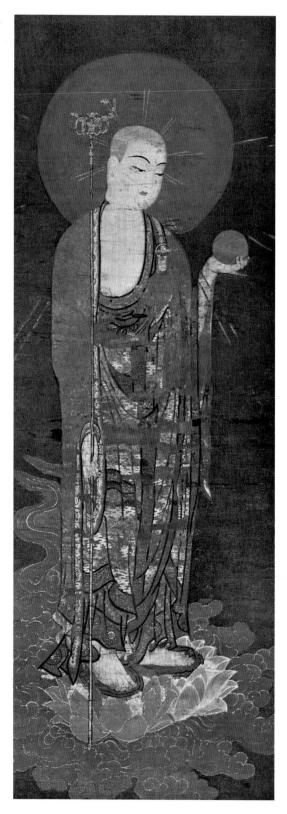

Jizō-bosatsu (Ksitigarbha). Late thirteenth century. Hanging scroll, painting on silk. (39¾×14¼″) Dan Inō Collection, Tokyo.

The two following chapters will be devoted to two important aspects of the art of this age: the flowering of scroll painting and the introduction of monochrome painting from China following the rise of the new sect of Zen Buddhism.

In the domain of religious iconography the Kamakura period seems to have brought about no fundamental change either of style or subject matter. The religious life of the day was nevertheless being infused with a new spirit which, in the event, gave an increasing realism of expression, and an increasing humanity, to the Buddhist gods. Just as Zen was being introduced into Japan, Amidism was being reformed by Hōnen (1133-1212), founder of the Jōdo (Pure Land) sect, which aimed above all at absolute selfsurrender in the worship of Amida by means of prayer. This doctrine took a still more radical turn in the hands of Hōnen's disciple, Shinran (1173-1262), who diffused the cult of Amida among the people, particularly in northern and eastern Japan. For these two reformers, the plastic representation of Amida was much less important than it had been in the aristocratic Amidism of the Heian period.

The faithful, however, required a tangible image of their promised savior, particularly in the scene depicting Amida descending to earth to welcome human souls into his paradise ($raig\bar{o}$). The great Zenrin-ji painting is one of the largest of such scenes. Dating from the first half of the thirteenth century, it represents a golden-bodied Amida solemnly appearing beyond two mountains, like the full moon of autumn. Making the sign of Supreme Salvation ($j\bar{o}bon-j\bar{o}sh\bar{o}$) by raising both hands before his chest, the Great Savior gazes into the eyes of the dying believer, beside whose death-bed this picture was meant to hang, to vouchsafe him a mystical vision of the approaching procession of gods. Two Bodhisattvas, Kannon (Avalokitesvara) and Seishi (Mahāsthāmaprāpta), standing on clouds, are already moving toward the mountainside, and two divine figures below carrying a banner herald the arrival of the procession; four celestial guardians, two on either side, contribute their stately presence to the scene. Disposed as they are in strictly symmetrical order, all these divinities harmonize with the beauty of a landscape that is typically Japanese.

The clean-cut, rational design of the composition and the realistic portrayal of each figure are, in our opinion, the essential features of Japanese painting in the thirteenth century. A mood of rather cool rationalism is impressed on the picture, down to the smallest detail, by the alternating colors of the symmetrical figure groups and by the scrupulously careful application of gold leaf cut out to form geometric designs. The landscape too is imbued with the taste of the period. Earthly and heavenly motifs are here more skillfully combined than they were in works of the eleventh and twelfth centuries; but their combination now lacks the paradisaical charm of the earlier art, and this shortcoming is characteristic of the Kamakura period.

The very same spirit makes itself felt in the figure of Jizō (Ksitigarbha) in the Dan Collection. This god, regarded as the merciful savior of souls consigned to hell, was deeply venerated in this period under the influence of the doctrine of *rinne* (the mystical circuit of the souls of all beings through the six spheres). Jizō, usually in the guise of a young Buddhist monk, went to the rescue of distressed souls on a cloud whose shape suggests

Illustration page 61

Illustration page 59

Although no genuine works by these early secular painters have survived, written records warrant the assumption that, by Hirotaka's time, both landscape and figure painting had achieved a mature style corresponding to the tastes and sensibility of the great noblemen. This is borne out, as a matter of fact, by the paintings which decorate the interior of the Phoenix Hall (Hōō-dō) of the Byōdō-in, built in 1053. As we have already noted in connection with Buddhist painting, the doors and walls of this extraordinary monument—erected by Fujiwara Yorimichi, head of the great aristocratic family, as an attempt to realize in this world the vision of the Western Paradise—are decorated with different scenes representing the Descent of Amida with his attendants, come to receive the souls of the faithful into his paradise; and in each of these compositions the divine processions are hovering over lovely Japanese landscapes which distinctly recall the quiet countryside of the Kyōto region. Although these are religious works (*raigō*), they are, at the same time, large-scale landscape paintings, carefully composed and including many details imbued with poetry. It will be noticed, moreover,

Illustration page 43

Early Spring Landscape, detail of the north door of the Phoenix Hall (Hōō-dō). 1053. Painting on a wooden panel. (Entire panel $147\frac{1}{2}\times54\frac{1}{2}$ ") Byōdō-in, Uji (near Kyōto).

that each landscape represents a particular time of year, so that one of the four seasons figures on each of the four walls of the building: spring on the north wall (right side), summer on the east (on the façade), autumn on the south (left side) and winter on the west (at the back). Some time ago, in examining the details of each composition, particularly of the painting on the doors which is the best preserved of them all, we came to the conclusion that, in keeping with a common practice of the day both in painting and literature, the four landscapes were intended to represent the four seasons; and this was confirmed by the discovery in 1955 of inscriptions to that effect written in India ink on the edges of the pictures, beneath the wooden frames.

The scene reproduced here figures on the upper part of the east panel of the north door. It represents a landscape in early spring: a river winds its way between low hills; on a sand shoal and on the river bank, dead reeds are waving to and fro; thin patches of snow remain on the ground; beyond a pine-clad hill two thatched cottages suggest the drab existence of the peasant woman who is crossing the river with a boatload of firewood. This glimpse of the Japanese countryside is handled with great technical skill, in soft colors, with freely flowing linework. Following the course of the river on to the other doorpanel, we see horses in a pasture, drinking beside the river; in the mountains beyond, cherry blossoms stand out against the greenery in the background. All these pastoral details are to be found in the poetry of the period, from which painters drew motifs for screens decorated on the theme of the Four Seasons.

The lyricism of this eleventh-century painting in the Phoenix Hall stands at a far remove from the strictly composed landscapes of the eighth century, in the T'ang style, like the one in the background of *Shaka-muni Preaching* (Museum of Fine Arts, Boston), or those in the Shōsō-in miniatures. Grandiose landscape views of the rugged mountains of China have given place to the smoothly rounded hills of the Kyōto country-side. The towering, superimposed mountains of T'ang painting conveyed an impression of depth and distance symbolizing the superhuman power of nature; these Japanese artists, on the other hand, sought to record nature in her more intimate moods, more congenial to man. To deep valleys flanked by dangerous peaks, they prefer lazy rivers flowing through quiet meadows or between smiling hills. The sharp angles of rocks and crags swept with vigorous brushstrokes are replaced by supple lines building up expressive forms lyrically interpreted. Such was the achievement of Japanese secular painting, the outcome of two centuries of experiment.

Another important remnant of the eleventh century, better preserved and slightly later in date than the Hoō-dō paintings, also vouches for this change of style. This is the famous Senzui-byōbu (landscape screen), preserved for centuries in the Tō-ji (or, more exactly, the Kyōō-gōkoku-ji) in Kyōto and since 1958 in the possession of the Commission for Protection of Cultural Properties, Tokyo. This silk screen was originally a non-religious painting of Chinese inspiration (*kara-e*) peopled with figures in T'ang costume. Later it was given a religious significance and used in the temple for ordination ceremonies. In the center of the composition stands a cabin in the woods, in springtime; there a poethermit sits in the throes of inspiration, with a sheet of paper and a brush in his hand,

Illustration page 68

Illustration page 26 Illustration page 32

The Tale of Genji (Genji-monogatari): Prince Genji holding in his Arms the Newborn Babe Kaoru (detail of the third scene of the Kashiwagi chapter). First half of the twelfth century. Handscroll, colors on paper. (Height 85/8'') Tokugawa Museum, Nagoya (owned by the Reimeikai, Tokyo).

to left, following the natural movement of the eye when the scroll is unrolled from right to left. In accordance with another convention, the artist omits the roofs of houses in order to bring the whole interior clearly into view. Equally remarkable is the handling of figures: faces are always indicated by the same conventional signs, a hook for the nose, two slits slightly accentuated in the center for the eyes, a red dot for the lips. No hint of character or personal feelings is allowed to show through. This stylization, however, cannot be said to spring from any lack of experience in the portrayal of facial features. The faces of Buddhist gods and the portraits of monks dealt with in the previous chapter reveal a great variety of facial expression and accordingly testify to considerable technical skill. In this same scroll, moreover, lower-class figures are portrayed in a more realistic manner. The facial uniformity of the leading characters, then, is undoubtedly deliberate; the reason for it probably lies in the fact that the high-born personages who owned and admired these paintings could thereby more readily identify themselves with the heroes and heroines of the story.

In this set of works, one of the gems of Japanese painting, the symbolic use of colors plays a very important part. Colors are laid on in thick, opaque coats which prevent the paper from showing through. The long hair of the women and the coiffures of the noblemen form an ever-varied rhythm of black patches within the color scheme as a whole. The choice and sequence of the colors has been carefully worked out beforehand, and each scene is dominated by a particular color appropriate to the subject. Take for example the third scene of the Kashiwagi chapter. Celebrating the fiftieth day after the birth of his son Kaoru, Prince Hikaru Genji, hero of the novel, is shown holding the babe in his arms. For all the impassiveness of his face (which recalls the neutral expression of the masks worn in No plays), can we not feel something of the prince's chagrin at the sight of this baby boy, the love-child of Princess Nyosannomiya, his wife, and their young nephew Kashiwagi? Thus at the end of a life full of glory and amorous conquests, the hero is punished for the criminal passion for his mother-in-law to which he gave way in his youth. This stroke of fate, which forms the climax of the first part of the novel, is symbolized in this scene by the figure of Genji: his white costume, now tinged with mauve through an alteration of the pigments, is indicative of old age and emphasizes his solitude by contrast with the bright colors around him, particularly the reds of the small ritual tables and the luxurious robes worn by the ladies-in-waiting or placed between the curtains to decorate the palace.

From the second part of the novel, which deals with the love adventures of Genji's successors after his death, we illustrate an episode in the Yadorigi chapter. In a room thrown open on a park in autumn, Prince Niou-no-miya, Genji's grandson, is playing the *biwa* to soothe his wife, Princess Uji, who is angry with him for having made love to his sister-in-law Ukifune. The rustling of the transparent bamboo curtain and the waving of the grass outside hint at the autumn wind that has sprung up between the married couple, symbolizing their discord. The slightly unbalanced composition, the bleakness of the colors, and even the pose of her figure, conspire to suggest the melancholy of the forsaken princess.

Illustration page 72

A keen eye will detect subtle differences of expression between the two scenes, notably in the treatment of figures. Study and comparison of details in the nineteen scenes now extant has led us to divide them into four groups exactly corresponding to four different styles of calligraphy, which form the vestiges of four scrolls. We have succeeded in entirely reconstituting one of the scrolls, which spans five chapters of the novel and comprises eight scenes now divided between two collections. As already noted, the complete work, numbering fifty-four chapters, must have comprised originally from eighty to ninety illustrations spread over ten scrolls. The work seems to have been carried out by five groups of painters and calligraphers, each group being placed under the patronage and supervision of an art-loving nobleman. Each of the five patrons presumably had two scrolls written and illuminated in accordance with his own taste and judgment; then together they presented the work to some high-ranking personage, the emperor, an ex-emperor or the empress, who had originally conceived the idea of illustrating the Tale of Genji. Collective art projects of this kind are often mentioned in records of the period, either for illuminated scrolls, albums of illustrated poems, or sūtras; mention is even made of a set of *Genji* illustrations commissioned by the emperor in 1119.

While it is impossible for us to prove that the extant *Genji* scrolls are actually those made in 1119, there can be no doubt that they were executed at some time in the first half of the twelfth century; a comparison of their stylistic maturity with the stiff and lifeless works of the same kind produced after 1160, makes this quite clear.

Where then did the *Genji* style of illumination originate, an art with a technique and esthetic so peculiarly its own? It cannot be traced back to the Chinese tradition, which derives from T'ang painting. Though admittedly we have only meager remains of early secular painting to go on, especially as regards the art of illumination from the ninth to the eleventh century, there are grounds for believing that the *Genji* style first arose in the tenth century in the cultivated, art-minded circles of the aristocracy, particularly among the noblewomen of the day who, desiring to illustrate their favorite novels with their own hands, devised this simplified representation of figures. Closely bound up with the feminine taste for novel-reading, this style was gradually matured and refined in the more skillful hands of the professional painters who adopted it; in time it attained to the symbolic expression we noted in the *Genji* scrolls. We can apply the term *onna-e* ("painting in the feminine manner"), often employed in the literature of the time, to the style conceived and developed among the great ladies of the nobility, a style whose graceful dignity and restraint reflects the atmosphere of the imperial court of the Heian period.

Delightful though it is, the style of the paintings illustrating the *Tale of Genji* by no means reigned supreme in all the illuminated scrolls of the period. Another style of illumination, also based on a long tradition, flourished in the second half of the twelfth century; it too, if under a very different aspect, reflected the spirit and substance of Japanese life, but of a more popular order.

Illustration page 77

This new style is exemplified in three illuminated scrolls called *Shigisan-engi-e-maki* (Origin of the Temple of Mount Shigi), preserved since the day they were made in the

The Tale of Genji (Genji-monogatari): Prince Niou-no-miya soothing his Wife, Princess Uji (third scene of the Yadorigi chapter). First half of the twelfth century. Handscroll, colors on paper. (Height 8¾") Tokugawa Museum, Nagoya (owned by the Reimeikai, Tokyo).

Chōgo-sonshi-ji temple on Mount Shigi, southwest of Nara. They relate three miraculous legends connected with the monk Myōren, who restored this mountain monastery at the end of the ninth century.

A native of the mountainous region of Shinano, Myoren received ordination at the Tōdai-ji, the temple of the Great Buddha at Nara. Thereafter he led a life of austerity on Mount Shigi, praying to his heavenly patron Bishamon-ten (Vaisravana), and never again left his hermitage. For food he depended on his alms bowl, which, invested with magic powers, flew through the air on its master's errands, visiting the neighboring villages and bringing him back such sustenance as he required. One day—relates the first scroll—a rich farmer, galled by the daily obligation of providing food for the monk, locked up the bowl in the barn where he stored his rice. But the magic bowl was not so easily balked: it flew into the air as usual, carrying with it the barn and its whole store of rice, which it duly deposited in the mountains at the feet of its master. The panic-stricken farmer went in pursuit of his runaway barn, climbing the mountain and entreating the monk at least to give him back his rice, which represented the whole extent of his fortune. Myören was lenient with the offender and ordered the bowl to carry back the sacks of rice, which it proceeded to do; and they all flew overhead like a flight of birds and came to rest on the very spot where the barn had stood. After this anecdote in a popular vein, full of movement and surprises, a more serious miracle is related in the second scroll.

covered over by the frames. These ink drawings represent, for the most part with humor and gusto, faces and figures which the artists saw around them at the time. The most remarkable of them were discovered on the east door of the $H\bar{o}\bar{o}-d\bar{o}$ (Phoenix Hall), of which much has been said in an earlier chapter. The faces of two old men and thirteen figure sketches of clerks and servants in the employ of noblemen are rendered with appealing realism in a few strokes of the brush. Here is proof that the painters engaged on the large compositions showing the Descent of Amida against panoramic landscape backgrounds could also have recorded the humbler life around them, the scenes and people that caught their eye, had circumstances allowed them a little more freedom in the choice of subject matter.

The art of ink line drawing, as a medium of rendering movement and life, was worked out over the centuries in the studios of professional painters, but its practice was impeded by the thematic repertory imposed by aristocratic taste. At last its opportunity came: it flourished in the mid-twelfth century and the master of the *Shigisan-engi* scrolls displayed his genius to the full in the three legends, more popular than hieratic, of the hermit Myōren. 5

We important sets of scroll paintings, illustrating the *Tale of Genji (Genji-mono-gatari)* and the three legends of the monk Myōren (*Shigisan-engi*), executed in styles signally different from each other, herald the flowering of this type of secular painting. In addition to these, there are still other works of the twelfth century, whose style and subject matter well reflect this transitional period.

Like the Shigisan scrolls, the three Ban-dainagon scrolls (Ban-dainagon-ekotoba) in the Sakai Collection, Tokyo, illustrate a tale full of surprises in an ingenious series of compositions. The subject, however, is a purely profane and historical one, turning on a political intrigue enacted against the background of the struggle for power among the different aristocratic clans in the ninth century. One night in the spring of 866 the main gate (Oten-mon) of the imperial palace was burnt down. Tomo-no-yoshio, secretary of state (dainagon) and known simply as Ban-dainagon, promptly accused his political enemy, Minamoto-no-Makoto, of having set it on fire. The latter was about to be condemned by the emperor when proceedings against him were suspended on the advice of the Prime Minister Fujiwara Yoshifusa. Summer passed and in the month of September the son of a butler in the imperial palace quarreled with the son of Ban-dainagon's book-keeper who, presuming on the political power of his master, seized the butler's son and gave him a thrashing. Indignant at the violence done to his son, the butler in his rage cried out that he knew the great secret of Ban-dainagon. This aroused the curiosity of the crowd and was soon reported to the imperial court. Summoned and questioned, the butler confessed that he had seen Ban-dainagon and his son steal out in the night and themselves set fire to the Oten-mon gate. So the truth came out thanks to this eye-witness, and Ban-dainagon, who had basely sought to discredit his political rival, was exiled with his family to a remote province of eastern Japan. This marked the downfall of the Tomo (Otomo) family, one of the oldest of the aristocratic clans, and greatly strengthened the position of the Fujiwara family. These memorable events left their impress on the entire Heian period and several legends connected with Ban-dainagon figure in contemporary collections of folk tales. It is interesting to note that this story gave rise to the production of some important scroll paintings in the second half of the twelfth century, at the very time when the Fujiwara family in turn was losing its

ascendancy. A great fire in the imperial palace, moreover, in 1176, may have recalled the events of the ninth century, so that the illustration of these scrolls was linked up with the curious destiny of Ban-dainagon.

Particularly striking in these scenes is the dynamic sequence of compositions following one another uninterruptedly. With the opening scroll, showing mounted policemen (kebiishi) riding off at a gallop, we are caught up in the urgency of the matter at hand. A mounted nobleman and his retinue, together with officials and monks, are rushing pell-mell to the left. Pouring through one of the outer gates (Sujaku-mon) of the imperial palace, the crowd pulls up short, jostling and elbowing one another as they recoil from the heat of the fire, which is fast consuming the main gate (Oten-mon). On the other side, further to the left, courtiers are looking on with alarm and dismay. All these scenes unfold without a break, forming a continuous composition over twenty feet long. The two hundred and twenty-seven figures taking part in it are treated with a more delicate brush than those in the Shigisan scrolls. The facial expression and gestures of each figure are tellingly individualized. Ink outlines, admirably sharp and supple, delineate forms with a rhythm and sense of movement that are skillfully heightened by the vivid colors of costumes, trappings and flaming buildings. The genius of the artist is well displayed in the famous scene of the second scroll, the "Quarrel of the Children," in which the different phases of the incident develop in a circular movement symbolizing the unexpected outcome of the quarrel.

A detailed study made by Suzuki Keizō, a specialist in ancient costumes, has shown that the dress of both noblemen and commoners is represented with scrupulous exactitude. The portrayal of the police officers (kebiishi) corresponds in every particular with the regulations in force at that period, as we find them recorded in official documents, even down to certain details which at the time were kept secret. This being so, we conclude that the artist who painted this masterpiece must have belonged to the atelier of the imperial court. As a matter of fact, there are grounds for attributing these three scrolls to Tokiwa Mitsunaga, an important member of the Painting Office (E-dokoro) attached to the imperial court, who between 1158 and 1179 produced an extensive series of sixty illuminated scrolls entitled Annual Court Ceremonies (Nenchū-gyōji). Although the original scrolls of this series were destroyed in the great fire at the imperial palace in 1661, copies of seventeen of them are still extant in the Tanaka Collection in Tokyo; a few other copies also survive, whose stylistic features and composition are closely akin to those of the Ban-dainagon scrolls. Mitsunaga is known to have been working in 1173 on wall paintings in the palace hard by the Saishoko-in temple, under the supervision of the courtier Yoshida Tsunefusa, a man who had a thorough knowledge of the police regulations. This might explain the minute and scrupulously accurate portrayal of police officers in the Ban-dainagon scrolls.

For these wall paintings dedicated to the ex-emperor Goshirakawa and his wife, Mitsunaga enjoyed the collaboration of another outstanding artist: Fujiwara Takanobu (1142-1205), who revived and renewed the art of portraiture. A courtier and member of the aristocratic Fujiwara family, he was highly appreciated as a writer of *waka*

(a Japanese poem in thirty-six syllables) and above all as a portrait painter. As the work carried out at the Saishōkō-in in 1173 largely consisted in representing the solemn visits of the ex-emperor and ex-empress to the Buddhist monastery of Kōya-san and the Shintō shrines of Hiyoshi and Hirano, Takanobu was commissioned to paint the faces of the courtiers taking part in the processions, while Mitsunaga, a professional painter, executed all the rest of the composition. The portraits made by Takanobu were so realistic that the courtiers were shocked by them and had the sliding doors on which they figured folded over in order to hide them from view. Fujiwara Kanezane, minister at the time, wrote in his diary that he was delighted to have missed these three visits and to have thus avoided figuring among the portraits in this painting.

The attitude of these courtiers is significant. It shows that the realistic art of Takanobu lay quite outside the earlier tradition of Japanese portraiture, hitherto purely religious in character (portraits of the great monks; see for example page 52) or purely ritual (posthumous and commemorative portraits). So alongside the rise of scroll painting, which depicted lively incidents of real life, a parallel trend in the field of portraiture arose in the second half of the twelfth century. Luckily we can form an idea of Takanobu's genius from three portraits preserved in the Jingo-ji temple at Kyōto. From the temple

The Story of Ban-dainagon (Ban-dainagon-ekotoba), attributed to Tokiwa Mitsunaga: Excited Crowd watching a Fire at the Imperial Palace (scene from the first scroll). Second half of the twelfth century. Handscroll, colors on paper. (Height 123%") Sakai Tadahiro Collection, Tokyo.

Fujiwara Takanobu (1142-1205): Portrait of the Minister Taira-no-Shigemori. Second half of the twelfth century. Hanging scroll, colors on silk. (547/8×44") Jingo-ji, Kyōto.

records we learn that Takanobu painted portraits of the ex-emperor Goshirakawa and four of his courtiers, Minamoto-no-Yoritomo, Taira-no-Shigemori, Fujiwara Mitsuyoshi and Fujiwara Narifusa. The three portraits still extant are considered to be those of the first three courtiers, all shown seated, in a black ceremonial robe, wearing the court headdress and holding a thin piece of wood (*shaku*, a kind of scepter) which symbolizes the dignity of high office. The sabre hilt decorated with gold and a broad strip of precious cloth (*hirao*) stands out beautifully against the black of the robes.

Posture and layout are similar in all three portraits, though Shigemori and Mitsuyoshi face to the left, while Yoritomo faces to the right. Reproduced here is the portrait of Taira-no-Shigemori (1138-1179), whose mild and sincere personality left an enduring mark on Japanese history, in striking contrast with the unbridled despotism of his father Kiyomori, dictator of the Taira family. Unfortunately the lower part of the picture was badly damaged and roughly repaired with a strip of cloth, thus eliminating both the crossed legs, covered with a white garment, and the high decorative edge of the dais. The rather angular, geometric treatment of the robe contrasts with the realistic portrayal of the face, with its fine black lines heightened by pink shading. The effect of the colors is simple but forcible. The vast, bluish black, rectilinear planes formed by the robe, whose folds are barely discernible, set off the light flesh-tints of the face and the dab of red visible on the back of the collar. In the portrait of Shigemori, and in those of the other two courtiers, the whole composition is imbued with a spiritual dignity well in keeping with a sensitive and spirited expression of the sitter's personality.

This realistic trend of portraiture was continued by Takanobu's son, Fujiwara Nobuzane. A courtier (of medium rank) and poet like his father, Nobuzane gained a great reputation as a painter. He made many portraits of men living or dead, singly or in groups, and his art is designated by the word *nise-e* (i.e. lifelike painting, or realistic portraiture). His descendants were also painters; practising the same style, they formed a distinctive school which lasted throughout the thirteenth century.

Alongside the varied output of the court painters, the painter-monks of the great monasteries also produced illustrated scrolls on both Buddhist and secular themes. The most famous are the four $Ch\bar{o}j\bar{u}$ -giga scrolls (Animal Caricatures) preserved since the thirteenth century in the Kōzan-ji temple, in the mountains northwest of Kyōto. These ink outline drawings have no unity of either subject or style. Moreover, in the absence of any accompanying text, it becomes difficult to grasp the meaning of each scene and to connect the four scrolls as a whole. Several different interpretations have accordingly been proposed for them.

The first scroll, consisting of a long sequence of compositions, represents the antics of monkeys, rabbits and frogs parodying human actions—swimming, practising archery, horseback riding and wrestling. In all these contests it is invariably the underdog who wins. The rabbits, having beaten the monkeys at swimming, are in turn outwrestled by the frogs. Some art historians regard these scenes as social satire alluding to the decline of the aristocracy after the rise of the warrior class. The end of the first scroll is devoted to a religious ceremony conducted by a monkey dressed as a Buddhist

Illustration page 84

Illustration page 82

Animal Caricatures (Chōjū-giga): The Contest between the Rabbit and the Frog (scene from the first scroll). Second quarter of the twelfth century. Handscroll, ink drawing on paper. (Height 12½") Kōzan-ji, Kyōto.

dignitary, solemnly praying before a statue of the Buddha in the guise of a frog seated on a lotus leaf. This is plainly an ironical "dig" at the clerics of the day. In this first scroll, full of movement and amusing touches, the frolicking animals are vividly rendered with deft and telling strokes of the brush—always in ink. The same highly skilled technique of ink outline drawing occurs in the second scroll, also of various animals, not humanized now but represented naturalistically: horses, dogs, cocks, etc. Fifteen kinds of real or imaginary animals are treated with naïve exactitude and liveliness. While the scenes of the first scroll are unmistakably satirical, there is nothing of this in the second; these animals have a purely pictorial significance.

The style of the drawing and details of the costumes worn by the humanized animals warrant us in assigning the first two scrolls to the second quarter of the twelfth century —a date still within the lifetime of the monk Kakuyū (1053-1140), better known as Toba-sojō, to whom tradition has always attributed the four Kōzan-ji scrolls, although there is no positive proof in support of it. There is this to be said for it, however: that the source of this remarkable technique of ink monochrome drawing is in fact to be sought for in Buddhist art.

As already noted at the beginning of the third chapter, the esoteric sects, attaching great importance as they did to the plastic and pictorial representation of divinities,

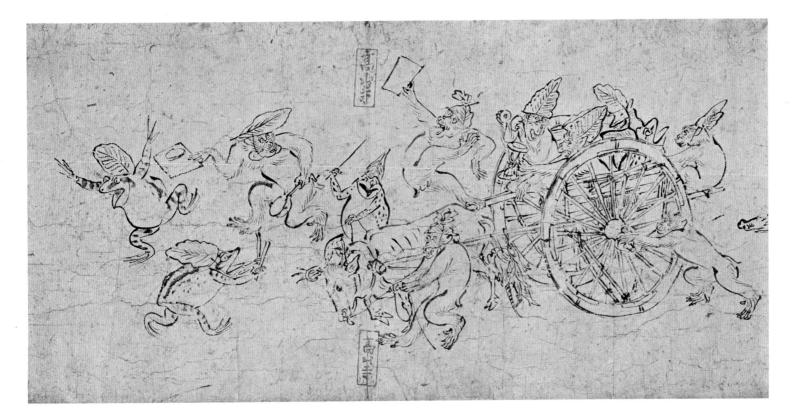

Animal Caricatures (Chōjū-giga): Animals at Play (scene from the third scroll). Late twelfth century. Handscroll, ink drawing on paper. (Height 12¼") Kōzan-ji, Kyōto.

numbered the art of painting among the accomplishments essential to the great monks. Furthermore, by dint of copying and recopying iconographic models, the artists in the temple studios became thoroughly proficient in the art of making rapid ink sketches. This technique is seen at its best in the twelfth century when several extensive collections of theological commentaries were compiled, accompanied by iconographic drawings whose deft and supple linework is very close to that of the *Animal Caricatures*. So it is not surprising that the Kōzan-ji temple, which was one of the main centers of Buddhist painting and collected a large number of iconographic drawings in the thirteenth century, should be found in possession of animal pictures of this kind, the work of some monkish painter of more or less professional standing.

The third scroll of the series represents monks and laymen at play (first part) and animals again parodying human actions (second part). The expression is quite as spirited and whimsical as in the first scroll, and the touch equally light; but the finer, less emphatic linework points to a different, slightly later artist, probably of the late twelfth century.

The difference of style is more marked in the fourth scroll, which is wholly confined to figures whose actions are relentlessly caricatured: antics of monks and laymen, scenes of Buddhist ceremonies, the construction of temples, etc. But the humorous extravagance of these drawings is carried to the point of outright vulgarity, and the linework is often

Illustration page 85

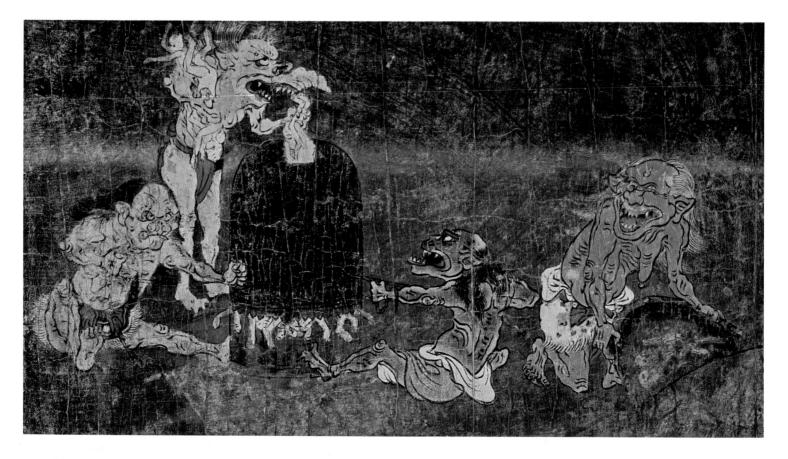

Hell Scrolls (Jigoku-zōshi): Demons crushing the Damned (scene from the Hell of the Iron Mortar). Late twelfth century. Handscroll, colors on paper. (Height 103/8") Commission for Protection of Cultural Properties, Tokyo.

so free as to sacrifice accurate form to the expression of violent movement. This scroll was presumably added to the series in the early thirteenth century, some time before the year 1253 inscribed at the end of the third scroll.

While the four Kōzan-ji scrolls satirize the conduct of the clergy in the face of sweeping social changes, the monks themselves have left other scroll paintings which testify to their zeal in saving souls and to the compassion aroused in them by the evils of this troubled period of Japanese history. These are the analogous scrolls of the *Hells* (*Jigoku-zōshi*), *Hungry Demons (Gaki-zōshi*) and *Diseases (Yamai-no-sōshi*). If these series of scrolls are not the product of a single collective effort, it was, nevertheless, the same Buddhist philosophy and the same social outlook which attracted public and artists to this bleak vision of death. To the people of this period, banking so earnestly on a future life in the Paradise of Amida, these glimpses of the terrors of hell must have come as a salutary warning, the more effective for being prefigured under their very eyes by the ravages of civil war.

To keep the people in the strait way of salvation, the monks confronted them with pictures of the different phases of hell, inspired by the Buddhist $s\bar{u}tras$ and accompanied

by written or oral commentaries dwelling extravagantly on the eternal torments in store for offenders. Three such scrolls are still extant in the original, together with copies of two others.

Instead of a long sequence of pictures telling a story, as in the Ban-dainagon scrolls, the five Hell scrolls are all composed of relatively short scenes of fixed sizes; they are invariably about 10 inches high and about 20 (occasionally 10) inches wide. Preceded by a commentary, each scene represents one of the many phases of the Buddhist hell, where the damned are subjected to various ordeals commensurate with the misdemeanors they were guilty of in their earthly life. Despite the similar handling of the scenes, the hands of different artists can be distinguished in these five scrolls. The most remarkable, from the purely pictorial point of view, is the scroll formerly in the Hara Collection (now owned by the Commission for Protection of Cultural Properties, Tokyo), of which seven scenes survive; the two illustrated here convey a fair idea of this masterpiece of infernal art. According to Buddhist doctrine, there are eight principal hells; attaching to each of these are sixteen subsidiary hells (*bessho*, in Sanskrit *utsada*). The Hell of the Iron Mortar (*Tetsugai-sho*) is one of the subsidiary hells where those guilty of wickedness

Illustration page 86

Hell Scrolls (Jigoku-zōshi): The Giant Cock. Late twelfth century. Handscroll, colors on paper. (Height 10%") Commission for Protection of Cultural Properties, Tokyo.

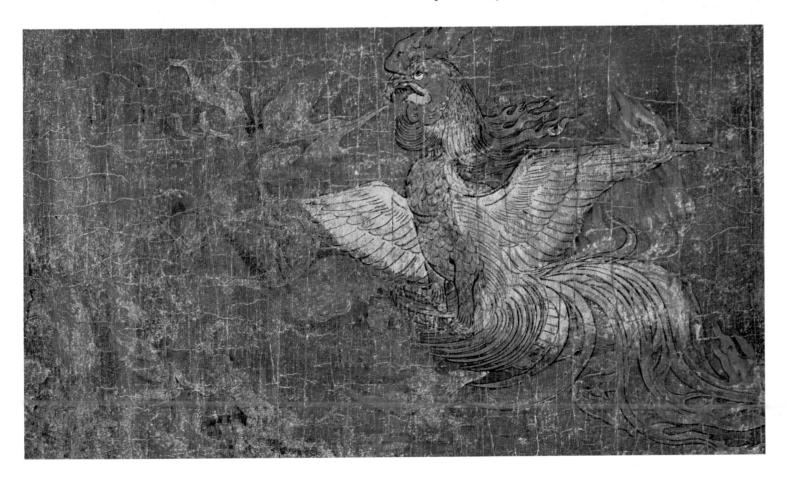

Illustration page 86

and theft are pounded and crushed in a huge mortar. Against a gray background symbolizing the eternal gloom of the underworld, four hideous demons are grinding the damned. Red, orange and violet-brown stand out from the surrounding darkness with an effect of powerful contrast which emphasizes the cruel, contorted faces of the demons. The one on the right, emptying out the victims' bones, looks like a spiteful old hag; his gaping mouth and leering eyes forbode nothing but evil. In the illustrations of a *sūtra* copied about 1119 for the Chūson-ji temple in northern Japan, we find a similar composition representing three demons around a mortar. So it is clear that the painter of the *Jigokuzōshi* scroll had earlier models at his disposal on which to base the different hell scenes which, throughout the Heian period, figured not only in temple paintings but also on the screens and sliding doors of palaces. Nevertheless, the dynamic expression of the Hell scroll rises far above all previous works on the same theme, and we feel here the apocalyptic unrest of the disrupted society of the late twelfth century.

Illustration page 87

This deep-seated anxiety is expressed in an even more symbolic manner in the scene of the *Giant Cock*. According to the accompanying text, men guilty of cruelty to animals are condemned to be torn and mangled by a large fiery cock. And this fiendish creature dominates the whole scene, against a somber background where the shadowy figures of the damned can be dimly seen moving convulsively amid the flames.

The gaki (pretas in Sanskrit) are condemned to eternal hunger and thirst. Since their realm of being (gaki-do) is located between the world of men and the underworld of hell, the gaki, being invisible to the living, can mingle with men unawares and eat the food offerings given to them out of charity by good Buddhists; failing this, they are forced to feed on human excrement. In the two scrolls of Hungry Demons (Gaki-zoshi), one in the National Museum, Tokyo, the other owned by the Commission for Protection of Cultural Properties, Tokyo, several scenes therefore depict the world of men, treated with keen-eved and, indeed, ironical realism, while others deal with continental subjects, like the story of Mokuren (Mangdalyana), the Buddhist disciple who relieved the hunger of his mother in hell. While the Gaki-zōshi deals incidentally with real life, the scrolls of Diseases (Yamai-no-soshi) deal with it exclusively. These curious works depict some of the many ills that flesh is heir to. Twenty-one scenes survive, divided between several collections, while another series is known to us through different copies of it. The tone of both text and illustrations treating of these clinical phenomena is fairly objective, and faintly tinged with irony, without the usual Buddhist interpretation of causes and effects. The similar layout of the scenes, however, also certain pictorial elements and the style of the calligraphy, make it clear that these three series of scrolls (Jigoku-zōshi, Gaki-zōshi and Yamai-no-sōshi) actually form a single group. The hypothesis advanced by Professor Fukui Rikichirō, who identifies the group thus formed with the series of Illuminated Scrolls of the Six Paths (Rokudo-e), often described in thirteenth century records, has lost none of its weight. The "six paths" are the cycles through which the souls of the living must pass in accordance with karma, from Heaven (ten) to Hell (jigoku). While certain details of these seven or eight scrolls cannot be explained by the doctrine of the Six Paths, and while they cannot be regarded as the product of a single collective effort in a single temple or palace, these demon paintings nevertheless bear witness to the social upheavals of the late twelfth century. Small wonder then that these works, which antedate the fantastic art of Hieronymus Bosch and other Flemish painters by over two hundred years, seem to us today particularly striking for their plastic power and mystic dynamism.

The restless souls of that troubled age were ministered to by several innovating movements which injected new life into Buddhism in the late twelfth and early thirteenth century; reformers appeared and new sects were founded. By their saintly way of life these men, the "great monks," attracted many followers, who were grouped together in brotherhoods. As a means of tightening the spiritual ties between the faithful and propagating the new doctrines, painting was called upon to play a leading part, chiefly in the form of illuminated scrolls setting forth the origin of the sect or narrating the life of its venerable founder. Each important monastery thus maintained a group of artists, and this fact characterizes the painting of the Kamakura period, which was as a rule the work of painter-monks and intended for a vast religious congregation.

The monastery most remarkable for its paintings is the Kozan-ji, re-established in 1206 by Köben, a monk better known by the honorary name of Myöe-shönin (1173-1232); its art reflects the new trend of the Kamakura period. After being initiated in his youth into the esoteric doctrines, Myōe-shōnin entered the Tōdai-ji at Nara, center of the Kegon sect. With a view to reforming and renewing this ancient sect, he spent over ten vears in metaphysical contemplation in mountain hermitages and finally re-established the Kōzan-ji, in a region of great natural beauty northwest of Kyōto. Outstanding among the treasures of the monastery is a series of six illuminated scrolls now entitled Kegonsh \bar{u} -soshi-eden, or more simply Kegon-engi, which tell the life story of two Korean monks, Gishō and Gengyō, who in the seventh century introduced the Kegon sect into the Kingdom of Silla (Shiragi) in Korea. The first four scrolls (to take them in their original order) tell the touching story of Gishō and the Chinese maiden Zemmyō. Going to China to pursue his Buddhist studies, Gishō (624-702), in the course of his pilgrimage, meets a Chinese girl of a well-to-do family who falls in love with him. Gishō explains the truths of religion to her and converts her to Buddhism. When the time comes for the Korean monk to return to his native land, Zemmyō prepares a handsome present for him and takes it down to the harbor—but his boat is already under way. In despair she throws the box containing the gift into the water, whereupon it begins to follow the boat of its own accord. Encouraged by this miracle, Zemmyō herself leaps into the sea, vowing to serve ever after as the monk's divine protectress. Forthwith changed into a dragon, she conveys Gishō's boat to Korea on her back. Zemmyō then becomes a goddess and continues to protect and patronize the Kegon sect.

These dramatic scenes follow one another uninterruptedly. In the third scroll Zemmyō and her attendants are shown on the shore in three different pictures. The alternation of this figure group with the ship leads up to the climax and produces an almost cinematographic effect. In all the scrolls, whether they deal with Gishō or Gengyō, we feel the ties of sympathy binding the artist to the legendary figures he is depicting.

Illustrations pages 90-91

The supple linework, whose accents are always natural, and the use of thinly coated colors, which allow the underdrawing to show through, are highly characteristic and sharply distinguish these works from those of an earlier day, like the Shigisan scrolls. Here we find a new style: that of the Kōzan-ji studio, presumably influenced by Chinese páinting of the Sung dynasty. Myōe-shōnin in fact is known to have imported a large number of contemporary Chinese paintings and it was he who formed a studio of trained artists in his monastery. Umezu Jirō of the National Museum of Kyōto has pointed out the close relation that existed between the monk Myōe and the two heroes of these scrolls, for the Japanese reformer of the Kegon sect always venerated Gishō, for whom he felt a strong personal sympathy. And in a book of his own entitled *My Dreams* (1220), Myōe tells how he dreamed that he was Gishō and found himself in the presence of the benign and beautiful Zemmyō.

After the civil war of Jōkyū (1221), the last counter-attack of the imperial court against the military government, Myōe gave help and protection to many refugees, above all to widows of courtiers killed in the fighting. The convent of Hiraoka, built for these widows by Myōe in 1223, was dedicated to Zemmyō, as tutelary divinity, and a polychrome statuette of the beautiful Chinese girl much resembles her features as portrayed in the Gishō scrolls; this being so, this series of four scrolls was presumably executed after 1223.

In several works written toward the end of his life, Myōe attaches particular importance to the other Korean patriarch, Gengyō, for his part in propagating the Kōmyō-shingon doctrine (the *mantra* of divine light). Following the biographies of the two Korean patriarchs as recorded in the Chinese book *Sung-kao-sêng-chuan* (Lives of

Lives of Gishō and Gengyō, Monks of the Kegon Sect in Korea (Kegonshū-soshi-eden), attributed to Enichi-bō-Jōnin: Zemmyō changed into a Dragon conveying Gishō's Boat on its Back (end of the third scroll of the Legend of Gishō). First half of the thirteenth century. Handscroll, colors on paper. (Height 12¾") Kōzan-ji, Kyōto.

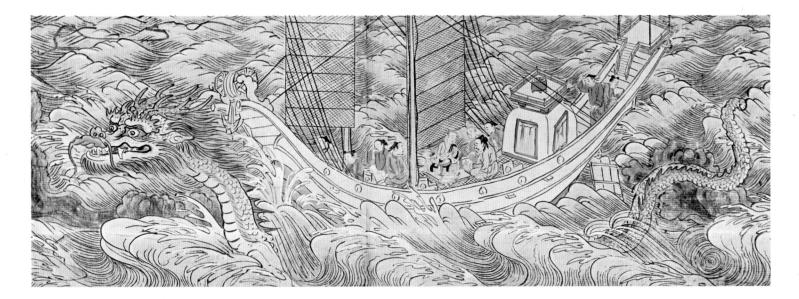

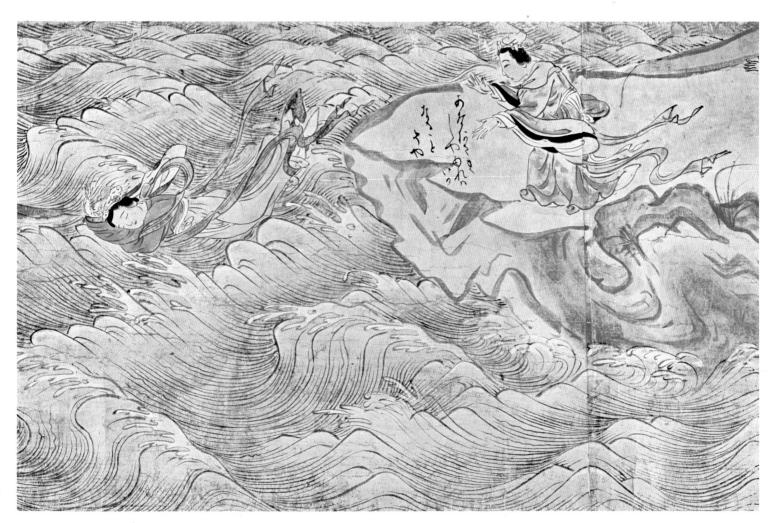

Lives of Gishō and Gengyō, Monks of the Kegon Sect in Korea (Kegonshū-soshi-eden), attributed to Enichi-bō-Jōnin: Zemmyō leaping into the Sea in Pursuit of Gishō (scene from the third scroll of the Legend of Gishō). First half of the thirteenth century. Handscroll, colors on paper. (Height 12%) Kōzan-ji, Kyōto.

the Great Monks), Myōe himself wrote the text of these scrolls and called on his favorite artist to illustrate the story. This was Enichi-bō-Jōnin, Myōe's best loved disciple and a painter of high repute.

To Enichi-bō-Jōnin we also owe several portraits of his master, one of them still extant in fine condition at the Kōzan-ji. This is a long hanging scroll, drawn in ink and lightly heightened with colors, like the Kegon scrolls. Myōe is shown in solitary meditation in the mountains near his monastery. The striking thing about this portrait is the painter's profound insight into the natural scenery and wild life surrounding the saintly monk. Though elements of Chinese style are present, the slender trees and the animals frolicking in the branches express the characteristically Japanese response to just such a landscape as may still be seen today in the neighborhood of Kyōto. And this tie between man and nature may well be a reflection of the bond of sympathy linking Myōe and his favorite disciple, painter of his portrait and of the great Kegon set of scrolls.

Illustration page 93

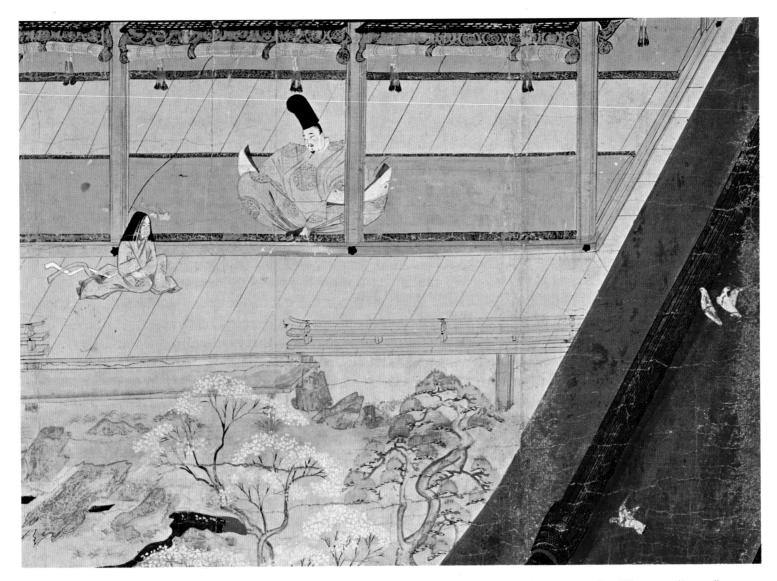

The Life of Sugawara Michizane and the Origin of the Shintō Temple of Kitano-tenjin (Kitano-tenjin-engi): The Child Michizane and his Father (scene from the first scroll). First half of the thirteenth century. Handscroll, colors on paper. (Height 201/2") Kitano Temman-gū, Kyōto.

In addition to these, some fifteen fragments of the original scroll of the *Fight at Rokuhara*, together with a copy of the scroll illustrating the *Fight at the Taiken-mon Imperial Gate*, have also survived. All these scrolls are characterized by a skillful sequence of compositions full of action and movement, yet well balanced throughout. The artist has lingered over harness, armor and accouterments, which reached their highest degree of perfection in the Japan of this age, and he has represented them with loving care, obviously delighting in the beauty of their workmanship. While displaying the common features of a single studio, these five scrolls also reveal some slight but distinct differences of expression which incline us to surmise that the execution of the complete set may have extended over half a century or so.

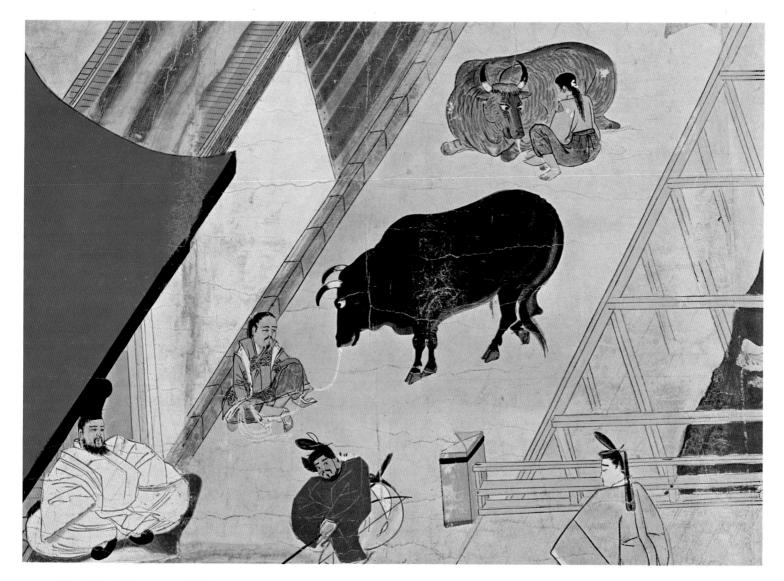

The Life of Sugawara Michizane and the Origin of the Shintō Temple of Kitano-tenjin (Kitano-tenjin-engi): Gate of the Palace of Sugawara Koreyoshi, detail (opening scene of the first scroll). First half of the thirteenth century. Handscroll, colors on paper. Kitano Temman-gū, Kyōto.

Illustration pages 98-99

The Boston scroll dates to the third quarter of the thirteenth century, and its long composition representing the attack on the palace is the most striking of all. It deals with the *coup d'état* organized by Fujiwara Nobuyori with the army of Minamoto-no-Yoshitomo. In the night of December 9, 1159, the Sanjō palace was taken by storm and the ex-emperor Goshirakawa made a prisoner in a sector of the imperial palace. The scene begins with a bustle of carts bringing noblemen and their valets to the palace at the news of the nocturnal attack. The Sanjō palace, already burning, is surrounded by the Minamoto warriors who, acting on the orders of Nobuyori, compel the ex-emperor to get into the cart which is to carry him away. Within the palace walls, there is bloodshed on all sides: imperial guards beheaded, courtiers hunted down and killed, ladies-in-waiting

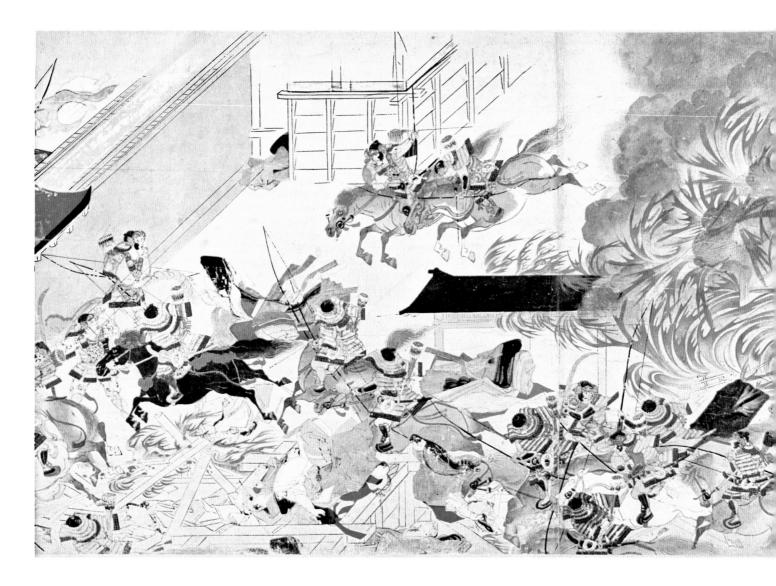

Story of the Heiji Insurrection (Heiji-monogatari): The Burning of the Sanjō Palace, detail. Third quarter

drowned in a well, as they flee distractedly from the fire, or trampled to death by fierce warriors running amuck. The horrors of war are delineated uncompromisingly, as seen through the eyes of an objective, realistic-minded artist. But the harmony of colors and forms, set to an agreeable rhythm, gives the scene a sheer pictorial beauty which deservedly ranks this scroll among the world's masterpieces of military art. Less metaphysical than the Hell scrolls, less calculated to move and harrow us to the depths, this war picture nevertheless appeals directly to the eye, and its epic beauty precisely corresponds to the position occupied by these novels in Japanese literature.

The realism and objectivity characteristic of thirteenth century painting are still paramount, at the very end of the century, in 1299, in a set of scrolls narrating the pilgrim's life of the monk Ippen (1239-1289). After studying the doctrines of the Tendai

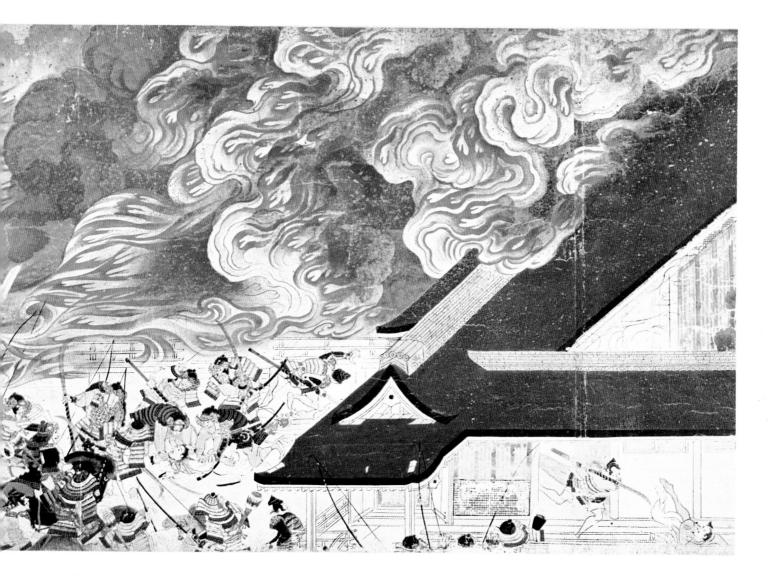

of the thirteenth century. Handscroll, colors on paper. (Height 161/4") Museum of Fine Arts, Boston.

and Jōdo sects, and meditating on them in solitude for many years, Ippen developed the theory of self-sacrifice in the charity of Amida, founded the Ji-shū sect, and spent the rest of his life traveling through the length and breadth of Japan, converting over two and a half million people. Shortly after his death, the story of his life was written by Shōkai, his favorite disciple, who had faithfully accompanied him in all his wanderings. The painter En-i, who no doubt was also a fellow pilgrim of the great monk, illustrated his life in forty-eight scenes mounted on twelve scrolls. Contrary to the practice of the time, when paper was the usual support for scroll paintings, this work is carefully executed on silk, which goes to show the importance attached by the brotherhood to the life story of its founder. As the scrolls are unrolled, we almost seem to be following the itinerary at Ippen's side, in the small company of his favorite disciples, visiting the famous places and leading temples of each province. So closely do the landscapes and buildings represented resemble those still in existence today, that we are forced to conclude that En-i drew these scenes on the spot in the course of his pilgrimage and based his work on these drawings. This procedure gives his paintings an unusual style and flavor, faithfully reflecting the varied aspects of Japan's natural scenery, from region to region and season to season. At the same time he draws a complete picture of the age: nobles and warriors, tradesmen and peasants, and even beggars and vagabonds, are recorded by the artist with such a wealth of detail that these scrolls hold the mirror up to Japanese society in the Middle Ages, comparable in this respect to the masterworks of Western miniature painting of the same period.

Illustration page 101

We reproduce here a winter landscape, in Mutsu province, seen under a light fall of snow. In the eighth scroll we follow Ippen on his journey through northern Japan, beginning with a spring scene of cherry blossoms in the hill country and ending with this bleak snowscape. White hills, an ice-bound river, clumps of frozen reeds—all this vividly conveys the nip of cold clear air in the dead of winter. The expressive lyricism, enabling us to share the moods and mentality of the figures represented, reflects the long tradition of Japanese secular painting, elaborated from the Heian period on, while this vision of steep river banks and snow-covered mountains points to the recent influence of Chinese painting of the Sung dynasty.

It will be sufficiently clear by now, from the various examples already reproduced here, that the scroll paintings *(e-maki)* of the twelfth to the fourteenth century form one of the richest sections of Japanese art. Over a hundred different sets of scroll paintings have come down to us; these may be classified under the following headings, in accordance with subject matter, technique, and the purpose they served.

I. Secular scrolls of a purely artistic character:

a) Illustrations of novels. — These illustrations, conditioned by aristocratic tastes, were produced throughout the Kamakura period, keeping all the while to the conventional mode of expression described and discussed above in connection with the Genji scrolls. Their style became increasingly stereotyped, either with stolid coloring or with a peculiar monochrome technique consisting solely of very fine black lines. The illustrations of such works as *Murasaki-shikibu-nikki* (Diary of the Lady-in-Waiting Murasaki-shikibu, author of the *Tale of Genji*) and *Makura-no-sōshi* (The Pillow Book, a collection of essays) present the same characteristics.

b) Folk tales and historical narratives. — This type of work, exemplified by the Shigisan-engi and Ban-dainagon-ekotoba, enlarges on the subject while reflecting the popular life of the time. For example the Eshi-no-sōshi scroll (the story of a painter) in the Imperial Collection narrates with bitter irony the life of a court painter whose social position is made increasingly precarious by the rising power of the military.

c) Illustrations of poetry. — Poetry competitions (uta-awase) and portraits of famous poets (kasen-e) were always highly appreciated in aristocratic circles, but from the

fourteenth century on the ancient and modern court poets were often replaced by parodical figures of tradesmen and artisans in several versions of *Shokunin-uta-awase* (poetry competition between the different crafts).

d) Illustrations of military novels. — Military novels, a genuine literary creation of the thirteenth century, gave rise to several illuminated scrolls on epic themes, like the *Heiji-monogatari*.

II. Secular scrolls serving a practical purpose, usually documentary:

At the court, ceremonial scenes and portraits of emperors and ministers were often painted in the new technique of *nise-e*, which gave a lifelike portrayal of the features of each personage. Military men, moreover, had paintings made of their exploits in this or that battle, either to commemorate them in their own home or to present to their leader as a token of their prowess. For example, two scrolls entitled $M\bar{o}ko-sh\bar{u}rai-ekotoba$ (Invasions of the Mongols), now in the Imperial Collection, were executed about 1293 to the order of Takezaki Suenaga, a warrior of the Higo province (Kyūshū), to commemorate his bravery during two Mongol attacks on northern Kyūshū in 1274 and 1281.

Life of the Monk Ippen (Ippen-shōnin-eden), painted by En-i: Winter Pilgrimage in the Northern Province (scene from the eighth scroll). 1299. Handscroll, colors on silk. (Height 14¾") Kankikō-ji, Kyōto.

III. Edifying scrolls of a religious nature:

The fact is that the development of scroll paintings whose field of inspiration extended to popular life was largely due to the religious milieux, both Buddhist and Shintō. Beginning with illustrations of $s\bar{u}tras$ and doctrinal commentaries like the Hell Scrolls, the *engi* (origin and miracles of the temples) and lives of the great monks, patriarchs and founders of sects came in time to be abundantly illustrated.

After the masterpieces we have already dealt with, later scrolls of an edifying nature tended to include an ever larger number of scenes. The *Hönen-shönin-eden* (Illustrated Life of Hönen) of the Chion-in temple depicts the life of the founder (1133-1212) in a series of no less than forty-eight scrolls, *each* of which, on an average, measures thirty feet in length. A detailed study of it made by Shimada Shūjirō has shown that this set of scrolls, begun at the emperor's behest in 1307, was twice added to and finally completed—or brought to the stage at which we now have it—toward the second half of the fourteenth century.

Another extensive series is the Kasuga-gongen-kenki (Miracles of the Shintō Deities of Kasuga), running to twenty scrolls, now in the Imperial Collection. Fujiwara Kinhira, minister of the left, commissioned the work from Takashina Takakane, head of the court atelier, and presented it in 1309 to the shrine of Kasuga at Nara, as a testimonial of fidelity and gratitude to the deities, the divine patrons of his family. It is the painstaking work of a master painter who, in these twenty scrolls, has achieved a synthesis of the various traditional techniques practised by the court painters.

The creative power of the art of scroll painting rapidly declined from the fourteenth century on. Thereafter we look in vain for the verve animating the figures in the great works of the twelfth and thirteenth centuries, in vain for the skill and invention that conveyed in the earlier handscrolls so wonderful a sense of space and time. Repetition of the same subject in religious scrolls deadened the style and vulgarized the expression, while the political and economic decline of the old aristocracy centering on the emperor handicapped the court artists, whose leadership from the fifteenth century on fell to the Tosa family and its descendants. Scrolls on literary subjects finally came to constitute the more popular art form called Otogi-zōshi, grouping illustrations of novels and tales of a very naïve inspiration. Artistic supremacy seemed to be passing into the hands of painters practising a new style, which will be dealt with in the next chapter. But, in the present writer's opinion, the long-standing tradition of secular painting in the Japanese style which gave rise to scroll painting, transmitted its vitality, along with its lyrical and decorative esthetic, to the popular painting of the fifteenth and sixteenth centuries rather than to the court ateliers, and from this subterranean source sprang, in the early seventeenth century, the genius of Sōtatsu and the early masters of the Ukiyo-e school.

The Renewed Influence of Chinese Art and the Development of Monochrome Painting (13th to 16th Century)

6

As we have seen in the previous chapters, Japanese painting developed until the twelfth century along fairly well-defined lines. Assimilating the style and technique of Chinese painting, more particularly that of the T'ang dynasty, the painters of the Heian period gradually forged a specifically Japanese art, imbued with lyricism and native delicacy; and this was true of both religious and secular painting. Although the national style thus established was still dominant in the thirteenth century, fresh influences from the Chinese mainland, first under the Sung, then under the Yüan dynasty, filtered into Japan and by the fourteenth century had given Japanese painting a different aspect altogether.

The earliest contact of the Japanese with Sung painting may go back to the middle years of the Heian period (tenth and eleventh centuries). In the absence of any official relations between the two governments at that time, cultural exchanges between Japan and China were maintained, in a very small way, by a few Chinese merchant vessels, carrying precious cargoes of textiles, pottery, medicaments and spices, which occasionally touched at the port of Hakata in northern Kyūshū, or even at Wakasa, nearer Kyōto. A few Japanese monks, like Chönen (982) and Jöjin (1072), enterprisingly crossed the sea to visit Chinese monasteries, from which they sent or brought back sculptures and paintings whose unfamiliar mode of expression attracted the attention of Japanese Buddhists. But this artistic influence remained very limited in scope, having only chance effects. We find, for example, in a large religious composition of the Resurrection of Buddha (Shaka-saisei-seppō-zu) in the Chōbō-ji, a late eleventh-century masterpiece, a peculiar use of broad, sharply accentuated lines which may well derive from Sung painting. But this new element remains an isolated feature within the picture as a whole; the emotional fervor it conveys is due to the happy effect of light emanating from the golden body of the Buddha standing in the open coffin.

These early links between Japan and the Sung dynasty were broken in the early twelfth century, when China was invaded and defeated by the northern barbarians (Liao and Chin) and the capital accordingly transferred to Hang-chou (1138). But contacts were resumed when the commercial activity of the Southern Sung happened to coincide with the interests of Taira-no-Kiyomori, who came to power in 1167 and encouraged economic and cultural relations with China. The open-door policy of this energetic leader of the military caste was maintained by the Minamoto government, and the crossing of Japanese boats to the continent is mentioned at least six times in official Chinese annals between 1176 and 1200. One of the Japanese monks who visited China at this time was Chōgen, who borrowed new Chinese building techniques for the reconstruction of the great Nara monasteries destroyed in 1180 by the army of the Tairas; another was Eisai, who introduced the Zen doctrine after two journeys to China in 1168 and 1187.

The resumption of relations with China meant that paintings were soon being imported into Japan—religious pictures to begin with. Characterized by the scrupulous representation of details and the use of accentuated lines patterned in accordance with a regular rhythm, these paintings had a slight influence on Japanese artists, as we have seen in dealing with the art of the Kōzan-ji. Most responsive to these new techniques were the artists of the Takuma school, made up of members of the same family. Takuma Shōga, the founder's son, active between 1168 and 1209, executed in 1191 a pair of screen paintings representing the *Twelve Devas* (Jūni-ten), still preserved today in the Tō-ji temple at Kyōto. This remarkable work shows the early and very skillful adoption of the Sung style, with its agreeably accented linework; at the same time, the artist sacrifices nothing of the delicacy and freshness of touch expressive of the Japanese sensibility. The fact that one of Shōga's brothers was summoned by Yoritomo to Kamakura in 1184 proves that this new style was also to the liking of the military.

While the activity of the Takuma school was admittedly important, owing to its assimilation of the new Chinese techniques, the influence of the Sung style on Japanese religious and even secular painting took effect, in our opinion, only partially in the thirteenth century and failed to modify the underlying character of Japanese painting, whose tradition was by now solidly established. And it is in the entirely new field of monochrome painting, closely bound up with the Zen sect, that we find the most significant results of this second encounter of Japanese painting with that of China. This new technique, associated in the fourteenth century with an esthetic reform, opened vast possibilities of development to Japanese painting.

The word Zen (*dhyana* in Sanskrit, *ch'an* in Chinese) means meditation which leads to a spontaneous illumination. The idea of Zen, which was already implicit in the original doctrine of Indian Buddhism, was introduced into China toward the end of the fifth century A.D. by Bodhidharma, who made it the working principle of a particular sect. The Zen doctrine was elaborated and systematized by Bodhidharma's successors in the course of the T'ang period. Combined with the traditional Chinese philosophies, it also found acceptance among Buddhist laymen and thus in time came to occupy an important place in the spiritual life of the Sung period. The great monasteries of the Zen sect then developed into intellectual centers where the monks composed not only metaphysical treatises but poetry full of sparkling wit. At the same time, they practised or appreciated painting as a means of spiritual exercise.

Zen Buddhism was introduced into Japan late in the twelfth century by the monk Min-an Eisai (1141-1215). Requiring above all the stern spiritual discipline of an ascetic

Mutō Shūi: Portrait of the Monk Musō Soseki (1275-1351). Fourteenth century. Hanging scroll, colors on silk. (47×25⅛") Myōchi-in, Kyōto.

family took a keen interest in cultural activities and zealously patronized the Zen sect in particular. Economic necessities, moreover, favored trade relations with China, and here the Zen monks played an important part as intermediaries and diplomats. Chinese culture thus came to exert a strong influence, always however by way of the Zen monasteries which, out of deference for the Sung and Yüan tradition, prevented the Japanese from fully assimilating the contemporary culture of the Ming dynasty.

In painting, the taste which the monks showed for washes had spread to the nobles of the military government by the end of the fourteenth century. The favorite subjects of the first Japanese painter-monks to practise wash painting were images of the divinities venerated by the sect: Shaka-muni, Monju (Mañjuśri), Kannon (Avalokitesvara), etc.; also the figures of saints, like Daruma (Bodhidharma) and Hotei (Pu-tai), and the deeds of the Chinese patriarchs and hermits. Often represented were plants symbolizing purity or spiritual solitude: the bamboo, the plum tree, the orchid. Landscape served first of all as a setting for the "scene of illumination" (zenki-zu) which explained how this or that patriarch attained spontaneous illumination thanks to some unexpected accident or in the course of a colloquy with his master.

Ink monochrome landscapes in the Sung and Yüan styles were, however, often used for interior decoration, in the form of screens or sliding doors, in the monasteries and even in the residences of laymen. Although no trace has survived of any such works of this period, we can form an idea of them from representations in miniature figuring in certain scroll paintings of the fourteenth century, for example the *Kasuga-gongen-kenki* (Miracles of the Kasuga Temple) and *Honen-shonin-eden* (Life of the Monk Honen). In order to cover a large wall space, artists merged into a single composition several landscape models created by the great Chinese masters (Ma Yüan, Hsia Kuei, etc.), with spring evolving toward winter in the time-honored sequence from right to left.

While owing to decorative preoccupations the monochrome landscapes on screens and sliding doors tended to be less concise and less spiritual, the exigencies of another, much smaller format, the hanging scroll, had the natural effect of leading Japanese landscapists toward a stricter conception of pictorial design. (It was now, moreover, that the toko-no-ma, a kind of niche containing a painting or a vase of flowers, began to appear both in monasteries and private homes. By providing a setting favorable to purely artistic appreciation, it stimulated the production of hanging scrolls on secular themes suitable for viewing in a niche of this kind.) From the beginning of the fifteenth century, the great Zen monasteries, at Kyōto and Kamakura in particular, patronized by the family of the Shogun or by other powerful lords, became the centers of the new Chinese culture, where monks led a life of scholarly refinement, exchanging poems written in Chinese. To represent their ideal of solitude and study in a setting of unruffled calm, they had landscapes painted, showing elegant pavilions to which they resorted in imagination. The upper part of the picture was reserved for poems in the Chinese style, which they asked their colleagues to write, extolling the delights of living in the bosom of nature. This special form of the vertical scroll, called *shigajiku* (scroll of painting and poetry), became fashionable in the first half of the fifteenth century. From the many extant

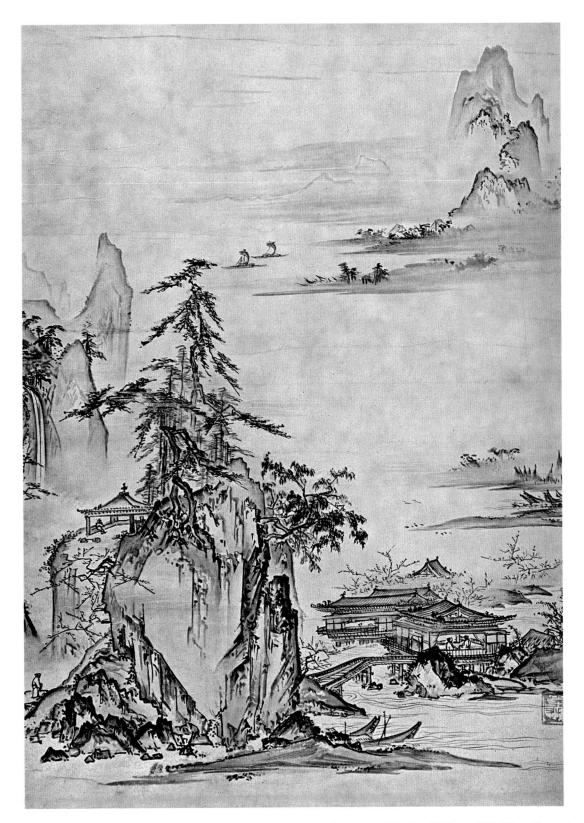

Ten-yū Shōkei: Landscape (Kozan-shōkei), traditionally attributed to Tenshō Shūbun. Mid-fifteenth century. Hanging scroll, ink and light colors on paper. (48%×13½") Ishii Yūshi Collection, Tokyo.

examples of shigajiku, which can often be roughly dated on the strength of their inscriptions, we can trace the development of landscape compositions whose esthetic was inspired by Sung painting: the notion of perspective and spatial depth (the theory of the three planes) became more and more accurately defined, while a high mountain in the center dominated the whole picture. This development must have come about through the instrumentality of the painter-monks who, from amateurs, had become professionals. Two great precursors represent this initial period of monochrome painting: Kitsuzan Minchō (1352-1431) and Taikō Josetsu. Minchō, who worked in the Tōfuku-ji monastery, has left us pictures on a variety of subjects: Buddhist paintings, polychrome portraits, and monochrome landscapes. Josetsu was a painter-monk of the Sōkoku-ji, another large monastery at Kyōto. Though little is known of his life, he is often mentioned in later records as the founder of the new school. Before 1415, to the order of the Shōgun Ashikaga Yoshimochi (1386-1428), he executed a painting called Hyonen-zu, illustrating the parable of an old fisherman trying to catch a catfish with a gourd. Here the monochrome technique is employed systematically, resulting indeed in a "new style," as it is expressly called in an inscription written by a contemporary monk.

The landscape in this picture was a mere decor, but in other *shigajiku* it became independent. A pertinent study by Kumagai Nobuo helps us to understand how the Japanese artists of this period succeeded in assimilating both the plastic construction of Chinese landscape and the expressive symbolism of "one-corner" compositions suggesting the grandeur and depth of nature. The art of the two Southern Sung landscapists, Ma Yüan and Hsia Kuei, was then particularly esteemed.

The assimilation of the new landscape style was definitively achieved by the famous painter-monk Tenshō Shūbun, whose activities are mentioned in records of the second quarter of the fifteenth century. A man of many-sided talents, he was in charge of the accounts and administration of the Sōkoku-ji monastery at Kyōto, and at the same time was highly appreciated for his genius as a sculptor and painter. According to a later tradition, he inherited the technique of monochrome painting from Josetsu and in turn passed it on to Sesshū. Some art historians, however, attaching more importance to his journey to Korea in 1423-1424, presuppose an influence of Korean painting on his art. However this may be, the fact that the shogunal government welcomed him as a master of the official academy reveals the synthetic character of his genius, from which the different tendencies of fifteenth and sixteenth century painting were to derive. Although there is no unanimous agreement as to which works are genuinely his among the many hanging scrolls and screen paintings attributed to him, there is reason to believe that he particularly excelled in rendering atmospheric qualities by means of delicate black linework heightened with washes and extremely light colors.

Illustration page 109

The landscape reproduced here is entitled *Kozan-shōkei* (View of a Mountain overlooking a Lake), after a stanza of poetry inscribed in calligraphy on the upper surface (not shown in our plate). While tradition attributes this painting to the hand of Shūbun himself, it is generally thought today that the red seal on the lower right indicates another artist of his school, Ten-yū Shōkei. The fact remains that, by virtue of the delicacy of its drawing, the spatial effect of the panoramic composition, and the harmony of the light touches of gold and blue, this mid-fifteenth century picture ranks among the masterpieces of the Shūbun style.

If the Sung and Yüan tradition of Chinese wash drawing was fully assimilated in Japan thanks to Shūbun's talents and practical common sense, it was Sesshū Tōyō (1420-1506) who first succeeded in giving a deeply personal and therefore national expression to the new technique. Born in the Bitchū province of western Honshū, he entered the Sōkoku-ji monastery at Kyōto as a novice. His Zen master, Shunrin Sūtō, then highly respected for his piety and truthfulness, must have influenced the future painter, while the activity in this very monastery of the great painter-monk Shūbun determined the career of Sesshū, who later called him "my painting master." Little is known of his life and art prior to his journey to China (1467-1469). Already enjoying great renown as a painter, he left the Sōkoku-ji some time before 1463 to settle at Yamaguchi, in the westernmost part of Honshū, which had become an important cultural centre under the patronage of the Ōuchi, an aristocratic family enriched by trade with China. Not caring to seek a position in the great monasteries of the capital or in the academy of the shogunal family, Sesshū presumably moved to western Honshū in the hope of making his way thence to China. And in fact he succeeded in crossing the sea on the third boat of the commercial fleet officially dispatched by the Shōgunate in 1467, the year in which the great civil war of Ōei began to disturb the capital, Kyōto. Landing at Ning-po, a South China port, the Japanese traveled as far as Peking. According to an inscription written a little later by Sesshū himself, he went in search of a good painting master and found only mediocre ones. The grandiose landscape of the continent, however, so very different from that of Japan, revealed to him the secret of composition in Chinese painting. This experience was important in the artistic schooling of Sesshū who, wherever he went, drew landscapes and scenes of popular life. During his stay in the Chinese capital, his talent as a painter was so much appreciated that he was asked to execute a composition on the wall of an official building recently erected. Actually the earliest of his authentic works that have come down to us is a set of four landscapes painted in China (now in the National Museum, Tokyo), which already display the essential qualities of his art: solid construction and concise brushwork. But the evident influence of the Chinese Che school, which represented the traditional Sung style in the Ming dynasty, weighs down each picture with an academic formalism.

After returning to Japan in 1469, Sesshū moved from place to place in northern Kyūshū in order to avoid the disorders of the civil war, and finally settled at Ōita, under the patronage of the Ōtomo family, where in 1476 his friend the monk Bōfu Ryōshin paid him a visit in the studio he called Tenkai-toga-rō. Of the life he led there, this monk has left a precious account, couched in terms of friendship and respect. "In the town, from the nobility to the common people, everyone admires Sesshū's art and asks for a piece of his work. In his studio, which stands in a beautiful landscape, the artist never grows weary of depicting his private world, while communing from time to time with the great world of nature outstretched beneath his studio balcony." This description

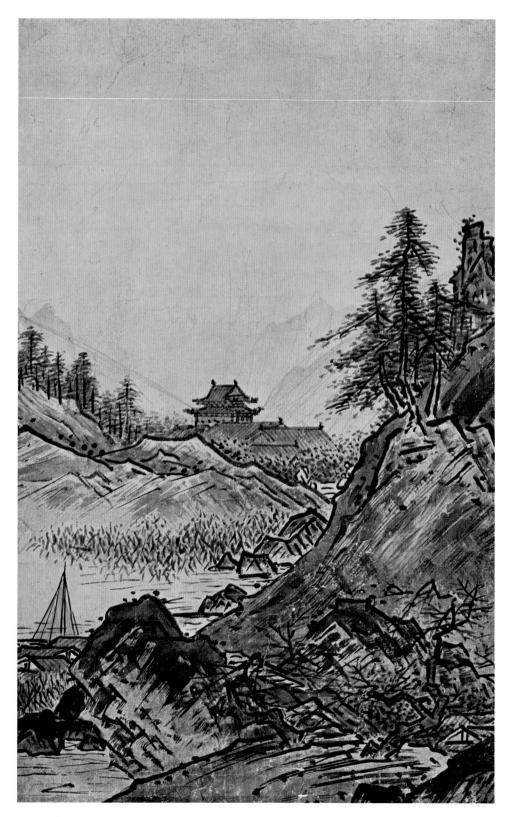

Sesshū Tōyō (1420-1506): Autumn Landscape (Shūkei-sansui). Hanging scroll, ink on paper. (18 $\frac{1}{8} \times 11\frac{1}{2}''$) National Museum, Tokyo.

makes it clear that Sesshū was entirely wrapped up in his art, though he always kept his clerical name and his Buddhist robe. Several authentic works, together with copies, leave no doubt that he thoroughly worked out and perfected a style of his own, and throughout his career he pushed back the limits of expression. We illustrate here an Autumn Landscape which forms the pendant of a winter scene; together they must have belonged to a sequence of the four seasons, a traditional theme for a set of landscapes. Into this small format the artist contrived to condense the grandeur of nature. Vigorous, jet-black brushstrokes define with precision the shapes of rocks, mountains and trees, which are emphasized with rather harsh dabs of ink. Spatial recession is carefully calculated, from the dark rock in the lower righthand corner to the distant peaks, laid in with a light wash, and all but concealed by mist. The spectator is led into this microcosm as the eye follows the path which winds its way into the depths of the picture. We come at last to feel, as Kumagai Nobuo has said, that the principle of verticality—which also characterizes the art of Cézanne-dominates the entire composition of this great Japanese master of the fifteenth century. Together with this stability, the vigor and willfulness of the expression in all his works vouch for his strong personality, which René Grousset has aptly summed up in comparing him with the Chinese master Hsia Kuei: "With Sesshū... the landscape remains *personalistic*, by which I mean that it is the man who selects its elements, stamps them with his seal, infuses them with his strength, his will, his impetus... The Japanese genius, like the genius of the West, clings throughout to human values, imposes them on the world, and victoriously refashions a world of its own."

Between 1481 and 1484 Sesshū made a long journey through Japan, even to the far north, making landscape drawings all the way. This artistic pilgrimage no doubt deepened his faculty of capturing the essential features of Japanese landscape scenery in his wash drawings. Returning to the west, he now set up his Tenkai-toga-rō studio in the town of Yamaguchi in Suhō province. A written work of 1486 by Ryōan Keigo testifies to the artist's increasing renown and to his independent way of life. The synthesis of his art is represented by the famous *Sansui-chōkan* (a long horizontal landscape scroll), for centuries in the possession of the aristocratic Mōri family; this is a long picture sequence illustrating the transition from spring to winter.

When in 1495 his disciple Josui Sōen, a painter-monk of the Enkaku-ji, took leave of him to return to Kamakura after a long course of study in his studio, Sesshū, then seventy-six, presented him with a "landscape in the cursive style," usually designated *Haboku-sansui*. With a few rapid wash-strokes accentuated with dark black lines, the master skillfully represented a tiny segment of nature lacking neither grandeur nor stability. This *haboku* technique (p'o mo in Chinese), elaborated by the Sung painter Yü-chien, is here fully controlled by Sesshū's vigorous style. In the inscription above the picture (not shown in our plate), the old artist summed up his artistic career by expressing his undying esteem for his two precursors Josetsu and Shūbun.

Undeterred by old age, Sesshū went on working. One of these later works is a large, deeply moving composition, *Hui k'o cutting off his Arm to show his Willpower to Bodhidharma* (Eka-danpi), executed in 1496. From his western province, in a letter of 1500

Illustration page 114

Illustration page 112

Sesshū Tōyō (1420-1506): Landscape in the Cursive Style (Haboku-sansui). 1495. Hanging scroll, ink on paper. (58¾×12⅔″) National Museum, Tokyo.

to his favorite disciple Sōen, he complained of having to live on in a troubled world. We see the climax of his art in the *Landscape of Ama-no-hashidate* (the Bridge of Heaven), which he drew on the spot during a visit to this famous place on the Sea of Japan between 1502 and 1506, the year of his death. In this panoramic view of a spit of land, all the details are represented with clean-cut lines, accompanied even by the names of the localities. This realism, however, in no way impairs the solid construction, seemingly on a cosmic scale, of the picture as a whole. The mountain range in the immediate foreground, the narrow strip of sand and the island on the left—all these elements form the broad base of the composition, while the shore line stretching into the distance indicates

Sesshū Tōyō (1420-1506): Landscape of Ama-no-hashidate (The Bridge of Heaven), detail. 1502-1506. Hanging scroll, ink and light colors on paper. (Entire scroll $35\frac{1}{2} \times 66\frac{3}{6}$ ") Commission for Protection of Cultural Properties, Tokyo.

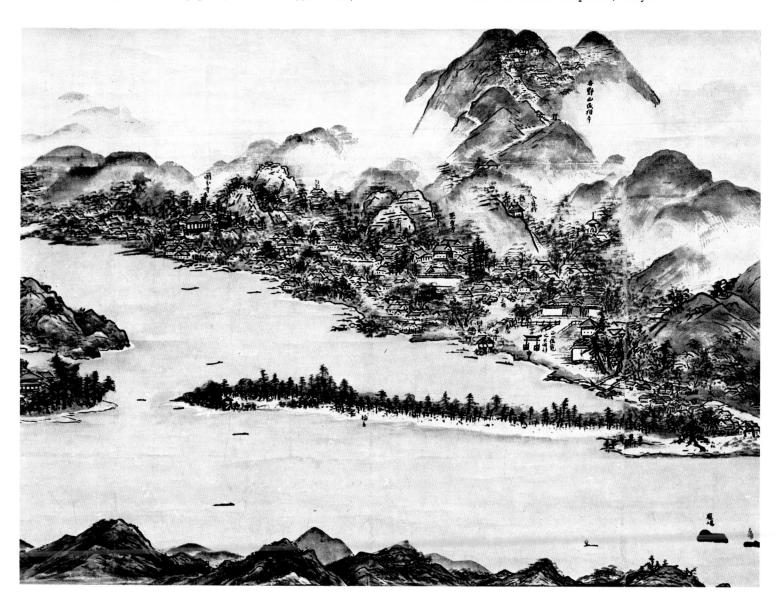

Illustration page 115

depth with astonishing effectiveness. A few touches of red, marking salient features of buildings, suggest the life-pulse of the great vista of space solemnly extended under the sky. Instead of keeping to an art of imaginary landscapes of Chinese inspiration, Sesshū succeeded, at the very end of his life, in capturing the innermost quality of a famous place, and with no sacrifice of plastic solidity he recreated the traditional lyricism of Japanese landscape painting. To the technique of wash painting Sesshū thus gave a highly personal expression based on accurate plastic construction. This latter quality, unique in Japan, distinguishes Sesshū moreover from other contemporary painters.

In the second half of the fifteenth century monochrome painting, introduced and developed first of all in the Buddhist milieux of the Zen sect, extended its sphere of influence to lay society. Something has been said above of Shūbun, the painter-monk of the Sōkoku-ji, who was invited to join the shogunal academy, of which he became chairman; this office he passed on to his disciple Ten-ō Sōtan (1413-1481). At Kyōto, Sōtan developed his master's style on the lines most congenial to the taste of his patrons among the nobles and the military. Highly appreciated in his time, his art is little known today owing to the scarcity of authentic works. Some idea of his style can be formed, however, from an important set of screen paintings, originally belonging to the Yōgen-in at the Daitoku-ji monastery, which Professor Tani Nobukazu has recently assigned with certainty to Sōkei, Sōtan's son, who probably painted them about 1490, thus completing a set of works begun by his father. Less dynamic than Sesshū's paintings, these screens, a fairly faithful adaptation of Chinese styles, give expression to a lyrical mood which must have appealed to the Japanese nobility.

Another school—or rather family—of artists excelled in wash painting: the Ami family, who were employed by the Shōguns for generations as connoisseurs and art advisers. The most important members were Nō-ami (1397-1471), his son Gei-ami (1431-1485), and his grandson Sō-ami (?-1525). The famous book called *Kundai-kan sōchō-ki* (Notebook of the Shōgun's Art Secretary), which lists the names of celebrated Chinese painters, classifying them in accordance with the taste of the time, and sets forth the principle of interior decoration, was the joint work of these three generations. The paintings of this family, which always relied on the wash technique, gradually departed from their Chinese models. The sliding doors of the Daisen-in temple, in the Daitoku-ji monastery, were decorated with magnificent landscapes (now mounted on hanging scrolls) attributed to Sō-ami. A vast expanse of nature, with mist effects delicately rendered by subtly shaded washes, soothes the spirit with that benign peace of mind which is the secret essence of the Japanese soul. Although they often worked for Zen monasteries, the artists of this family were not Zen monks, but Amidists—as is indicated moreover by the common suffix of their names, Ami.

Several other artists and different schools took inspiration from the work of Shūbun: for example Gakuō who, while keeping to the traditional style, reveals a distinct personality in several signed landscapes; Hyōbu-bokkei, who forged a powerful style of his own under the spiritual influence of the Zen monk Ikkyū; and his successor Jasoku, who founded the Soga school, characterized by incisive ink line drawing.

Shūkei Sesson (c. 1504-after 1589): Landscape and Boat in Stormy Weather. Hanging scroll, ink and light colors on paper. (85%×123%") Bunei Nomura Collection, Kyōto.

Outside the capital, monochrome painting spread to the east and west. Local rulers, having established their political and economic independence, patronized painters and in some cases themselves practised monochrome painting. Sesshū spent the latter part of his life in western Japan, while his favorite disciple Sōen worked at Kamakura, the eastern cultural center. A little later, another highly original artist, Shūkei Sesson (c. 1504-after 1589), appeared in the northeastern region. Though born shortly before Sesshū's death at the other end of Japan, he claimed to be his spiritual successor and added the same epithet, *setsu* (snow), to his name. A searching study by Professor Fukui Rikichirō has thrown light on his life and art. He lived to be over eighty and spent his whole life in the country districts of Hitachi and Aizu. He deepened and matured his art by a solitary, unremitting study of the works of the great Chinese and Japanese masters,

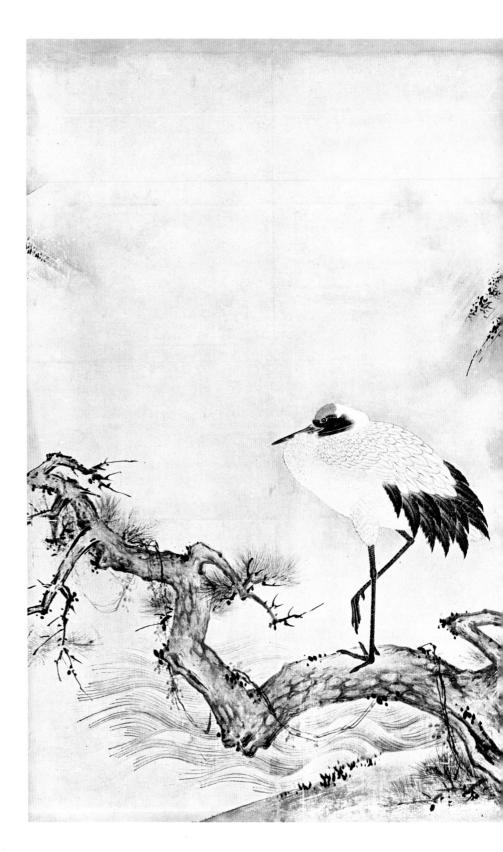

Kanō Motonobu (1476-1559): Landscape with Waterfall and Crane. 1543-1549. Painting on sliding doors in the

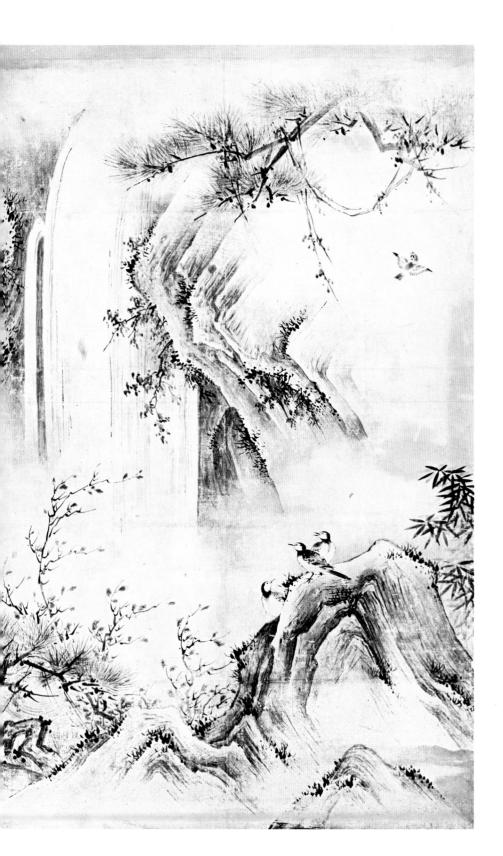

Reiun-in Temple (now mounted on hanging scrolls). Ink and colors on paper. (Each scroll 70×46½") Myöshin-ji, Kyöto.

Illustration page 117

like Yü-chien and Mu-ch'i, Shūbun and Sesshū. Rough and coarse from the technical point of view, his pictures are nevertheless endowed with an intense and spirited vitality reflecting his personality. The storm landscape which we reproduce is the vivid expression of a state of mind, and into the boat gallantly contending with adverse winds one is tempted to read the symbol of his destiny. This small picture, whose colors are more carefully handled and the brushstrokes less violent than usual, gives us an insight into the secret of his art, which, by adapting a Chinese technique to a Japanese outlook, calls forth a profound emotional response.

Of all the various tendencies which in the fifteenth and sixteenth centuries attempted to assimilate the new wash technique, the Kanō school is the one whose historical impact was strongest. Born into a small warrior family of eastern Japan whose name derived from the village of Kanō in Izu province, Kanō Masanobu (1434-1530), founder of the school, went to Kyōto and took service under the Shōgun. Studying either with Shūbun or Sōtan, he made himself proficient in the craft which he probably learned from his father Kagenobu. His talents were admired and gained him admittance to the shogunal academy, where he succeeded Sōtan. He was the first lay painter to work in the wash medium, hitherto a monopoly of the painter-monks of the Zen sect. Already his pictures showed the fundamental characteristics of the Kanō school: clarity of expression, sharply defined linework, and balanced composition, while treating the traditional subjects of Chinese inspiration. Disengaged from Zen symbolism and mysticism, this lay painting appealed directly to the taste of the military class.

Kanō Motonobu (1476-1559), Masanobu's son, placed the school on solid foundations from both the artistic and the social point of view. Instead of embarking on severe, purely plastic researches, such as Sesshū had pursued all his life, Motonobu opened up another path, one no less difficult but more appealing in the eyes of the public, and thereby revived the decorative element and the lyricism inherent in the Japanese tradition. He retained the incisive design that provided a sound structural basis for the work, but to this he added several decorative elements, above all a vivid color scheme, thus creating a new style admirably suited to the vast wall surfaces of palaces and monasteries. And indeed he had to work hard to fill the commissions he received from different social milieux; he did so without concerning himself with religious questions. Though his family remained faithful to the Hokke sect, founded by Nichiren, the great Buddhist reformer of the thirteenth century, Motonobu spent many years (1539-1553) decorating the fortified monastery of Hongan-ji at Ishiyama (present-day Ōsaka), the Amidist center of the Shinshū sect, and also executed paintings in many Zen monasteries. All the members of his family had a share in his work, notably his brother Yukinobu, his sons Munenobu (1514-1562), Hideyori (?-1557) and Naonobu, better known by his artist's name, Shōei (1519-1592). The latter's son Kuninobu—usually designated by his pseudonym Eitoku—also began a brilliant career under the guidance of his grandfather Motonobu. According to family tradition, Motonobu married the daughter of Tosa Mitsunobu (?-1522), head of the court academy, and it seems highly probable that this marriage gave him a chance to learn the secret techniques of traditional Japanese painting, jealously guarded

The Golden Ag

A FTER the great civ ravaged the capit family of Ashika to decline. The first th period," were marked b still kept their title of S anarchic state of affairs the seventeenth century notable progress, and t

Among the feudal region, then the whole c (1534-1582), succeeded in 1568 made himself r first, for one thing, to m in 1543 when a Portuga statesman who worked finally achieved, ushere

Great leaders alway ideals. And thus a grai Nobunaga with a young

While still a boy, I grandfather Motonobu ; his own reflecting the da of the Jukō-in sanctuary still enables us to comp other; for the work was Eitoku, with three of h Konoe. This fact indicat of an atelier highly ester for himself when Nobur by the imperial academy. Thanks to his professional status and a large, well-organized studio composed of members of his family and disciples, the genius of Motonobu far exceeded the scope of a mere head of the shogunal academy, and in Japanese history he represents a new type of painter heralding the independence enjoyed by modern artists.

In addition to several authentic paintings showing the magnitude of his powers, there survive two important series of large compositions made for sliding doors at the Daisen-in temple (c. 1513) in the Daitoku-ji monastery and the Reiun-in temple (1543-1549) in the Myōshin-ji monastery, both at Kyōto. Mounted today on hanging scrolls, these two series contain compositions which vary from one room to another, yet offer a satisfying harmony. Most of them are well-aired landscapes, either dotted with flowering trees and birds or peopled with Chinese historical figures. The persistence of Chinese elements, reflecting the traditional taste of the Zen monasteries, does not seriously interfere with the bland expression of Japanese sentiments pervading his works. But it is above all the landscapes with flowers and birds, of which we reproduce a fragment from the Reiun-in, that represent Motonobu's most original creation.

Unfolding from right to left, the landscape is dominated by a waterfall on one side, from which a white mist arises, concealing the rest of the background. But the real master of this microcosm is a red-headed crane *(tanchō-zuru)* resting on a pine branch, with an air of meditative calm, like an old philosopher. This symbolism is nevertheless in keeping with the decorative arrangement of the picture elements, from the curve of the treetrunk to the contour of the rocks. In the other part of this composition—and above all in the Daisen-in series—the use of brighter colors is presumably due to the artist's contact with the technique of early secular painting in the purely Japanese tradition.

The art of large-scale mural composition, inaugurated by Motonobu, was one of the most fruitful results of the influence of Sung and Yüan painting, and it flourished in the subsequent Momoyama period (sixteenth and seventeenth centuries) thanks to Eitoku, Motonobu's grandson, and to many other artists of genius.

Illustration page 119

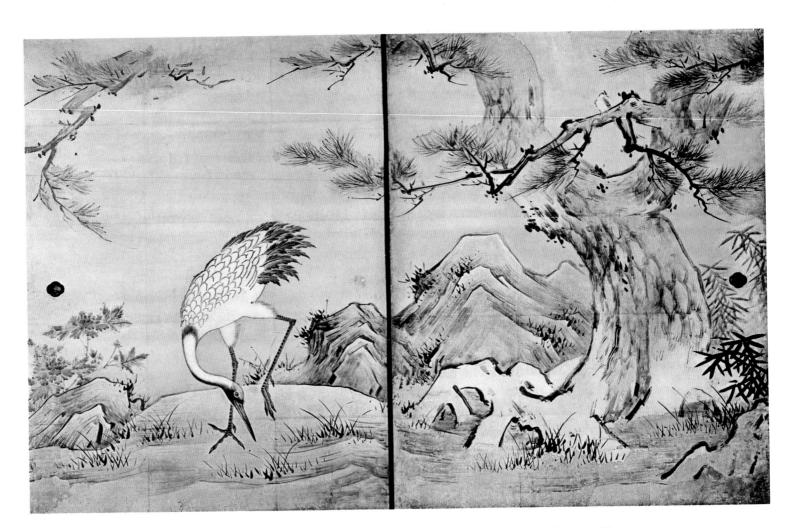

Kanō Eitoku (1543-1590): Crane and Pine Tree, detail. About 1566. Painting on sliding doors in the Jukō-in temple. Ink and colors on paper. (Height 69") Daitoku-ji, Kyōto.

Illustration page 126

of the tree and bird contribute to the decorative effect of the whole; space is better filled, the linework is firmer, and the features of the landscape are more vividly rendered. Less philosophically minded than his grandfather, the young artist succeeded in infusing the traditional techniques of his family with fresh vigor and decorative power, thus paving the way for a new age.

The new style initiated by Eitoku gave birth to several great artists even outside the Kanō school. They had ample opportunity to exercise their talents, for aristocratic, military, clerical and merchant patrons vied with each other in commissioning large mural compositions and screen paintings from their favorite artists. But only one other famous painter dared to compete with Eitoku: Hasegawa Tōhaku (1539-1610). Many points in connection with his origin and career are still obscure. Born, presumably, in the province of Noto in northern Japan, he first practised the painter's craft in the country. Some art historians, such as Doi Tsuguyoshi, identify him with Hasegawa Nobuharu, whose name figures on several portraits and Buddhist paintings, all in a very delicate and even slightly affected style. It is this stylistic peculiarity, however, which prevents other historians from accepting this hypothesis. Anyhow, after learning the technique of monochrome painting as practised by the Sesshū school, the artist went to Kyōto where he may have worked in the Kanō studio; but he was independent minded and did not long pursue this apprenticeship. Meanwhile he must have assumed the name of Tōhaku and, claiming to be "the fifth artistic generation of Sesshū," he made a thorough study of the works of this great artist. He was also much influenced by the Chinese masters of the Sung period, by Mu-ch'i in particular

It was the spiritual power of his wash drawings that first earned Tōhaku the esteem of the warrior and clerical classes, especially that of the Zen monks. We still have today a considerable number of his monochrome paintings in a highly personal style, both on screens and on the sliding doors of the Zen temples of Kyōto.

There is one masterpiece, however, which in itself easily accounts for the fame of this artist of genius; this is a pair of screen paintings representing a pine wood, now in the National Museum, Tokyo. Far from imitating the conventional compositions inspired by Chinese landscapes, Tōhaku here records a bit of Japanese scenery under one of its most characteristic aspects: a pine wood seen through a mist. Four or five clumps of tall slender trees are represented in Indian ink alone, with infinitely delicate gradations of tone. Making full use of the varied effects possible with a brush thinly or thickly charged with ink, the painter admirably expressed the peculiar quality or texture of each substance: leafage, tree trunks, and roots emerging from the ground. The great white space of the background was by no means left empty: the indistinct silhouettes of pine trees looming dimly in the mist hint at the vast depth of the woods. In the upper center, the snowcapped peaks of distant mountains stand out faintly against the background, suggesting infinite recession. For all its symbolism, the work has nothing heavy or mystical about it. An engaging rhythm enlivens the composition, and the spectator experiences the same sense of refreshing exhilaration that one gets from an early walk in a pine wood swathed in the morning mist. Here then, three or four centuries after the introduction of monochrome painting, a Japanese artist successfully expressed the distinctive poetry of the Japanese landscape, thanks to a technique of continental origin. This work of Tohaku's maturity shows the mastery he acquired in the art for which Mu-ch'i had been famous; but the metaphysics of the Chinese painter-monk have given place to the poetic sentiment peculiar to the long Japanese tradition which originated in the Heian period.

An ambitious artist, Hasegawa Tōhaku was not content with his success in the field of monochrome painting. He was eager to develop and perfect his style by decorating palaces and temples with large polychrome compositions. With the help of his sons, above all Kyūzō (1568-1593), a talented painter, he founded a school of his own and angled for some of the official commissions for large-scale decorative work which were then being distributed, notably by Toyotomi Hideyoshi. With the backing of the friends he had made among the Zen monks and the great tea masters, like Sen-no-Rikyū, he was able to compete with the Kanō school and break the monopoly it had enjoyed. Most of Eitoku's works have been destroyed. Such is not the case with Tōhaku. Still extant

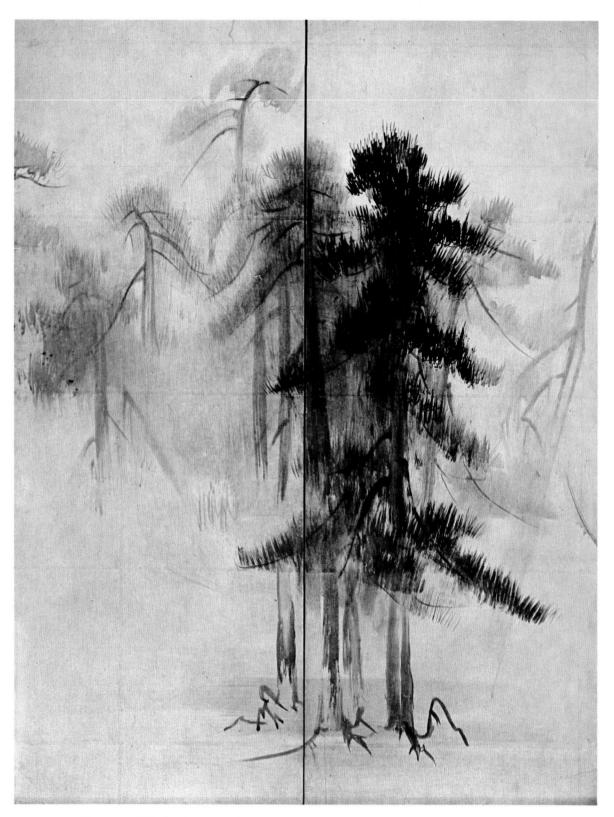

Hasegawa Tōhaku (1539-1610): Pine Wood, detail of a screen painting. Ink on paper. (Entire screen $61_{8}^{3} \times 136_{2}^{n}$) National Museum, Tokyo.

is a large sequence of wall paintings reflecting not only his own art but that of his period: these are the compositions decorating the interior of the Chijaku-in temple at Kyōto.

According to the archives of this sanctuary, there existed on the grounds another temple, the Shōun-ji, built to the order of Hideyoshi in 1592 to console the departed spirit of his favorite son Sutemaru, who died at the age of three. After the downfall of the Toyotomi family in 1615, the conqueror Tokugawa Ieyasu entrusted to the administration of the Chijaku-in the grounds and buildings of the Shoun-ji, considered to be the finest of the capital, with their wonderful mural decorations. During the fire of 1682, a good many of these paintings were detached from the wall and removed to a safe place; later, when the buildings were reconstructed (on a smaller scale), they were reinstalled. Miraculously saved once again when fire ravaged the temple in 1947, these compositions show us today exactly how the interior of the great temples looked in Hideyoshi's time. It so happens that present-day stylistic analysis has confirmed the almost forgotten tradition attributing these works to Tohaku and his school. We consider as being by the master's hand the grandiose representation of a maple tree amid autumn plants, which extends over four large sliding doors (in all nearly 6 feet high and 18 feet wide) forming part of the partition of the main hall. Inasmuch as the other ancient doors of the Shōun-ji measure a little over 7 feet in height (these are preserved intact in the form of screens at the Chijaku-in temple), the sliding doors with the maple tree composition, which were later adapted to a smaller building, must originally have been much higher than they are now. And indeed the power and sweep of the great red-leafed maple, as we now see it, are out of proportion to the size of the wall. But what charms us above all in this work is the eager, vital movement of the trunk as it shoots out its branches on either side. The same vitality quickens the autumn plants in bloom at the foot of the tree; their colors, standing out sharply against the gold background representing the soil or clouds, are bright and harmonious. Nature is less distorted by decorative and expressive effects, and colors and composition less encumbered by them, than in the works of Eitoku and his school. The brushstrokes accurately and unemphatically delineating trunk, branches and rocks show the close kinship between this polychrome work and the monochrome painting of the same artist. Here, as in the *Pine Wood* (National Museum, Tokyo), we find the grace of movement, the serenity of tones and the freshness of expression that characterize the masterly style of Hasegawa Tōhaku.

The painting of the Momoyama period was further enriched by another master, whose style, like that of Tōhaku, was original and independent of the Kanō school. Son of a nobleman of the province of Ōmi, Kaiho Yūshō (1533-1615) was still a child when he became a novice at the Tōfuku-ji, one of the most important Zen monasteries of Kyōto; thanks to this circumstance, he escaped the fate of his family, which was ruthlessly exterminated in the attack of Oda Nobunaga in 1573. Recognizing the artistic vocation of his young disciple, the superior of the monastery had him taught painting by Kanō Motonobu, who keenly appreciated his talent. It was perhaps the downfall of his family which prompted him to pursue a painter's career, in order to perpetuate in art the glory his ancestors had acquired in arms. It was said, however, that all his life he felt remorse

Illustration pages 130-131

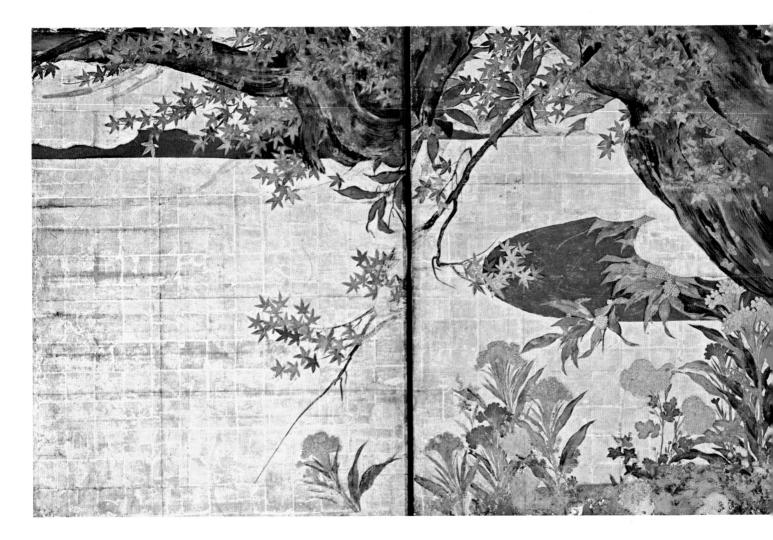

Hasegawa Tōhaku (1539-1610) and his school: Maple Tree and Autumn Plants, detail. 1592. Painting originally

at having "fallen to the rank of an artist" and never ceased to practise hurling and thrusting the spear and to seek the company of military men and the great Zen monks.

It seems probable that Yūshō first endeavored to form a style of his own in wash painting by pushing his studies beyond the art of Kanō, to the original source—the Chinese masters of the Sung period, in particular Liang K'ai. Now mounted on fifty large hanging scrolls, the interior decoration of the main building of the Kennin-ji, another Zen monastery of Kyōto, shows his skill in this technique: landscapes in the simplified cursive style, figures of Chinese inspiration, a dragon in the clouds and even flowering trees with birds, all treated solely in Indian ink with varied touches of the brush and gradations of washes. Emphasis has often been laid on his characteristic manner of drawing the bodies of figures with long, highly simplified lines. What particularly strikes us, however, is his exquisite use of washes, whose shaded tones, in his hands, alone suffice to represent the full volume and movement of trees, rocks, flowers and birds without any

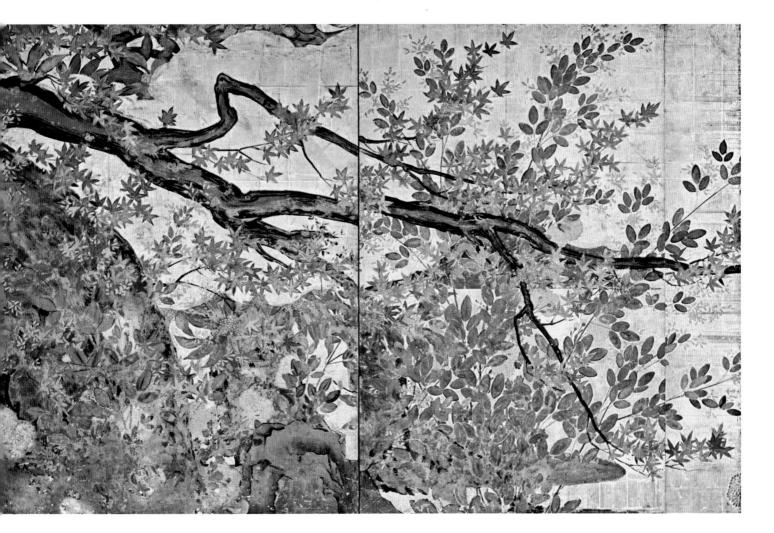

on sliding doors in the Shōun-ji temple. Colors on gold paper. (Entire panel 69¾×218¼") Chijaku-in, Kyōto.

contours. It is this technique that sets Yūshō apart from other artists of the period, especially from those of the Kanō school. While the delicate handling of flowers and birds, both in this great decorative sequence and in other monochrome compositions executed for different sanctuaries connected with the Kennin-ji monastery, expresses the artist's sensitive response to nature, perhaps the sharply jutting branches of his trees, which seem to strike out like so many spear thrusts, spring from the vigorous warrior blood flowing in his veins. These characteristics reappear unchanged in his polychrome works, such as the three pairs of screens preserved in the Myōshin-ji at Kyōto, which, like the Kennin-ji decorations, are regarded as examples of his mature style (between 1595 and 1600), to which he attained fairly late in life, probably not before the age of sixty. The handsome signature he made a point of adding to each work—a practice by no means generalized as yet among the painters of his time—goes to show the high opinion he held of his own work. The originality of these screen paintings fully justifies

the renown he enjoyed. The painter here succeeds in introducing wash elements into the decorative, polychrome composition, notably when dealing with figures of Chinese history or legend. Rocks and tree trunks are built up solely by means of shaded touches of ink on the white paper, while vivid colors are reserved for costumes and leafage, set off by the gilding of ground and clouds. A decorative tendency is more marked in the third pair of screens, one with peonies, the other with plum blossoms and camellias. Against a uniform gold background evoking the glowing atmosphere of early summer, full-blown peonies, symbol of luxury and nobility, nestle amid the leafage. A few rocks, colored green and dotted with dabs of ink, create a happy equilibrium. Except for the varied and delicate tints of the flowers (white, pink, orange and very light green), the color scheme is fairly simple and quite in keeping with the temperament of the artist who liked to reduce things to their essentials. What above all gives life to this composition is an agreeably light and sprightly touch: a sudden gust of the May breeze, and all these flower-laden branches shake and sway to one rhythm. Less showy than Eitoku's style, less compelling than the vision of Tohaku in his maple tree composition, Yusho's art breathes a serenity and elegance which, however, are never lacking in grandeur.

After the sudden death of Hideyoshi in 1598 followed by the defeat in 1600 of the army of his favorite Ishita Mitsunari and his allies, political power passed to Tokugawa Ievasu who in 1603 set up his military government (bakufu) at Edo (present-day Tokyo) and assumed the official title of *shogun* (commander-in-chief of the army). Having reached its height, the Momoyama style of painting, initiated by Eitoku and developed by Tohaku and Yūshō, fell into a decline in the early seventeenth century, although these two last named masters went on working for over a decade, until the final downfall in 1615 of the Toyotomi family, which until then resided in the luxurious castle of Ōsaka. It was Eitoku's successors who were entrusted with the large-scale compositions commissioned by the Toyotomi and the Tokugawa. The leadership of the Kanō school was taken over by Mitsunobu, Eitoku's eldest son, until his premature death in 1608, and later by his son Sadanobu (1597-1623), assisted by many artists who were kinsmen and by many disciples: Naganobu, Takanobu, Kōi and above all the famous Sanraku. The wall paintings of the Kangaku-in at the Mildera monastery at Ōtsu, executed by Mitsunobu in 1600, well represent the style of this second generation, characterized by a more intimate naturalism and refinements of technique and expression, to the detriment of grandeur and vigor of composition. This tendency is clearly manifested in the interior decoration of the castle of Nagoya, built by Tokugawa Ieyasu in 1614. Fortunately most of his paintings survived the bombings of the Second World War. The mild spring landscape with cherry trees and pheasants, decorating one of the main rooms, is attributed to Takanobu, Mitsunobu's younger brother, who also worked at the imperial court. Of the activity of their uncle Naganobu, whose studio was probably responsible for the interesting scenes of popular life painted in the audience halls of the same castle, we shall have more to say in Chapter 9 in connection with genre painting.

The most representative artist of the second half of the Momoyama period is unquestionably Kanō Sanraku. The son of a warrior, he served as a page under Hideyoshi who,

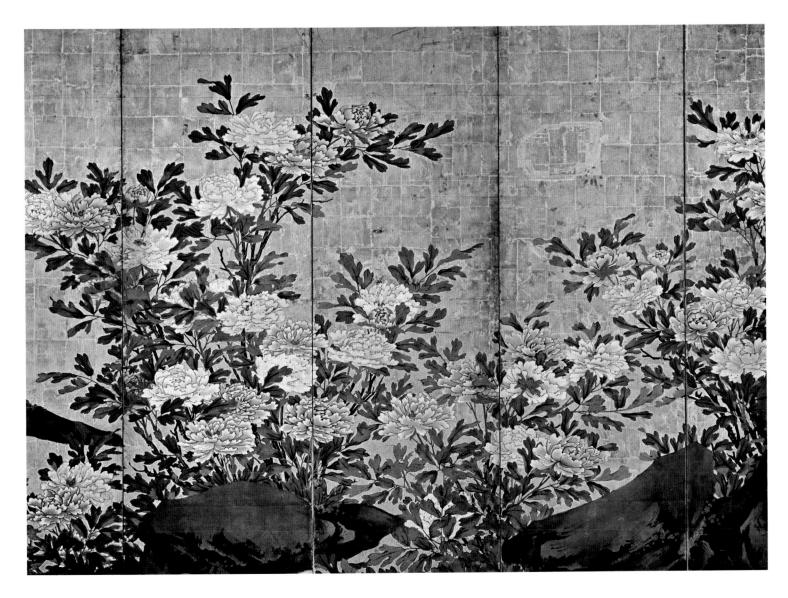

Kaiho Yūshō (1533-1615): Peonies, detail of a screen painting. About 1595-1600. Colors on gold paper. (Entire screen 70×142¼") Myōshin-ji, Kyōto.

noticing his aptitude for painting, had him apprenticed to Eitoku. His gifts and diligence so endeared him to Eitoku that he became in time one of his foremost assistants and even his adoptive son. After his master's death, Sanraku enjoyed the patronage of Hideyoshi and soon had a chance to deepen his artistic experience by decorating the castle of Momoyama (1592), among others. In gratitude to his patron, Sanraku remained faithful to the Toyotomi family, down to the very last days of the castle of Ōsaka; and even after the catastrophe he did not leave Kyōto with the other members of the Kanō school who moved to Edo (Tokyo), the new center of political power. Sanraku's descendants, moreover, ensured the continuity of his school under the name of the "Kanō family of Kyōto" (Kyō-Kanō). side of the castle) has come down to us in its original state, or almost so. This complex of five superb buildings connected by broad corridors was erected when the castle was founded in 1603 and redecorated in 1626. It thus remains a unique example of the large pompous palaces of that period. The decoration of the most important part (\bar{o} -hiroma, the main audience halls) is presumably the work of Tannyū and his studio assistants. All the walls are covered with large polychrome compositions on a gold ground treating the traditional theme of pines and birds. But here the artists' efforts tend to magnify the power of the new dictator. On a long partition of the fourth room, for example, a single gigantic pine occupies an area 46 feet wide and 16 feet high. Perched in the foliage, an old eagle seems to dominate the whole room with his regal dignity. But the space uniformly filled by the gold background is so far out of proportion to the whole that one cannot help feeling the vanity of this display of luxury: the painting has turned into a set piece despite the imposing size of trees and birds.

This dangerous trend toward academicism was destined to corrupt the Kanō school under the leadership of Tannyū's direct successors, who still enjoyed the patronage of the shogunal government. These artists will be dealt with in Chapter 10.

It is worth while mentioning a few other masters of the early seventeenth century, active chiefly in the field of monochrome painting. Unkoku Tōgan (1547-1618), who claimed to be the successor of Sesshū, whose style he imitated, worked in the province of Suhō in the westernmost part of Honshū, where his descendants formed the Unkoku school. Soga Chokuan maintained the severe tradition of the previous period. The paintermonk Shōkadō Shōjō (1584-1639) is remarkable for his acute and spirited draftsmanship. Miyamoto Musashi (1584-1645), better known as Niten, was not only an artist but a famous swordsman; he showed great vigor of mind in his fine wash drawings, a technique he was especially fond of, regarding it as a means of spiritual exercise.

In less than a century the whole aspect of Japanese painting had changed. No account of this exceptionally rich and momentous period would be complete without some mention of an event of considerable historical interest: the first contact of the Japanese with Western art as introduced by Christian missionaries. The Catholic Church put forth all its efforts in an intense burst of activity in the age of the great voyages of discovery. In 1549 the great Jesuit St Francis Xavier landed in Japan at Kagoshima, in southern Kyūshū, a port at which Portuguese ships had been calling since 1543. Dispirited and unsettled as they were by continual civil wars, the Japanese were immediately attracted by the Christian doctrine of supreme salvation. Local rulers and chieftains, lured at first by self-interest and coveting Western firearms or the profits to be had from trading with the Portuguese, offered their support to the missionaries and several of them ultimately became sincere converts to the Christian faith. From Kyūshū Christianity soon spread to the capital, Kyōto (called Miyako by the Jesuits), thanks to the tireless efforts of Xavier's successors. In 1560 the Shōgun Yoshiteru granted Father Gaspar Vilela official permission to spread propaganda and proselytize. But the flourishing period of Christianity in Japan was ushered in by Oda Nobunaga who, upon his entry into Kyōto in 1568, accorded his patronage to the missionaries. A handsome church of two storeys was built

in the capital in 1578, followed in 1580 by another at Azuchi, where Nobunaga resided. By 1581 there were already 150,000 Japanese Christians, over one hundred churches and at least seventy-five missionaries.

Needless to say, the oil paintings and engraved work required by Catholic churches had at first to be imported from Europe in considerable numbers. Besides these sacred images, the Portuguese also brought secular paintings, battle scenes, portraits of European princes, views of European cities, etc., all of which excited keen interest among the Japanese, whether Christian or not, to whom both the subjects and the technique came as complete novelties. But the steadily increasing number of converts and churches soon led to the production of Christian paintings in Japan itself. It seems very probable that, to begin with, native painters versed in the traditional Japanese technique were employed to copy imported European paintings. After 1579, when Father Alessandro Valignano,

Kanō Sanraku (1559-1635) and his adoptive son Sansetsu (1590-1651): Plum Tree and Pheasant. About 1631-1635. Painting on the sliding doors of the Tenkyū-in temple (west room). Colors on gold paper. (Each panel 72¼×40⅛″) Myōshin-ji, Kyōto.

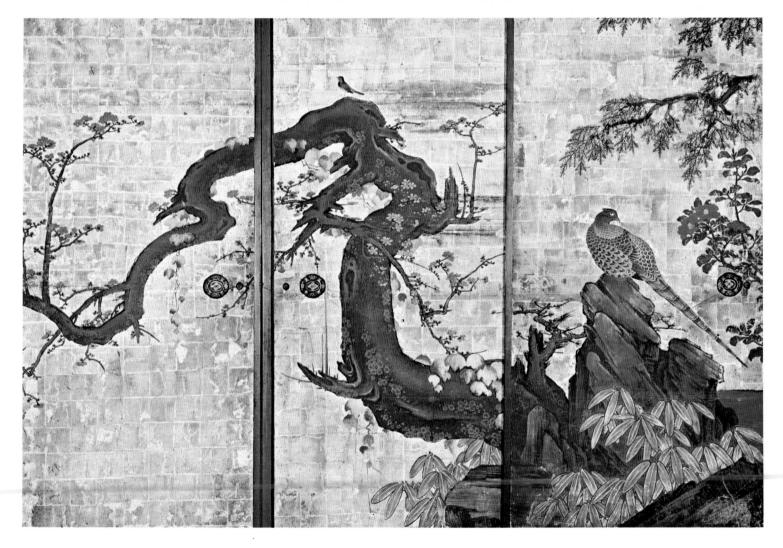

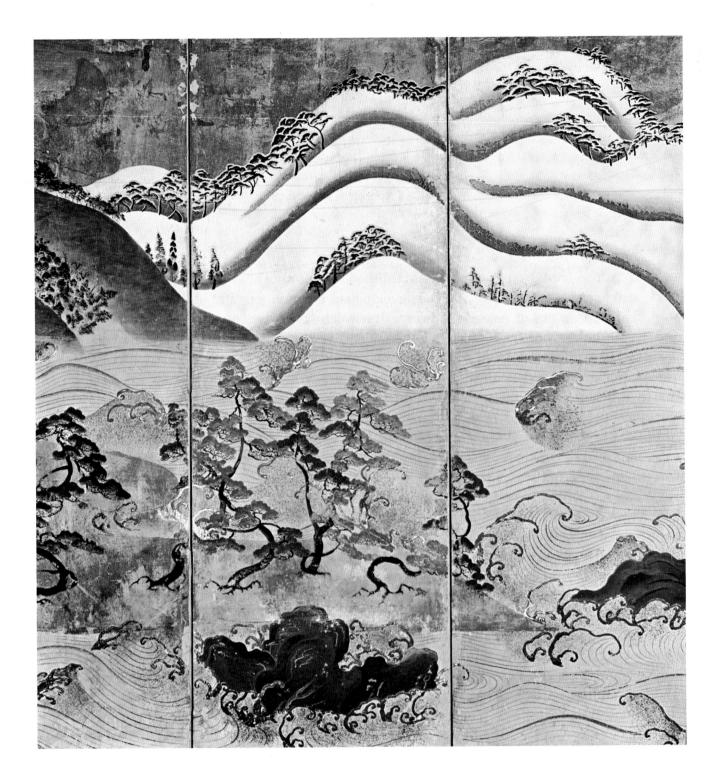

Winter Landscape by Moonlight (Nichi-getsu-sansui-byōbu), detail of a screen painting. Late sixteenth century. Colors on paper. (Each panel 58×187%") Kongō-ji, Kauchi, Ōsaka Prefecture.

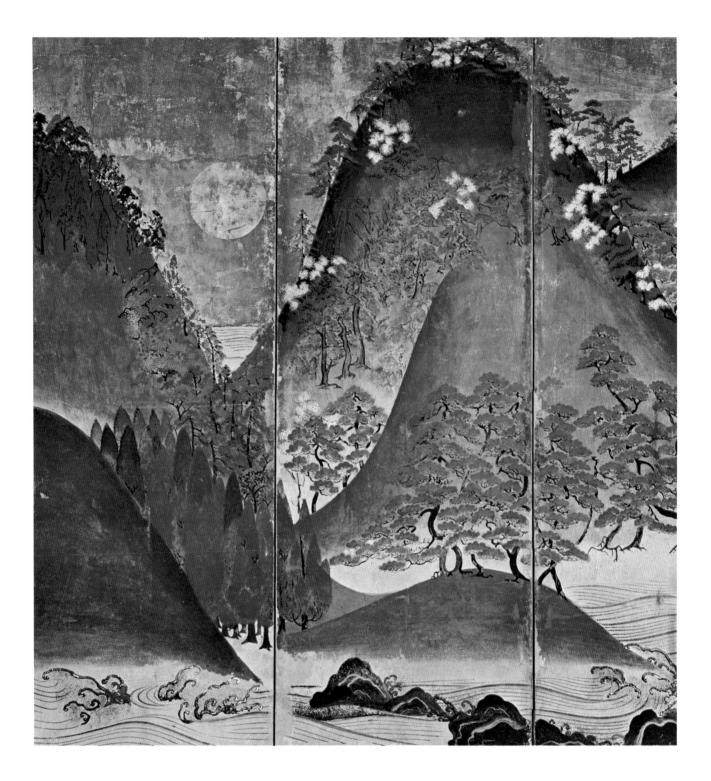

Spring Landscape in Sunlight (Nichi-getsu-sansui-byōbu), detail of a screen painting. Late sixteenth century. Colors on paper. (Each panel 58×187%") Kongō-ji, Kauchi, Ōsaka Prefecture.

Sötatsu (early seventeenth century): Sekiya Scene from the Tale of Genji.

ina

Screen painting, colors on gold paper. $(59\%\times139\%'')$ Seikadō Foundation, Tokyo.

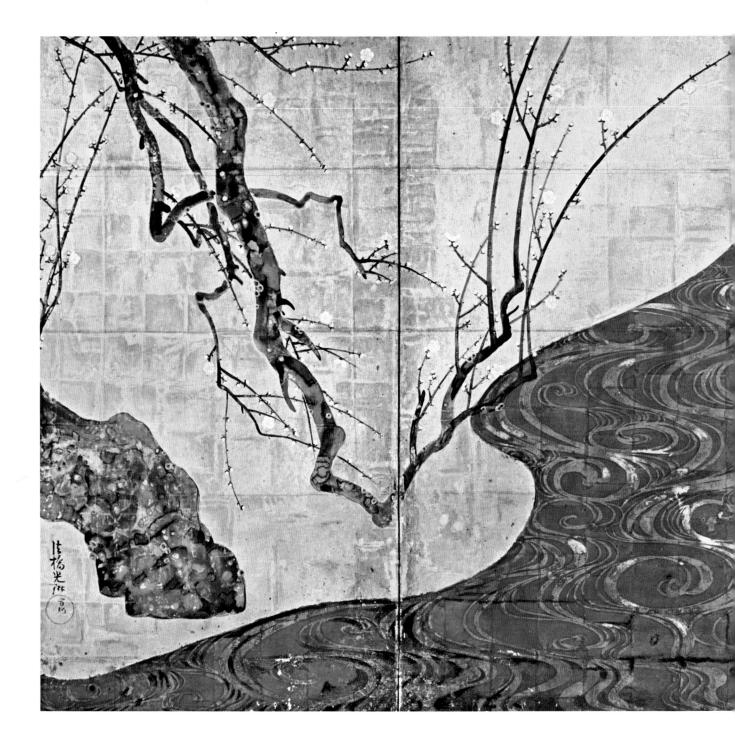

A . A . A . A

154

Ogata Körin (1658-1716): White and Red Plum Trees. Pair of screen paintings, colors of

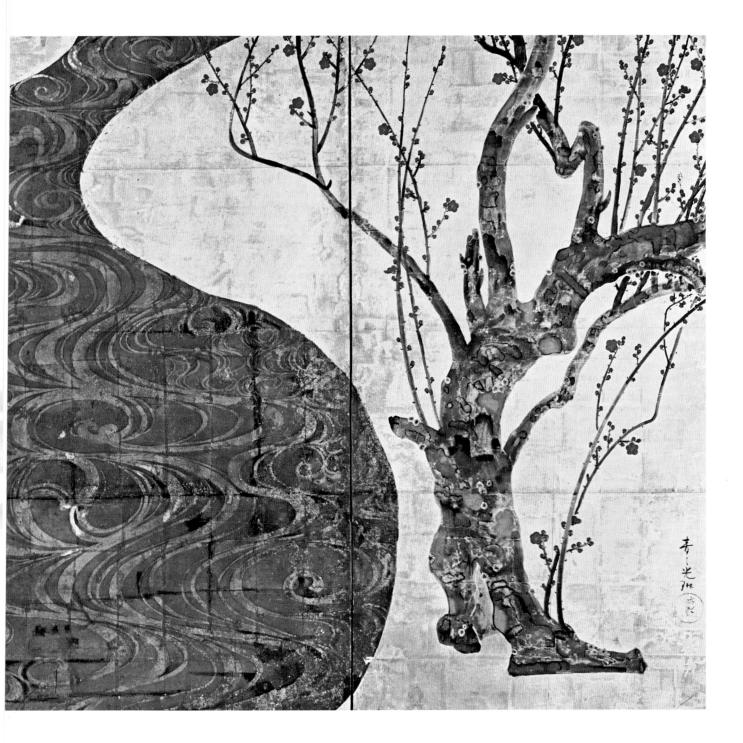

gold paper. (Each screen 61¼×68") Sekai-kyūsei-kyō Collection, Atami Museum, Shizuoka-ken.

outstanding works. One of the standard subjects remained the bird's-eye view of Kyōto and its outskirts, combined with scenes of popular life and festivities (rakuchū-rakugai-zu). During the first half of the seventeenth century, these compositions served increasingly as a pretext for illustrating topical events: new monuments, entertainments and public rejoicings, unusual ceremonies (like the commemorative festival for Toyotomi Hideyoshi in 1604 or the emperor's visit to the castle of Nijō in 1626) and fashionable gatherings (the inauguration of the Kabuki Theater for example). While the mass production of these general views, sold as mementoes or souvenirs of life in the old capital of Japan, gradually deprived them of any artistic value, the interest of both patrons and artists shifted to particular scenes treated in detail. A leading theme was chosen, for example the different trades plied in the busy streets of Kyoto, and sets of leaves, each leaf illustrating a specific occupation (shokunin-zukushi), were produced in quantity and went to form screens or albums. Other themes in high favor were picturesque events like the horse race at the Shintō shrine of Kamo or the memorial celebration at the Hōkokujinja shrine, the mausoleum of Hideyoshi, on the seventh anniversary of his death. In two surviving works on these themes (one of them signed by Kanō Naizen, 1570-1616) the composition is enlivened by dancers in fanciful disguises, representing each quarter of Kyōto. The fervent homage paid to the dead hero, deepened perhaps by the anxiety caused by the transfer of power, imparts a vivid emotionalism to these screens.

Painters also took a keen interest in the recreations and amusements of the people. The theaters grouped on the banks of the river Kamo, in the Shijō quarter of Kyōto, formed the entertainment center of the city. They are shown in bird's-eye view in spirited compositions full of people in quaint and colorful profusion. Particular entertainments—for example the troupe of Izumo-no-Okuni, a fine actress reputed to have inaugurated the Kabuki dance in front of the Kitano shrine about 1603-are illustrated on a great many screens, with the alluring figures of female dancers and musicians (Kabukibyobu). Outings in the country, open-air dancing, and all the pleasures freely indulged in now that peace had descended on Japan after a long period of disorder and civil war-these were favorite themes with artists, and in treating them they recreate the brilliant atmosphere of the Japanese Renaissance. The scenes showing the arrival of Westerners (Namban-byobu) also number among this class of subjects; indeed one of the best of them is signed by Kanō Naizen, who also painted screens representing the memorial ceremony at the Hokoku-jinja shrine. This proves that the academic painters, the Kanō in particular, were among the first to take up genre painting, though the bulk of their work consisted of large, solemn compositions decorating official buildings.

Illustration page 161

We reproduce a detail of a remarkable work bearing the seal of Kanō Naganobu (1577-1654), Eitoku's brother. This screen painting represents the cherry blossom festival organized by a noble family. On the left is a young prince, cutting a very handsome figure; surrounded by noble ladies, he is watching a group of dancers from the balcony of an octagonal pavilion, perhaps a shrine. Below, serving women are preparing a luncheon while footmen are resting between the pillars of the building, having just put down the palanquins they brought in on their shoulders. So this is not a scene of popular life, but

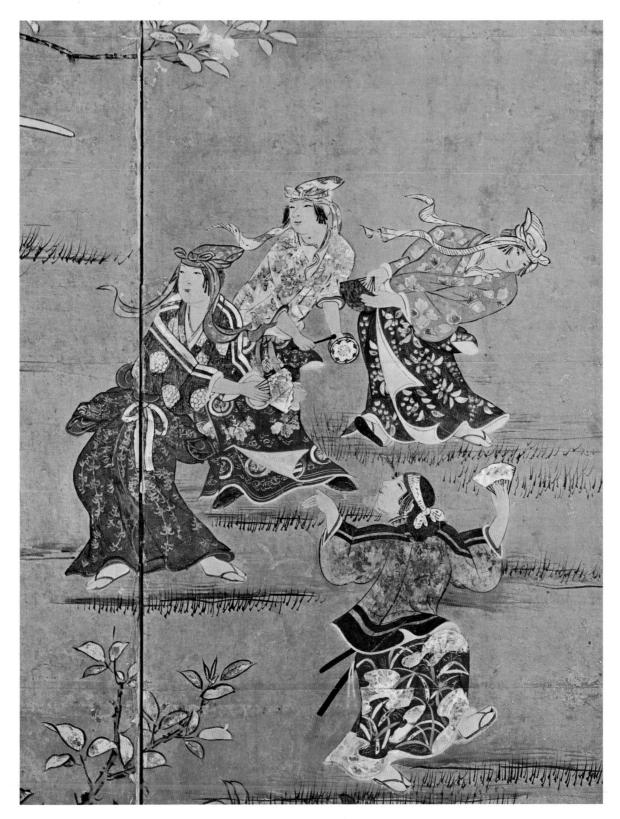

Kanō Naganobu (1577-1654): Cherry Blossom Festival, detail of the Dancers. Screen painting, colors on paper. (Entire screen 58¾×140″) Hara Kunizō Collection, Tokyo.

Illustration page 161

an aristocratic gathering worthy of being represented by an academic painter. The real theme of the picture, however, is the group of four dancers who, together with those on the right, form a merry ring under the full-blown cherry blossoms. Three girls with headdresses are dancing briskly to the beat of a small drum, keeping time with their fans, while a young man (or a girl in male disguise) makes spirited gestures of encouragement. Trees and plants are indicated by sharply drawn ink brushstrokes, in accordance with the traditional technique of the Kanō school. Figures stand out against the neutral ground of the paper, which brings out to the full the decorative effect of the luxurious costumes. (As a rule, these genre painters are fond of lingering over the delineation of women's costumes, faithfully imitating rich fabrics, brocades, embroideries and hangings, whose manufacture was then greatly on the increase.) The expressive, freely flowing lines of Naganobu's characteristic brush aptly render these feminine figures and their graceful movements. This elegance and freedom already tend to exceed the academic bounds of the Kanō school, and we are therefore inclined to attribute to the same artist some of the scenes of popular life decorating the castle of Nagaya.

As this new trend of secular painting gained ground and attracted a wider public, independent artists known as machi-eshi (city painters or popular painters) began to specialize in the production of screens decorated with genre scenes. Presumably trained for the most part in the studios of the Kanō school, these artists, by combining the academic style with other techniques, notably that of the Tosa school, achieved a freer mode of expression better suited to the representation of contemporary life. In response to the taste of the public, their interest shifted, as we have seen, from general views to details; figure paintings in particular, above all of beautiful women, unaccompanied either by architecture or landscape, met with an immense success. Many of these charming works have come down to us, nearly always mounted on screens, in which anonymous painters portray different types of feminine beauty, vivacious and appealing, dressed in the latest fashion-for example the richly clad ladies seen in different poses on the screens in the Yamato-bunka-kan at Nara. Moreover, the free and even licentious manners of the period gave rise to pleasure haunts and gay quarters in the cities. Courtesans, dancing girls and yuna (women of easy virtue who worked in the hot baths) accordingly played the leading part in these compositions, the most original of which is the one in the Atami Museum showing six yuna in all their finery walking in the street, wearing the kosode, a gaudy, short-sleeved kimono with a thin belt.

Illustration page 163

The rhythmical patterning of these six willowy figures and the agreeable harmony of the colors say much for the talent and ingenuity of this unknown artist. But even more striking is his keen-eyed observation, as ironical as Toulouse-Lautrec's. Instead of depicting conventional female beauty, he has given each of these women a pose and manner all her own, and to each a characteristic physiognomy, a little overdone, whose rather cheerless sensuality evokes the whole tenor of their lives. His technique, moreover, owes nothing to the orthodox styles of either the Kanō or the Tosa school. A new style had emerged, already fully worked out in the second quarter of the seventeenth century and well suited to representing the everyday pursuits and amusements of the common people. Yoshiwara; he contemporaries in signing his p which recalls tl had in mind tl expressed his c spirit of the tir with the Chine Nishikawa Suk Moronobu the latest tech in no way infe

in no way infer female models, simple but sha logical concluss by Moronobu, and technique Japanese print 1716?) and Ki particular emp actors (yakus) theater and pe

The paint for a walk. Th a plastic effect up by print de their own: Ok Toyonobu (17)

Thanks to evolution, part eye-catching co it was left to fe and white prin known as *tan-o* the distinctive family. By the by Okumura A wider varie but always by rose-red (*beni*) *beni-zuri-e* (ex which refers to

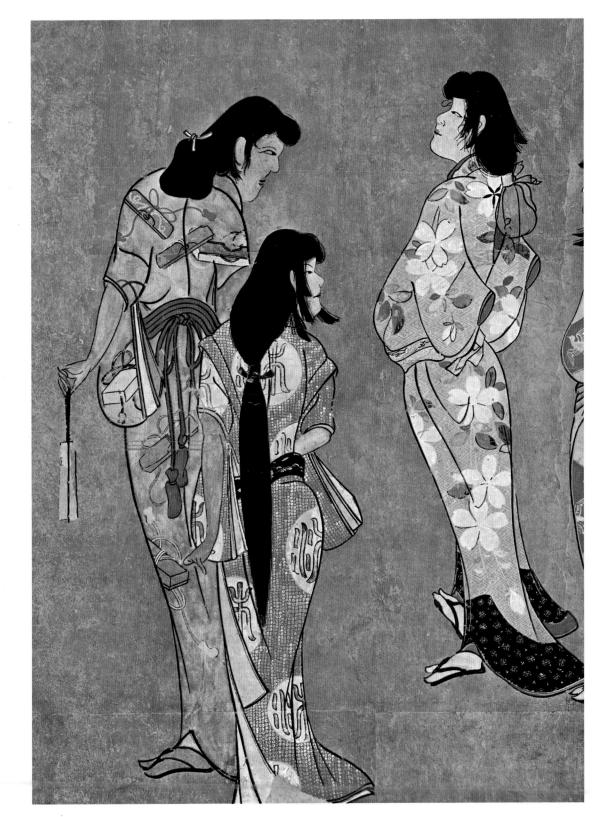

Anonymous: Serving Women of the Hot Baths (yuna), detail. Seventeenth century. Hanging scroll, colors on paper. (285%×315%") Sekai-kyūsei-kyū Collection, Atami Museum, Shizuoka-ken.

Η

pa

in

ty

of

0

ca

ci

br

pa

tr

Te

 $\mathbf{p}\mathbf{I}$

kr

né

 \mathbf{K}

lir

th

al

th

in

SO

 $^{\mathrm{th}}$

be

w: in

of

ar

pc

rie

fo

in

W

sh

ac

Μ

di

siį

Α

To illustrate this initial phase of the Japanese print, we have chosen a charming work of the *urushi-e* type by Torii Kiyonobu II, whose skill in this technique was equal to that of Okumura Masanobu. It represents the actor Ogino Isaburō in the role of Araoka Genta, which he interpreted in 1726 at the Ichimuraza theater in the play *Hinazuru-tokiwa-genji*. Following the practice of Masanobu who often produced portraits in sets of two or three, this print forms a pendant with the portrait of Arashi Wasaburō disguised as a girl—which thus accounts for the actor's movement toward the left. His body, the long curving sabre and the pine all go to form a well-balanced whole, while the simple colors and the sharp black lines emphasize the impression of movement. Herein lies the charm of these early prints, which have a more direct appeal than the later, more highly developed works.

Nevertheless, the public and even the artists of that day regarded both the absence of color and the use of these simple color schemes as the chief drawback of the print. So it was that Miyakawa Chōshun (1683-1753) and his disciples ignored printmaking and confined themselves to painting for their pictures of women, which gave them scope for lavish displays of color. But publishers and artists continued to seek a way of coloring prints by means of wood blocks. Presumably following the methods used in Chinese polychrome prints (in particular the lavishly decorated sheets of paper used for calligraphy), they began by adding several colors (rose-red and bluish green) to the black and white engraving, each color being printed with a separate wood block, and the blocks kept in perfect register by means of guide marks (kento). This technique, known as beni-zuri-e (painting printed with rose-red), first used only for the printing of de luxe calendars (e-goyomi) about 1745, was soon adopted for commercial printmaking. It remained in vogue for nearly twenty years, and the addition of new colors (violet and yellow) gradually prepared the way for the full development of polychrome prints. Among the artists of this period Ishikawa Toyonobu (1711-1785) admirably explored the possibilities of this technique, occasionally adding bright colors in fanciful harmonies beautifully adapted to his mild and seductive style.

After a century-long evolution, the Japanese print finally attained to technical and esthetic perfection in the polychrome print called *nishiki-e*. It so happens—and this is very unusual in the history of art—that this result was obtained at one blow, at a given date, thanks to a group of art lovers and craftsmen and a single painter. At Edo, early in the new year, 1765 (the second year of the Meiwa era), a group of *haikai* poets (a witty poem of seventeen syllables) designed and printed some illustrated almanacs (*e-goyomi*) whose beauty and *esprit* made them objects of friendly rivalry, which they exchanged with each other. Edo at that time was enjoying a period of undisturbed peace which left its inhabitants free to pursue an ideal of elegance and refinement in all the arts of good living. To these groups of amateur poets, which included both military men of the middle class and rich tradesmen, their elegant pastimes seemed more important than anything else in life, and they accordingly spared no expense to make the decorative design of each leaf of the abridged calendar of that year (*ryaku-reki*) as perfect as possible. Several of these dilettanti conceived the idea of printing a de luxe edition of their almanac in seven or eight colors. Thanks to the collaboration of Suzuki Harunobu (1725-1770), a talented artist, and the best block-cutters (hori-shi) and printers (suri-shi), all thoroughly familiar with the art of beni-zuri-e, the undertaking achieved astonishing results. The wide range of delicate colors greatly enhanced the graceful designs of Harunobu, and the print acquired a beauty far surpassing anything seen before. The public responded enthusiastically to the new works and the publisher lost no time in issuing a commercial edition of these luxurious surimono (prints in a limited edition for distribution among friends), which came to be called nishiki-e ("brocade painting"), the effect obtained being reminiscent of fine brocade (nishiki). This was naturally a triumph for Harunobu, whose career as a painter had hitherto been by no means remarkable in any way. The highly refined compositions of these first surimono (reissued later in commercial editions of nishiki-e) were undoubtedly inspired by these elegant amateur poets and designed in accordance with their taste; a hatamoto (direct vassal of the Shōgun), for example, often had his artistic pseudonym Kyosen inscribed on prints, accompanied by the suffix $k\bar{o}$ (meaning "based on the idea of ... "). But without Harunobu's genius, those ideas might never have been so successfully realized.

Encouraged by the reception of these prints, Harunobu worked unremittingly until his death in 1770, leaving over six hundred wood blocks executed in the space of six years. Having assimilated the style of his predecessors, of Ishikawa Toyonobu and even Nishikawa Sukenobu of Kyōto, he succeeded in endowing his female figures with the almost superhuman grace of weightless bodies, with slender waists and tiny feet and hands, whose stylized faces convey no expression of feeling. Unlike those of his precursors, the "primitives," who portrayed their beautiful women against a neutral background, his compositions stand in a natural or architectural setting. Not that he is concerned with realistic effects; on the contrary, the setting of Harunobu's fanciful figures, whether indoors or out of doors, is imbued with lyricism and an appealing sense of poetry. His wide range of colors, with their harmonies or contrasts, renders the appropriate texture of every detail and tends toward a purely pictorial effect. The girl making her way on a stormy night to the Shintō shrine-to pray for the success of a love affair and perhaps to curse her rival-is an almost fantastic vision in which the lantern alone suggests the darkness, and the broken umbrella the violence of the storm: her delicate features betray no hint of heartache or sorrow, but an extraordinary, well-nigh mystic beauty emerges from the design and color harmony. Is there not a parallel to be drawn here with the scroll paintings of the Tale of Genji? Is there not a mysterious correspondence between these pretty girls and the fine ladies of six centuries before, seated in their aristocratic palaces, with their characteristic features, the eyes reduced to a slit, the nose a mere hook, the lips a small dot of red? It is here, in our opinion, that the expression yamato-eshi ("Japanese painter"), which Moronobu proudly prefixed to his signature, finds its full and explicit meaning. Moreover, the interest Harunobu took in the classical arts of Japan often prompted him to insert in his pictures the ancient poems from which he took the subject. This was a deliberate evocation of the aristocratic period, and Harunobu's works thereby hark back to the oldest classical tradition of Japanese painting.

Torii Kiyonobu II (1702-1752): The Actor Ogino Isaburō on Stage. Hand-colored print (urushi-e). (12×6¼") National Museum, Tokyo.

Suzuki Harunobu (1725-1770): Girl on her Way to the Shintō Shrine on a Stormy Night. Color print. (10¾×8⅛″) National Museum, Tokyo.

His art, whose roots lie deep in the Japanese soul, exerted a decisive influence on the prints of the Meiwa era (1764-1772). Not only the masters of the female figure, like Isoda Koryūsai, imitated his style, but those who specialized in actors' portraits, like Katsukawa Shunshō (1726-1792) and Ippitsusai Bunchō, also adopted his elegant mode of expression. It was not until after Harunobu's death in 1770 that these artists reverted to a more personal style. Koryūsai, like Kitao Shigemasa (1739-1820) and his disciples, then proceeded to give female figures a realistic expression quite devoid of poetic overtones. Seen against a neutral background, as in the early prints, they unaffectedly display the graceful curves of their body and the beauty of their costume. Katsukawa Shunshō also treats his portraits of actors with straightforward realism, thus breaking away from the conventional expression of the Torii school. (At the end of his life he painted beautiful women with unfailing finesse and discrimination in settings of everyday life.)

Another great artist, Torii Kiyonaga (1752-1815), whose style was shaped by the realism of the An-ei era (1772-1781), successfully created a new type of elegance. A pupil of Torii Kiyomitsu (1735-1785), he began his career about 1770 with portraits of actors. But he soon abandoned the tradition of the school to try his hand at female figures, following the example of his master Kiyomitsu. Kiyonaga freed himself in turn from the influences of Harunobu, Koryūsai and Shigemasa, and by the beginning of the Temmei era (1781-1789) he was in possession of a personal style, to which he remained faithful until his death in 1815. His illustrations of fine ladies with beautifully proportioned figures and gentle features, usually before a landscape (sometimes a famous site in Edo) or in an elegant interior, strike a happy mean between realism and idealism. But while the setting is always imbued with the poetry of a particular season, the reality of their presence is never weakened by the lyrical atmosphere or the pictorial design of the whole. Thanks to the technical progress made by this time, his works are remarkable for their bright and harmonious coloring. One cannot help feeling that the equilibrium and serenity of this art may well be a reflection of the character and the smooth, untroubled career of the artist, who, born into a family of booksellers, became in time the head of the school of the Torii family (1785). Or should we rather see in his art an echo of the sobriety and common sense of the bourgeoisie of Edo in the Temmei era? A highly skilled designer. Kiyonaga was not content with the limited format of nishiki-e (usually about 15 inches by 10). He was the first to conceive the ingenious idea of assembling several sheets either horizontally or vertically, thus obtaining a large composition, each part of which, taken separately, was independent and sufficient unto itself (tsuzuki-mono).

The beauty of the female form, raised to a "classical" perfection by Kiyonaga, found a fresh interpretation in the art of Kitagawa Utamaro (1753-1806). His talent was discovered by an intelligent publisher, Tsuta-ya Jūzaburō (known to art lovers by his emblem, an ivy leaf—tsuta—surmounted by Mount Fuji), who established him as Kiyonaga's rival. His early works of the Temmei era, skillful compositions of girls grouped in picturesque settings, followed the way opened up by Kiyonaga. But about 1790 Utamaro created a style of his own with his "large-faced" prints in close-up ($\bar{o}kubi-e$). This innovation, enabling him to focus expression wholly on bust and face, ensured his success. Tireless interpreter of feminine charm, he took as his models not only the ladies of what Edmond de Goncourt called the "green houses," but all types of womanhood of different ages and social classes. So much has been said and written about this master physiognomist and psychologist that we can most fittingly pay homage to him here by reproducing one of his most fascinating and accomplished works.

In the series of *Love Poems (Kasen-koi-no-bu)* Utamaro interpreted the different aspects and changing moods of love (melancholy, unavowed, disclosed, etc.), according to the time-honored classification of the classical anthologies; and each shade of feeling is reflected on the faces of these young wives. In "Melancholy Love" (mono-omou-koi) the profile of a woman wrapped in her thoughts stands out against the yellow background symbolizing the glow of the oil lamp. Tender colors—gray, mauve, bright yellow—evoke the secret charm of tender thoughts, while the dab of red on lips and sleeves hints at hidden passions whose chagrin peeps out, moreover, through the half-closed eyes. Without any literary allusions or lyrical setting, the whole psychology of love is conveyed by purely pictorial means.

We may note a technical refinement of which Utamaro took advantage with a good deal of skill. Already in Harunobu's time the new technique of *nishiki-e* called for the use of high-quality paper capable of withstanding several successive impressions. $H\bar{o}sho$ paper, thick and immaculately white, provided the solution, and its soft, spongy texture added a new element of beauty to the print. To represent any white object, linen or snow for example, it was enough to print the outlines without any color (*kara-oshi*, uninked impression). Utamaro explored every possibility afforded by the "tactile" quality of the paper's texture. Sometimes, in defiance of the Japanese tradition of draftsmanship, he even dispensed with the contour lines, first of the face, then of the body, and built up the form with color alone.

But Utamaro's brilliant style, of which the artist himself was so proud, even to the point of arrogance, failed to overshadow the work of his contemporaries, as had been the case with Harunobu. Kiyonaga, who survived him by nearly ten years, went on working with undiminished success and extended his field of activity to the world of actors portrayed in their everyday pursuits. Hosoda or Chōbun-sai Eishi (1756-1815), owing perhaps to his military origin, gave an expression of noble distinction to his beautiful women with their slender figures and elongated faces. Utagawa Toyokuni I (1769-1825) began his career as a designer of actors' portraits and female figures. It was his host of disciples, moreover, who throughout the nineteenth century perpetuated the traditional prints of beautiful women, but the heights attained in the art form in the late eighteenth century were never again equaled.

It would be unjust to leave the eighteenth century without some mention of another great artist, Tōshūsai Sharaku, a superlative portrayer of actors and a man whose life is shrouded in mystery. It has already been said that the chief sources of inspiration of *ukiyo-e* were the Kabuki theater and the gay quarter of Yoshiwara. Portraits of famous actors in each of their new roles were much sought after by the theater-goers of Edo and indeed of all Japan. Katsukawa Shunshō and his disciples introduced a personal note into

Kitagawa Utamaro (1753-1806): Melancholy Love (mono-omou-koi). Color print from the "Love Poems" series. $(14\frac{1}{4} \times 9\frac{1}{2}")$ Shibui Kiyoshi Collection, Tokyo.

Tōshūsai Sharaku (eighteenth century): Portrait of the Actor Ichikawa Ebizō. 1794. Color print. $(14\% \times 9\%)$ National Museum, Tokyo.

their prints by laying a maximum of emphasis on graceful gestures and attractive faces. But one group of portraits lies conspicuously outside this tradition: all of them bear the signature of Tōshūsai Sharaku and the mark of the publisher Tsuta-ya Jūzaburō. Ever since attention was focused on Sharaku's genius by European critics, Dr Kurth among others, some hundred and forty prints have been attributed to him, and their dating carefully worked out on the basis of the actors' names or emblems (inscribed on the prints) and their roles. This chronological study results, however, in an astonishing conclusion: Sharaku would seem to have published his first works immediately after the theatrical season of May 1794 and to have abandoned art altogether at the beginning of the following year. His career as an artist, then, seems to have lasted about ten months, and to this enigma is added the mystery that surrounds his life. According to a book (Shin-ukiyoe-ruikō) published in 1869, he was a Nō actor under the name of Saitō Jūrōbei, and was patronized by the lord of Awa; but this legend is unsupported by any proof.

In any case, the first published set of Sharaku's prints consists of twenty-eight portraits in close-up of famous actors playing in the three theaters of Edo in May 1794. Their heads and upper bodies stand out against a dark, silvery gray background (of powdered black mica); their faces and gestures, characteristic of their personality and role, are unforgettable. Take, for example, the portrait of Ichikawa Ebizō in the role of Takemura Sadanoshin at the Kawarasaki-za theater. The striking features of the veteran actor are recorded with astonishingly acute powers of observation: the semicircular eyes heavily made up, the long hooked nose, the broad slit of the mouth, the clenched hands. The straightforward contrast of the three colors further emphasizes the power and boldness of the expression. All the portraits of this series (some of them coupled two by two, the contrast between them throwing the salient features of each into relief) are handled with the same vigor, the same relentless exaggeration, diametrically opposed to the grace, refinement or showiness to which the ukiyo-e owed their beauty. The second set of Sharaku's prints refers to the July performances. This time all the actors are shown full length in arresting attitudes. In the next two sets, however (of November 1794 and February 1795), the scope of the composition tends to broaden still further and includes the stage—except for ten or twelve busts, less impressive than those of the first set—while facial expressions are appreciably less bold. Here, then, we find the artist moving progressively back from his subject; beginning with close-ups of heads, he went on to full-length portraits and ended with "long shots" of actors on stage amid the sets. This receding viewpoint is curiously contrary to the main evolution of Japanese genre painting, which had developed from the general to the particular, from overall views to details. This change of approach and the artistic deterioration that ensued have often been explained as follows: the bold expression of the first set of prints, though encouraged by his publisher, must have offended the public, which preferred to have its favorite actors idealized. Sharaku accordingly attenuated the violence of facial expressions, while stepping back from the subject and attempting to convey something of the same effect in the gestures of his figures. This ill-fated artist then disappeared from the art world, leaving behind him a whole series of virtually unrecognized masterpieces.

Katsushika Hokusai (1760-1849): Mount Fuji in Fine Weather (Gaifū-kaisei), called the "Red Fuji., About 1825. Color print. (10¼×135¼″) Sekai-kyūsei-kyō Collection, Atami Museum, Shizuoka-ken.

With fashionable beauties and actors' portraits as its staple themes, the Japanese print reached its height in the late eighteenth century. But it had not yet said its last word. It was still to achieve great things in another field, that of landscape. Leaving the pleasure haunts and the Kabuki theater which had hitherto been their sources of inspiration, and to which their art owes its name of *ukiyo-e* (painting of the "floating world"), the print designers turned now to a more stable world common to all men.

The pioneer of this new venture was Katsushika Hokusai (1760-1849), the *fou de peinture* to whom Edmond de Goncourt paid homage so movingly. "I was born at the age of fifty," he liked to say, alluding to the long artistic pilgrimage that prepared the way for the flowering of his art at the end of the eighteenth century. Born on the eastern outskirts of Edo, in what was then still a countrified part of the city, he never lost the "peasant spirit of the Katsushika district"; not for him the genteel manners of Edo's

bourgeoisie. After trying several handicrafts, he entered the studio of Katsukawa Shunshō in 1778 and worked there for fifteen years on actors' portraits and illustrations for serial stories, under the name of Shunrō. On the death of his master in 1792, he left the studio owing to a conflict with his colleague Shunkō. It was then that, with indomitable perseverance, he set himself to study the techniques of the Kanō, the Shumiyoshi (a derivative of the classical Tosa school), and the Sōtatsu-Kōrin schools (adopting the name Tawara-ya Sōri in his enthusiasm for the latter), and even Dutch engravings! This encounter with Western art was to play a key part in the formation of his style.

Despite the strict policy of isolationism maintained by the Tokugawa government, Dutch traders were granted permission to communicate with Japan through a single port, Nagasaki (though their privileges were limited to a small concession on the artificial islet of Dejima). Through this loophole on the West, following the adoption in 1720 of a more tolerant policy by the eighth Shōgun Yoshimune, a few Dutch books on scientific subjects, illustrated with engravings, filtered into Japan. The technique of these copper engravings, and above all the rules of perspective they embodied, did not fail to exert a certain influence on Japanese painters of the period, on Maruyama \bar{O} kyo, for example (who will be dealt with in the next chapter). Print designers working in the *urushi-e* style (roughly between 1716 and 1736) had already made some rather naïve and clumsy attempts at perspective landscapes called *uki-e* (painting in depth). Utagawa Toyoharu (1735-1814), founder of the powerful Utagawa school, reverted to this "trompe-l'œil" technique, but in a more refined style, and used it to represent famous sites in Edo and even to produce a view of Venice!

But starting out from these elementary landscapes and from the settings used by Harunobu and Kiyonaga for their fashionable beauties, how did Hokusai achieve so original an expression of nature? The opinion of the late Kondō Ichitarō, a leading specialist in *ukiyo-e*, carries most weight and may be summed up as follows. Hokusai—to use the pseudonym finally chosen by the artist in 1798 after a long string of other names began by publishing a set of pure landscapes in the Western style inspired by Dutch engravings. These views of Edo and maritime scenes of the surrounding region, with Japanese inscriptions in syllabic characters imitating the Latin alphabet, are seen in exaggerated perspectives and chiaroscuro which form a curious contrast with the linear expression of the figures. Hokusai here adopted for the first time a single, very low viewpoint, utterly foreign to the Japanese tradition. And it was these two principles which enabled him to create his masterpieces, among others his famous views of Mount Fuji. This unexpected meeting of East and West was to have further repercussions half a century later when Hokusai's prints were discovered and studied by artists in Paris.

Hokusai then produced several sets of views of the Tōkaidō (from 1804 on) and famous spots in Edo. In 1814 began the publication of the famous *Hokusai Manga*, a kind of picture encyclopedia in which he incorporated his whole repertory of drawings, the fruit of a lifetime's experience. (Thirteen books appeared during his life, and two more after his death.) Finally he published the first Mount Fuji series (from about 1825 to 1831) which, in spite of its title (*Thirty-six Views*), actually includes forty-six scenes. Departing

from the Japanese tradition, he generally adopted a low angle of vision, which enabled him to achieve picturesque and impressive effects-Mount Fuji, for example, seen in the distance beyond a huge wave. At the same time a few human figures serve to enliven his landscapes. Here, nevertheless, we have chosen to reproduce the wonderful "Red Fuji," untroubled by any sign of human life. "The south wind brings fine weather" (Gaifūkaisei), reads the inscription on the upper left, and thus we have a view, almost a vision, of the sacred mountain standing out against a blue sky streaked with wispy, fair-weather clouds. I know, for having admired it so many times myself, that when the rays of the sun strike Mount Fuji at the dawn of a summer's day, the upper part of the cone, covered with volcanic ash, kindles to a blood-red glow which the dark green of the virgin forest on the slopes only serves to emphasize. Hokusai's coloring is therefore quite authentic, but in the telling simplification of his design the artist departs from reality, the better to convey the grandeur of the great volcano within the limits of this small print. The "Red Fuji" of Hokusai comes like an echo of the charming background landscapes of medieval scroll paintings; of the independent landscapes of Sesshū, sturdily built up with powerful brushstrokes; of the decorative scenery of Sotatsu, composed of colored planes; and indeed it conjures up in the mind's eye the whole glorious past of Japanese painting. After a lifetime of passionate research and unswerving devotion to his art, can he really be said to have found the sincerest expression of his "impression?"

Encouraged by the favorable reception of his prints (the Red Fuji, the Stormy Fuji with a Thunderbolt, and the Fuji seen beyond a Wave all belong to the first period of this series), Hokusai finished this mighty group of works in 1831 and, though now over seventy, embarked on a new series even more grandiose, the *Hundred Views of Mount Fuji*, published from 1834. It was then that his supremacy was challenged by the unexpected success of a young rival: Andō or Ichiyū-sai Hiroshige (1797-1858), who aroused general enthusiasm in 1833 with the publication of his *Tōkaidō-gojū-santsugi* (Fifty-three Stages of the Tōkaidō Highway, a scenic route connecting the two capitals, Edo and Kyōto).

Hiroshige differed from Hokusai both in his temperament and his way of life. Son of the chief of a fire brigade, belonging to a well-to-do military family of the lower rank, he began as an amateur painter and, after abandoning his father's profession, entered the studio of Utagawa Toyohiro (1773-1828), an artist who was less famous than Toyokuni, but whose bland and dispassionate style was better suited to his temperament. He tried his hand at the different types of print in vogue in the early nineteenth century: historical scenes, actors' portraits, and beautiful girls. After his master's death he turned to landscape, taking inspiration from Hokusai's views of Mount Fuji, and to bird and flower compositions. His first set of ten prints, *Famous Sites of the Eastern Capital* (*Toto-meisho*), published in 1831 or 1832, at once revealed his gifts and the qualities of his design, despite the strong influence of Hokusai. Then in August 1832 he took the opportunity of accompanying an official messenger of the Shōgun dispatched to the imperial court at Kyōto. He made the journey there and back by way of the great Tōkaidō highway, executing countless sketches of the landscape scenery and relay

stations (*shukuba*) along the road. The experience thus gained helped him to work out a style of his own, and with the *Fifty-three Stages of the Tokaido*, issued in the following year by the publisher Hoei-do, he gave the full measure of his genius.

Contrary to Hokusai's spirited style, Hiroshige steeped nature in a subdued atmosphere of gentle poetry conveyed in terms of delicate strokes and harmonious color schemes—an all-pervading mildness and lyricism better suited to the taste of the public. His vision of nature is always bound up with man and charged with a poetic appeal. A perfect example of Hiroshige's pictorial and poetic genius is the well-known scene of Shōno which, by courtesy of the National Museum, Tokyo, we were able to photograph from one of the best of the original prints, until recently still in the possession of the artist's family. The slanting, criss-crossing lines of the hillside, the roofs, the swaying bamboo and the pelting rain convey the movement and bustle brought on by the shower, as people run for shelter, and convey it without impairing the balance and harmony of the

Illustration page 178

Andō or Ichiyū-sai Hiroshige (1797-1858): Landscape at Shōno, from the Fifty-three Stages of the Tōkaidō Highway (Tōkaidō-gojū-santsugi). 1833. Color print. (8%×13%") National Museum, Tokyo.

Illustration page 178

composition. The figures, drawn straight from life, reveal the sureness of his draftsmanship; but, a great colorist as well, he successfully unifies the whole scene by means of a prevailing darkness of tone evoking the sadness of a rainy day in the country. One of the most striking things about the work is the effect produced by the clumps of bamboo silhouetted against the sky. Much of the beauty of Hiroshige's art springs from his sensitive response to variations of weather and the changing seasons, and this feeling for nature links his work with the lyrical landscapes of the *yamato-e* of the Heian period.

The fame Hiroshige enjoyed proved to be more lasting and widespread than that of Hokusai, and it encouraged him to go on publishing landscapes and bird and flower compositions in successive sets until his death. By the time he had composed forty different sets of views of the Tōkaidō highway, his inspiration had, not unnaturally, begun to fail him. But the full refinement and depth of his sense of poetry and form are apparent in the Kiso-kaidō series (the great highway running east and west through the central mountains of Honshū), dating to about 1837-1842, and in the large composition with three landscapes, published toward the end of his life (in 1857) and featuring the three essential elements of Japanese scenery: snow, flowers and the moon. As for Hokusai, though fallen on evil days, he went on working in proud solitude, indulging in a mannered style increasingly marked as he grew older. With the freshness of his vision gradually clouded by care, he reached the end of his tragic life in 1849, dying at the age of ninety. On his death bed he said, "If Heaven had given me but ten years more, I should have become a true painter."

The long domination of the Tokugawa was drawing to a close. The feudal regime was now unable to cope with the problems facing it: economic difficulties, the movement for the restoration of the imperial power, and pressure from abroad for the opening up of the country to the West. The prevailing uncertainty of the times led the people at large, and the inhabitants of Edo above all, to seek relief in the pleasures and excitements of the moment. Mirrors of this "floating world," the *ukiyo-e* prints of courtesans and actors faithfully reflect this state of mind. Despite the efforts of Utagawa Kunisada (1786-1864) and Utagawa Kuniyoshi (1797-1861), the best pupils of Toyokuni I, and the efforts too of Kikukawa Eisen (1790-1848), influenced in his art and eccentric way of life by Hokusai, the Japanese print now lost the spacious design and grace of the eighteenth century and lapsed into sensual expression. Being issued in increasingly large editions, it suffered a fatal decline both in workmanship and in the quality of the materials employed. The vivid colors, red and blue especially, which had been so impressive in the great landscapes of Hokusai and Hiroshige, become showy and crude in the later prints of pretty girls and actors.

The Japanese print reached the end of its cycle of development in the mid-nineteenth century, just as it was beginning to arouse the interest of artists and art lovers on the other side of the world, in France in particular. This is not the place to study the delicate problem of the "influence" exerted by Japanese prints on Western art, notably on the Impressionists. It is interesting to observe, however, that the "marvels" from the land of the Rising Sun which fired the enthusiasm of Manet, Monet, Degas, Whistler, Gauguin,

Van Gogh, and so many others, were actually but debased, third-rate works of the nineteenth century. This is quite clear not only from the Japanese prints that figure in pictures by these artists (for example, in Manet's Portrait of Emile Zola and Van Gogh's *Père Tanguy*), but also from the many prints in Van Gogh's own collection bequeathed to the Musée Guimet, Paris, by the family of Dr Gachet. Recently published records preserved in the National Library, Tokyo, are equally enlightening in this respect. These are the official archives relating to one hundred prints ordered by the shogunal government for exhibition at the Paris World's Fair of 1867. Fifty of these prints, divided into two albums, consisted of female figures representing different occupations and intended to illustrate Japanese life; the other fifty were landscapes, for the most part views of Edo. The artists who shared this official commission numbered among the leading print designers of the day, but they all belonged to the last generation of *ukiyo-e* (Hōen, Kuniteru, Sadahide, Hiroshige III, Kunisada II, etc.). Sold off after the exhibition, these prints contributed powerfully to the first wave of "*japonisme*" that swept over the Paris art world. Such was the "Japanese revelation," as it has been called, and one cannot help marveling that French artists should have been able to draw so important and fruitful a lesson from prints which strike us today as banal and decadent. How could they grasp the whole esthetic of *ukiyo-e* from the mannerism of this art? How could they divine the message of the great masters of the eighteenth century through the works of these minor artists? (As a matter of fact, it was not until the Paris World's Fair of 1889) that they discovered the seductive grace of Utamaro, and much later still before they became acquainted with the idyllic beauty of Harunobu and the dynamic design of the "primitives.") So once again it was the decadent mannerism of a country's art that made it known and influential abroad.

10

In the previous chapters we have studied two developments—the Sōtatsu-Kōrin school and the *ukiyo-e* or popular school—which ranked low in the official hierarchy of art forms but which were actually of the highest interest and importance. This chapter will be devoted to the other trends of Japanese painting in this late phase, particularly in the flourishing period of the eighteenth century.

The official academy of the Shōgunate and the feudal nobility was still constituted by the Kanō school. Four dynasties of painters (known as Kajibashi, Kobikichō, Nakabashi and Hamachō, from the different quarters of Edo in which they lived), the direct successors of Tannyū and his brothers, had controlled the leading studios (oku-eshi) sponsored by the shogunal family. Other Kanō families, descendants or disciples of these dynasties, furnished painters to the official academy (omote-eshi) from generation to generation. Still others worked for the military classes. And it was to the Kanōs again, from father to son, that local rulers looked to take charge of their own academies.

What had been established was nothing less than a monopoly. Artists under this system were virtually regimented: they could neither change their style nor seek to improve their technique, but went on for three centuries tirelessly imitating the models established by their ancestors (by Tannyū above all) for the interior decoration of palaces and the conventional pictures required for official use; they were also called upon to appraise ancient works. Their only merit lay in faithfully transmitting the traditional technique of painting to the masters of the late nineteenth century who, on the basis thus provided, were able to renew Japanese art. Moreover, several literati painters of this school (for example Kanō Einō, Sanraku's grandson, the Japanese Vasari) have left us not only valuable historical and biographical works, but also many copies of ancient works now lost.

From the artistic point of view, only a few "rebels" among this host of academics are of interest to us today. One of Tannyū's best pupils, Kusumi Morikage, carried his master's researches even further and, enlarging on the sharp and rigid linework of Sesshū, developed a linear freedom of design characteristic of his style. In addition to landscapes of Chinese inspiration, he painted a great many scenes of peasant life with a homely accent of intimacy. Tradition has it that Tannyū dismissed Morikage from his studio. Later another pupil of the Kanō school, Hanabusa Itchō (1652-1724)—his real name was Taga Shinkō, and his first pseudonym Chōko—painted scenes of daily life in a vein of expression peculiarly his own. Born at Ōsaka, he moved with his father to Edo and while still a boy entered the studio of Kanō Yasunobu, younger brother of Tannyū. But his independence in artistic matters made him anathema to the academic school. He steadily pursued his career on lines of his own and his art reflects the intellectual freedom and cultural refinement of the middle-class society of the Genroku era (1688-1704), from which Kōrin and Moronobu had also drawn their strength.

A friend of Bashō, who revived the *haikai*, and of other poets of his school, like Kikaku, Itchō gave his scenes a refined, often satirical tone. But his independence of mind got him into trouble with the authorities and he was exiled in 1698 to the small island of Miyake-shima, where he spent twelve years. After his return to Edo his art grew increasingly subtle and several collectors began patronizing him. It was now that he assumed the pseudonym Itchō and founded a school of his own, called the Hanabusa school. The small picture reproduced here bears the signature of his early period. A young peasant is seen leading his horse across a river in the morning mist. The movements of boy and animal are vividly recorded in deft and telling strokes, while a few lightly shaded touches of ink suffice to evoke the bridge, a willow tree on the bank, and faint gleams on the water as the sun rises over the mist. His vision of daily life is conveyed in a somewhat sophisticated style, more refined than that of the early *ukiyo-e* painters.

In the course of the eighteenth century, an age in Japan of economic prosperity and cultured humanism, some new trends of painting emerged, notably the realist movement of the Maruyama-Shijō school and the idealism of the literati painters (bunjinga). One would expect two such trends to stand opposed to each other, but this was not the case; both were affected by foreign influences and had many points of contact.

The first exponent of "realism" was Maruyama Ōkyo (1733-1795). He seems to have been a native of a village in the province of Tanba. At the age of seventeen he entered the studio of Ishida Yūtei (1721-1786), a painter of the Kanō school of Kyōto, where he acquired great proficiency in the handling of the brush. By a mere chance his eyes were opened to a new esthetic, or better, a new "way of seeing"-that of Western art. Something has already been said of the increasing interest felt in everything Western during the first half of the eighteenth century. A peep show, imported by a curio dealer of Kyōto, caught the fancy of the public, who were surprised and intrigued by unfamiliar landscapes painted in perspective and chiaroscuro, and optically magnified to the point of seeming real. The young Okyo must have taken a keen interest in this device, for the dealer commissioned him to enlarge the repertory of these imported pictures by making copies, in accordance with the same principles, of the European landscapes and adding landscape views of Japan. These "peep-show pictures" (megane-e), painted by Okyo about 1760, were a great success and a considerable number of them are still extant. Resolutely departing from the conventional designs of the Kano school, Okyo profited by the experience thus gained and went on to apply the principle of perspective, and to embody other realistic elements, in a scroll painted in 1765, consisting of a series of landscapes

Hanabusa Itchō (1652-1724): Peasant leading his Horse across a River. Before 1698. Hanging scroll, colors on silk. (1174×19¾") Seikadō Foundation, Tokyo.

along the banks of the river Yodo between Kyōto and Ōsaka. He made a point of basing his style on the direct study of nature. However, this concern for realism, or better, for naturalism, was carried only to a certain point and no further. The real forms of objects were carefully conveyed by means of subtle drawing and nuances of ink and colors, which produced a striking effect of chiaroscuro. But to render space tangibly and convincingly in terms of depth and volume following the rules of Western art—this was a conception utterly foreign to the Japanese painters of the eighteenth century and they maintained the tradition of open, unlimited space peculiar to the art of the Far East.

Another factor played its part in shaping the "realistic" style of Okyo. This was the renewed influence of Chinese painting penetrating into Japan by way of Nagasaki. Located in the extreme southwest of the Japanese archipelago, this seaport was the country's sole point of contact with the outside world. Through Nagasaki, from the seventeenth century on, works of both Chinese and Western painting filtered into Japan. A new Zen sect called Ōbaku (Huang-po) had been introduced by the Chinese colony of Nagasaki and propagated as far as Kyōto by the Chinese monk Itsunen (I-jan) who came to Japan in 1644. Portraits of the patriarchs of the Obaku sect were painted in a curious style remarkable for the thoroughgoing realism of facial features. Local Japanese painters like Kita Genki followed these models, adding to them, it would seem, reminiscences of Western works brought to Japan by the Christian missionaries. The influence of Itsunen, himself an amateur painter, was brought to bear on the official painters known as the Nagasaki school, whose works are characterized by a realistic, minutely detailed representation of objects. The arrival of Chinese artists in Nagasaki further speeded up the diffusion of Ming and Ch'ing painting. Along with the idealistic style (noticeable chiefly in the landscapes of the literati painters, to be dealt with presently), the realism of the bird and flower painters of the Ming period, both academics and independents, was introduced in a style already somewhat eclectic by Shên Nan-p'in (or Shên Ch'üan), who worked in Nagasaki from 1731 to 1733. The Japanese liked his detailed compositions with their meticulous brushwork and showy colors, and he soon had a number of imitators, for example Kumashiro Shukko, known as Yūhi (1712-1772). This style, moreover, spread to the Kyōto-Ōsaka region thanks to the painter-monk Kakutei, and even to Edo itself with the school of Sō Shiseki (1712-1786). The realistic or naturalistic tradition of Chinese painting obviously counted for something in the formation of Okyo's style, even if we accept a later testimony, according to which he severely criticized one of Shên Nan-p'in's compositions for its inaccurate proportions.

Thanks to the generous patronage of the Prince-Abbot Yūjo, superior of the great Emman-in monastery, and to his own unremitting efforts, \bar{O} kyo achieved a fully developed style of his own based on the objective study of forms. Several notebooks and sketch scrolls dating from 1770 to 1776 (preserved in the National Museum, Tokyo, and in the Nishimura Collection) reveal the thoroughness and almost scientific precision with which he scrutinized plants and animals. There also exist some figure studies in which \bar{O} kyo began by drawing nude bodies which he then proceeded to "clothe" in different colors. The charm of his open-space pictures, composed of realistic elements, lies in their harmonious tones and the graded refinements of their ink brushwork. Easy to understand, involving neither metaphysical abstractions nor bold stylizations, they answered perfectly to the moderate, unpretentious tastes of the Kyōto and Ōsaka public; they dominated the painting of that region throughout the last quarter of the eighteenth century.

Ōkyo practised all forms of painting: landscapes, flower pieces, animal pictures and figure paintings, from small and dainty pictures to large-scale compositions. In addition to the works of his maturity preserved in the Emman-in (scroll of *Fortunes and Misfortunes*, the *Peacock*, etc.), he left a great many screen paintings intended for temples or well-to-do middle-class homes (for example, the *Dragons* in the Kanchi-in temple, the *Pine Trees in Snow* in the Mitsui Collection, and the *Hotsu River* in the Nishimura Collection, which was one of his last works). He also decorated the interior of many temples, like the Kongō-ji at Tanba, the Daijō-ji at Hyōgo, and the Kotohira-gū at Sanuki. The sheer abundance of his output and the technical mastery that remained unimpaired until his death, are undoubtedly the marks of a great talent. Nevertheless, during the thirty years of his career, his untiring quest of the essentials of objects as reflected in their outward features gradually lost its intensity and by slow degrees he reverted to a decorative and lyrical key, to technical refinements of color and design. Is this, after all, the inescapable destiny of a Japanese artist? Is there a limit beyond which the techniques and esthetic based on a foreign tradition cannot go when enlisted in the service of a thoroughly realistic representation of the world? In any case \bar{O} kyo's later works, especially his large compositions, are often so clear in design, so unsubstantial in content, as to seem trite and uninspired. The saving, life-giving feature of his masterpieces is certainly not the painstaking accuracy of their realism, but the skill and variety of the brushwork, ranging from delicately flickering touches to broad, sweeping strokes. The artist often makes use of background shadings to suggest forms.

Together with an evident technical mastery, the *Pine Tree in Snow* (1765), in the National Museum, Tokyo, has all the spontaneity of a youthful work. By a simple effect of ink brushstrokes on a background faintly heightened with gold, the white of the silk serves to represent snow on the tree and on the ground and conveys its full tactile quality, its lightness, softness and freshness. The pine needles are drawn with swift strokes of the brush, while shaded dabs of ink indicate the volume of branches and trunk. It may well be questioned whether the term "realism" is applicable to such a work, whose beauty lies above all in its lyrical and symbolic effect.

Ōkyo also excelled in flower and animal painting, and the wooden doors of the so-called Ōkyo Pavilion offer a good example of these charming works. In 1784 he decorated the inner partitions of this building, an annex of the Meigen-in temple at Aichi (it has now been moved to the park of the National Museum, Tokyo). On one of them figure two dogs, one white, the other brown, playing with blue morning glories. This work, exemplifying his powers of observation and his flawless draftsmanship, reveals the secret of this artist who, while catering for a wide public, maintained a high level of achievement.

The lyricism that lent its elusive charm to Ōkyo's best works softened the impact of reality and grew still more marked in the art of Goshun (1752-1811), founder of the Shijō school. Under his first name of Matsumura Gekkei, he also wrote poetry and, having studied the technique of the *haikai* under Yosa Buson (1716-1783), the master of literati painting, it was naturally in the style of Buson that he began to paint. A meeting with Ōkyo in 1788 acquainted him with the realistic representation of nature, which he subsequently worked out in accordance with his own temperament. His landscape style, fully mastered by about 1800, reflects a sensitive artist's response to the gentle, intimately poetic beauty of the countryside around Kyōto and Ōsaka.

The landscape depicted on a pair of screen paintings in the National Museum, Tokyo, is typical of Goshun. All the picture elements, hills, stream, rocks, trees and thatched roofs, drawn in the naturalistic manner of Ōkyo, fade into the distance in a rainy atmosphere which effectively creates depth. Thanks also to the refined, delicately brushed works of his brother Matsumura Keibun, the school of Goshun met with a favorable reception in western Japan and supplanted the school of Maruyama Ōkyo after the latter's death. This skillful technique and poetic sense of intimacy have remained the distinctive feature of the style of Kyōto painters until recent years.

Illustration page 186

Illustration page 187

Maruyama Ōkyo (1733-1795): Pine Tree in Snow. 1765. Hanging scroll, ink and gold on silk. $(48\frac{1}{2} \times 28\frac{1}{4}'')$ National Museum, Tokyo.

Ōkyo and the painters of his school were not the only exponents of realism. Several other independent artists created a style reflecting in varying degrees the positive outlook of the period, among them the animal painters Mori Sosen (1749-1821), known even outside Japan for his pictures of monkeys, and Ganku (Kishi Ku, 1756-1838), noted for his vigorous style. In all these men we find doctrines of the Kanō school combined with the lessons of Ōkyo and the influence of Shên Nan-p'in.

The art of Itō Jakuchū (1716-1800), who preceded Ōkyo as a realistic painter, calls for special mention. Born in Kyōto of a well-to-do family of grocers, he was able to devote himself exclusively to painting, being quite free of both economic and artistic trammels. At the Sōkoku-ji monastery, where he was a welcome visitor, he had the opportunity of studying a number of bird and flower compositions of the Sung and even the Ming period, and their realism must have impressed an artist like him, dissatisfied as he was with the conventional style of the Kanō school. Jakuchū is known to have lived in a large house in Nishiki Street, the market district of Kyōto, and this picturesque part of the city no

Goshun (Matsumura Gekkei, 1752-1811): Landscape in the Rain, detail of a screen painting. Ink and colors on paper. (Entire screen 49⁵/₈×150") National Museum, Tokyo.

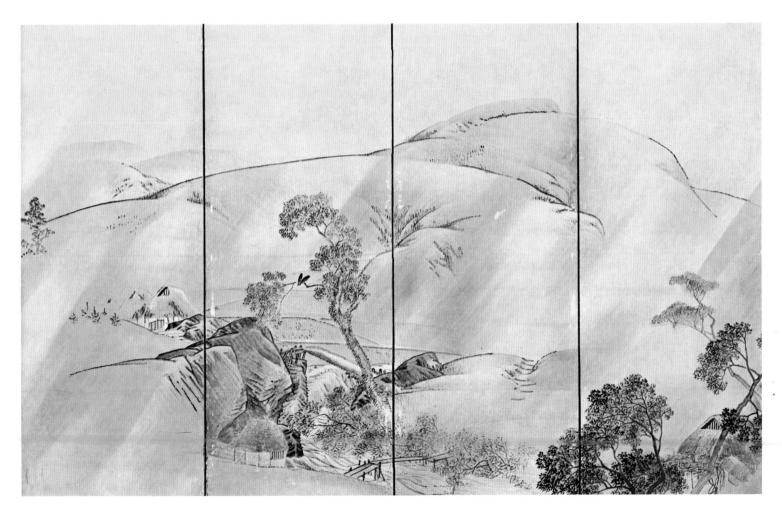

Illustration page 189

doubt stimulated and developed his taste for real, palpable objects, as did the animals and birds he raised in his park—among them a peacock and a parrot, then very rare in Japan, and various kinds of cocks. So he had before his eyes a pageant of nature sufficiently rich for him to dispense with anecdotes and poetic themes. "Many are the painters who paint," he said, "but rare are those who represent living beings." Here was a bolder assertion than those made by Okyo. From 1758 to 1770 he executed thirty large pictures of flowers, birds and fish, a pictorial essay in natural history, which he presented to the Sōkoku-ji (the complete set is now in the Imperial Collections). The great fire that ravaged Kyōto in 1788 cost him his house and his fortune; he thereupon retired to a monastery where he pursued his career in peaceful seclusion, aloof from the professional painters. The Cocks and Cactus on the sliding doors of the Saifuku-ji, north of Ōsaka, is the fruit of his long researches. An acute observer, he succeeded, by means of an exaggerated stylization, in giving these animals an expression of intense vigor and even majesty. The contrast of vivid colors is emphasized by a huge cactus, a token of his curiosity about exotic plants. The realism of Jakuchū thus resulted in expressionism. and this trend of his art-very unusual in Japan-accounts for the renewed interest now being taken in this artist, who cuts an isolated figure in the history of Japanese painting.

The movement of bunjin-ga (literati painting, called in Chinese wen-jen-hua), which has been mentioned in passing, also contributed to the enrichment of Japanese painting in the eighteenth century. Originally the term wen-jen-hua did not designate a specific style. In China the work of the professional and academic painters was often overshadowed by that of non-professional painters, of scholars and literary men in particular, owing to their creative power and freedom of expression, and this in spite of a great diversity of trends, for this art was essentially individualistic. By the end of the Yüan period, however, the literati painters, especially the "Four Great Masters" (Huang Kung-wang, Ni Tsan, Wu Chen and Wang Meng), had evolved a new style of landscape painting, fairly close to that of the early Sung period. Taking their stand on their own experience of nature, these painters broke away from the rigid design and overemphatic expression which characterized the works of the academic painters of the Chê school. Mountains are modeled with fine, supple lines instead of rigid brushstrokes and washes of ink or color, and the landscapes embrace a broader, more panoramic vision than the "one corner" compositions adopted by Ma Yüan's successors. Theorists called this new style the "Southern School" (Nan-ga in Japanese, Nan-hua in Chinese), in contradistinction to the "Northern School," which designated the traditional academic style of landscape of the Sung and Yüan periods (the latter style was better known in Japan, where it was introduced during the fourteenth, fifteenth and sixteenth centuries). Scholars like Shên Chou became famous for their handling of this new technique, which finally came to dominate the painting of the late Ming period (seventeenth century). The theorist Tung Ch'i-ch'ang (1555-1636) and other writers on painting defended and vindicated "literati painting" (wen-jen-hua), which they referred to as the "Southern School" (Nan-hua), so that these two terms have remained closely linked and are employed in Japan almost interchangeably.

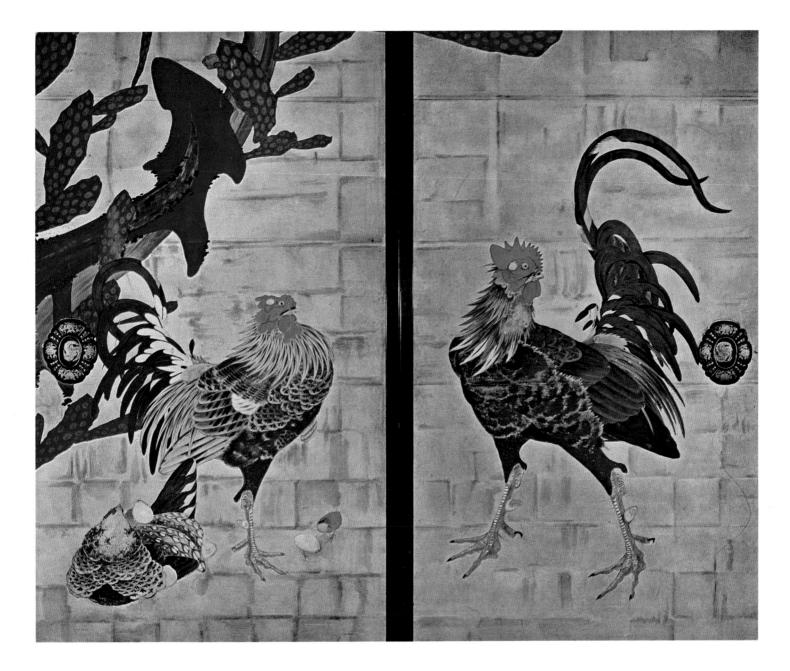

Itō Jakuchū (1716-1800): Cocks and Cactus, detail of a painting on sliding doors. Colors on gold paper. (Each panel 69½×36") Saifuku-ji, Ōsaka.

It was not until the early eighteenth century that literati painting (*bunjin-ga* or Nan-ga) was introduced into Japan, at a time when Japanese intellectuals were taking an eager interest in the outside world and studying the arts and sciences of China in a less conventional spirit than hitherto. An influx of technical and esthetic works opened their eyes to Chinese culture. After the *Eight Albums of Painting (Hasshu Gafu,* written in China about 1620, published in Japan in 1671), the famous encyclopedia of Nan-ga,

entitled Kaishi-en Gaden (Mustard Seed Garden, published in China in 1679) became a precious work of reference and a Japanese edition was issued in 1748. Meanwhile the arrival of Chinese painters in Nagasaki, of I Fu-chiu in particular (who came several times after 1720), contributed to the diffusion of this technique, which was adopted chiefly by amateur literati painters. The first adepts were Gion Nankai (1676-1751), Sakaki Hyakusen (1697-1752) and Yanagisawa Kien (known as Ryū Rikyō, 1704-1758), but their works are still close imitations of Chinese models, and it was not until the second half of the century that these were fully assimilated and a new vision of landscape emerged in the work of two artists: Ike-no-Taiga (1723-1776) and Yosa Buson (1716-1783).

Taiga, who learned to paint in the Tosa style (and while still a boy allegedly earned a livelihood by painting fans), discovered the literati style of landscape painting in a Chinese album. He learned the technique of this art from Yanagisawa Kien and in 1750 paid a visit to Gion Nankai, at Wakayama, who shared the fruit of his experience with him and presented him with an album illustrated by the Chinese master Hsiao Ch'ih-mu. The young artist traveled throughout Japan, studying nature and climbing several mountains, notably Mount Fuji. Other techniques appealed to him, that of the Sotatsu-Körin school and even that of Western painting. By about 1760 he was in full possession of his style, drawing the contours of mountains and trees with a free and supple linework all his own. Besides his landscapes in the Chinese manner, he painted a great many views (shinkei) of actual places in Japan, a practice that saved him from too close an imitation of continental pictures; and even when he represents Chinese figures, he has a highly original way of handling them. The pair of screen paintings on a gold ground in the National Museum, Tokyo, reveal the vigorous art of his maturity (c. 1760-1770). On one side, an elegant gathering of hermits around a pavilion; on the other, a vast river landscape stretching away at the foot of a mountain, with a boatful of scholars on their way to the meeting. The river bank, the distant mountain and the boats are drawn with the utmost simplicity in jet-black ink, while waves consist of clusters of more flexible lines heightened with touches of blue. Vivid colors, scattered here and there, stand out against the gold ground and reinforce the composition. Taiga's love of fancy and free invention is seen at its best in this imaginary landscape of Chinese inspiration.

The same constructive power reappears in a great many screens and sliding doors, in which the painter, disregarding the conventional rules of *Nan-ga*, resorts to a variety of techniques; to broad touches of light-tinted ink he adds *tachiste* effects by the juxta-position of dots of color. His works are often accompanied by an arrestingly expressive calligraphy. The untrammeled freedom of his style and his independent way of life made Taiga the central figure of a whole group of artists and amateurs who were alienated by the strictly professional attitude of \bar{O} kyo and his school.

It was also by means of the Nan-ga technique that Taiga's friend Yosa Buson succeeded in working out a style of his own. A gifted writer of haikai, he retrieved the Bashō school from the mannerism into which it had lapsed, and the picturesque and intimate images of his poems reflect the temperament and outlook of a painter. The two albums of $J\bar{u}ben J\bar{u}gi$ (Ten Advantages and Ten Pleasures of Country Life) in the Kawabata

Illustration page 191

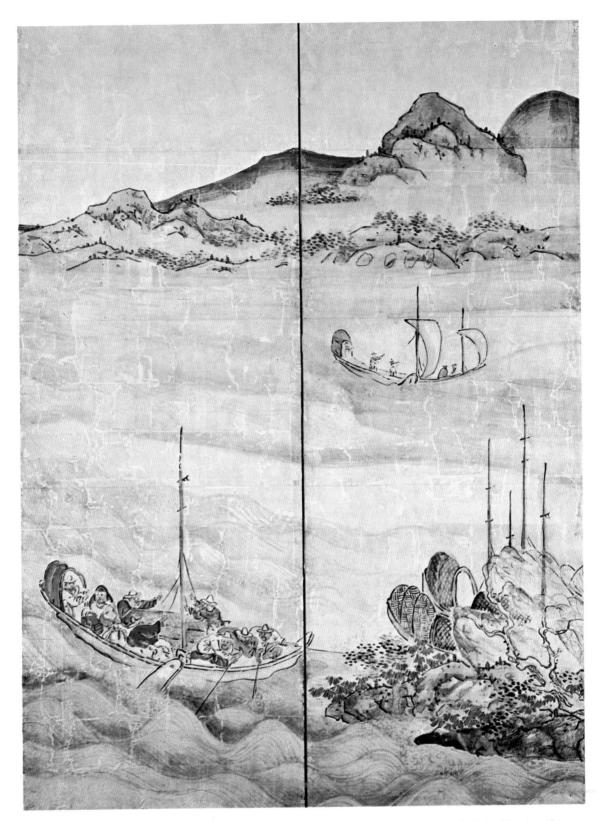

Ike-no-Taiga (1723-1776): Landscape in the Chinese Manner, detail of a screen painting. About 1760-1770. Colors on gold paper. (Entire screen 66¼×140″) National Museum, Tokyo.

Collection, jointly illustrated by Taiga and Buson, permit a most interesting comparison between the two masters. Buson's interpretation of the poems of the Chinese poet Li Yü, which supply the subject matter of these paintings, is highly ingenious; his brushwork is delicate and his vision clear and lyrical. To our thinking, however, he fails to achieve the creative energy that vitalizes the visual world of Taiga.

Buson also illustrated *haikai* poems and poetical accounts of travels with drawings remarkable for their freedom of expression, in which the poetic theme is enlivened with spirited and even humorous figures. These *haiga* (paintings illustrating *haikai*) were highly appreciated and imitated by his successors both in poetry and painting.

The Nan-ga movement soon spread throughout Japan. Among Taiga's disciples should be mentioned Noro Kaiseki (1747-1828) at Wakayama, Kuwayama Gyokushū (1746-1799), one of the best theorists of the school, and Satake Höhei (1750-1807) of Shinano province. From the eighteenth century on, each region gave birth to notable artists, among them Kushiro Unsen (1759-1811), Todoki Baigai (1749-1804), Hirose Taizan (1751-1813), Okada Beisanjin (1744-1820) and his son Hankō (1782-1846), Tanomura Chikuden (1777-1835), Nakabayashi Chikudō (1776-1853) and Yamamoto Baiitsu (1783-1856). The artistic contacts made in the course of their travels through Japan enabled each of these artists to work out a personal style answering to his own temperament. But mannerism was the great pitfall of the Nan-ga technique, which was always apt to become a too exclusively subjective vehicle of expression, lacking form and solid construction. The consciousness of their intellectual superiority and the pride they took in their Chinese culture often had the effect of making the literati painters excessively sophisticated. It should be noted, moreover, that those who practised the Nan-ga style in Japan were not always the scholarly men of leisure that the Chinese literati painters were; the latter belonged to the upper class, they were retired officials or members of powerful families who had withdrawn from public life for political reasons. Neither Taiga nor Buson had a personal fortune or even a small private income; both earned their living by painting, thanks to the patronage of rich merchants.

Among the Japanese literati painters, two other artists are outstanding for their originality and spirit of independence. The first is Uragami Gyokudō (1745-1820), a samurai in the service of the lord of Ikeda, in the province of Bizen. A fine musician (he played the *koto*, the Japanese harp), as well as a painter and calligrapher, he resigned his commission as an officer in 1794 to live and meditate on life after his own fancy. He spent the rest of his days as a philosophic wanderer, accompanied by his two sons and with no other baggage but his harp and his paint brushes. When inspiration was upon him, he drank *sake*, played the *koto*, and plied his brushes in the throes of artistic exaltation, committing to paper in nimble touches of ink and wash the landscapes glimpsed by the mind's eye. Despite their subjective character, his subtle observation of nature and sensitive response to it give his works a real and satisfying equilibrium; his landscapes are genuine states of mind. The second artist referred to above is Aoki Mokubei (1767-1833), a painter and potter, who produced simplified compositions of flowers and landscapes; his charm lies in his vivacity and the freshness of his colors.

The trend toward mannerism that threatened the Nan-ga style grew increasingly marked among the artists of Edo, whose painting was of a composite character. Tani Bunchō (1763-1840), the favorite painter of the military men of the Shōgunate, concentrated in Nan-ga the techniques of the Kanō, the Tosa, Nan-p'in and even Western painting. He painted an interesting series of realistic landscapes, drawn in perspective with scientific accuracy, which were ordered by a minister for the coastal defense of Tokyo Bay. Watanabe Kazan (1793-1841) executed not only conventional compositions, but also highly realistic portraits of his friends wholly in accordance with Western ideals. In our opinion, however, the fame he has enjoyed is largely due to his tragic life, which symbolized the misfortunes of this transitional period in Japanese history.

Japan was officially opened to the outside world in 1858; the restoration of the imperial power took place ten years later, and the reorganization of the country as a modern nation began. The events of the new Meiji era (1868-1912) changed the face of Japan at an almost bewildering rhythm during the second half of the nineteenth century. The impact of Western techniques and traditions, so very different from those of Japan, enriched and rejuvenated all forms of Japanese art which, many times in the past, had assimilated foreign influences to the benefit of its own modes of expression. The study of this new phase, however, in which traditional painting evolved toward the forms of contemporary art, lies outside the scope of this book.

In conclusion, it may be of interest to point out an essential element of present-day Japanese art. Since the late nineteenth century a great many painters have introduced and assimilated various aspects of modern Western art, and have done so with a rapidity and an eagerness equal to those of their ancestors. Another school has endeavored to modernize painting by following the traditional methods of the Japanese technique and esthetic. The existence of these two trends might have been expected to split contemporary painting in Japan into two opposite camps. Actually, however, the artists of the so-called "Western" school, even though they express themselves in the most advanced international style, are steeped in the long art traditions of their country (this is even true of the younger generation of abstract painters), while the artists of the "Japanese" school, which has successfully enriched the native sources of expression, at the same time continually renews itself through contact with the Western esthetic. So in spite of the conventional names of the two schools, the only essential difference between them is one of technique, or rather of the materials employed. Today, in the West, painters are seeking to break free of certain technical and esthetic limitations (those notably of the traditional media, like oil painting) and are looking to the art of the Far East. Differences tend to be effaced by this double rapprochement. Thus, after two thousand years of evolution, Japanese painting stands on the threshold of a new age of artistic creation, with two traditions only waiting to be united. It promises to become a vivid reflection of our century, of an age when East and West together are bringing forth a new art out of the fullness of their respective traditions.

Chronological Table

1	PREHISTORY	
Pre-Jōmon culture	100,000 B.C.	Paleolithic Mesolithic
Jōmon culture	7,000 B.C.	Neolithic Hunting and fishing
Yayoi culture	300 B.C.	Bronze Age Rice-growing
Engraved pottery Line reliefs on <i>dōtaku</i>	A.D. 100	Metal-working
	A.D. 200	
PROTOHISTORY: PER	IOD OF THE GRE	AT BURIAL MOUNDS
Decoration of burial mounds Terracotta statuettes <i>(haniwa)</i>	300	Relations with the Chinese dynasties
Wall paintings in funerary chambers		Unification of the country by the imperial family
	538	Official introduction of Buddhism
ASUKA PI	ERIOD (6th and 7th	centuries)
Influence of Chinese art of the Wei		
and Ch'i Foundation of the Hōryū-ji temple,	592-622 c. 607	Regency of Prince Shōtoku
Nara Tamamushi-no-zushi shrine	646	The Taika Reform
HAKU	HÖ PERIOD (7th c	entury)
Influence of Chinese painting of the		
early T'ang period Burning of the Hōryū-ji Wall paintings in the sanctuary of	670 c. 700	
the Hōryū-ji	710	Transfer of the capital to Heijō (Nara)

Influence of Chinese painting of the		
middle T'ang period		
Consecration of the Great Buddha	752	
of the Tōdai-ji, Nara		
Initial donation to the imperial col-	756	
lection of the Shōsō-in, Nara		
	794	Transfer of the capital to Heian (Kyōto)

HEIAN PERIOD (9th to 12th century)

EARLY HEIAN OR JOGAN PERIOD (9th century)

Influence of Chinese painting of the late T'ang period Introduction of esoteric painting Appearance of native themes in secular painting	805-806	Return from China of the monks Saichō and Kūkai
		Penetration of the esoteric sects of Buddhism
		Rise to power of the Fujiwara family
	894	Suspension of diplomatic relations with China

LATE HEIAN OR FUJIWARA PERIOD (10th to 12th century)

Consecration of the pagoda of the Daigo-ji temple	952	
Daigo-ji temple		Spread of the cult of Amida
Flowering of the aristocratic arts	966-1027	Regency of Fujiwara Michinaga
Construction of the Phoenix Hall of the Byōdō-in temple	1053	
"Nirvana" painting in the Kongōbu-ji	1086	
	1086-1129	Regency of the ex-emperor Shirakawa
	1167-1184	Political preponderance of the Taira family
The great age of scroll painting		5
	1184	Shogunal government set up at
		Kamakura
	1192	Appointment of Minamoto Yoritomo as commander-in-chief of the military establishment

KAMAKURA PERIOD (13th and 14th centuries)

	Founding of the Jodo sect
c. 1219	
1274 and 1281	Mongol invasions
	Penetration of Zen Buddhism
1299	
1309	
1334-1336	Short-lived restoration of the imperial
	power
1338	Restoration of the Shogunate by the Ashikaga family
	1274 and 1281 1299 1309 1334-1336

MUROMACHI OR ASHIKAGA PERIOD (14th to 16th century)

	1401 on	Official relations with the Ming dynasty of China	
Formation of the new style under Chinese influence, chiefly in monochrome painting Sesshū Tōyō (1420-1506)		Ōei civil war	
Founding of the Kanō school Kanō Motonobu (1476-1559)	1467-1477		
First contact with Western painting	1549	Arrival of St Francis Xavier in Japan	
	1568	Rise to power of Oda Nobunaga	
AZUCHI-MOM	OYAMA PERIOD (16th and	17th centuries)	
Construction of the castle of Azuchi	1576		
Kanō Eitoku (1543-1590) Hasegawa Tōhaku (1539-1610)	1582	Rise to power of Toyotomi Hideyoshi	
Kaiho Yūshō (1533-1615)	1603	Appointment of Tokugawa Ieyasu to the Shogunate	
Sōtatsu (active c. 1630)	1615	Fall of the Toyotomi family	
EDO OR TO	KUGAWA PERIOD (17th to	o 19th century)	
Vant Tanna (zfog zfra)			
Kanō Tannyū (1602-1674)	1637-1638	Revolt of Japanese Christians at Shimabara	
Rise of genre painting (ukiyo-e)	1639	Closing of Japan to foreigners	
Development of Japanese prints			
Hishikawa Moronobu (1618-1694)			
· Ogata Kōrin (1658-1716)	1680-1709	Reign of the Shogun Tsunayoshi (Genroku era)	
Introduction of literati painting Ike-no-Taiga (1723-1776) Uragami Gyokudō (1745-1820)	1720 on	Infiltration of Western culture	
Modern trends of painting Suzuki Harunobu (1725-1770) Maruyama Ōkyo (1733-1795) Kitagawa Utamaro (1753-1806)			
Katsushika Hokusai (1760-1849)	1853	Arrival of Commodore Perry at Uraga	
	1868	The Meiji Reform	
	MEIJI PERIOD (1868-1912)		
Influence of Western painting		Modernization of Japan and fruitful contacts with the outside world	
Т	AISHŌ PERIOD (1912-1926	o)	

SHŌWA PERIOD (since 1926)

JAPAN

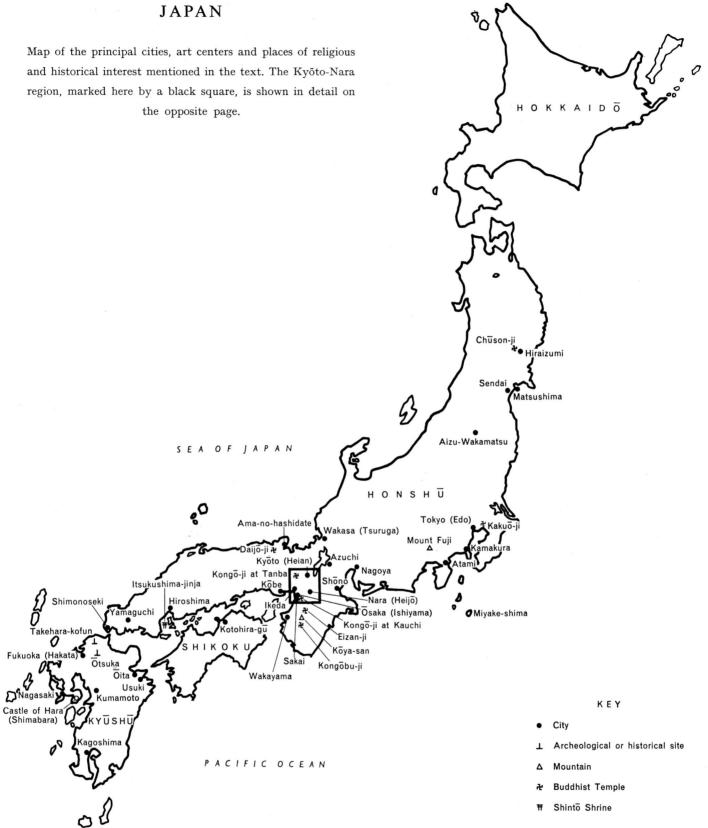

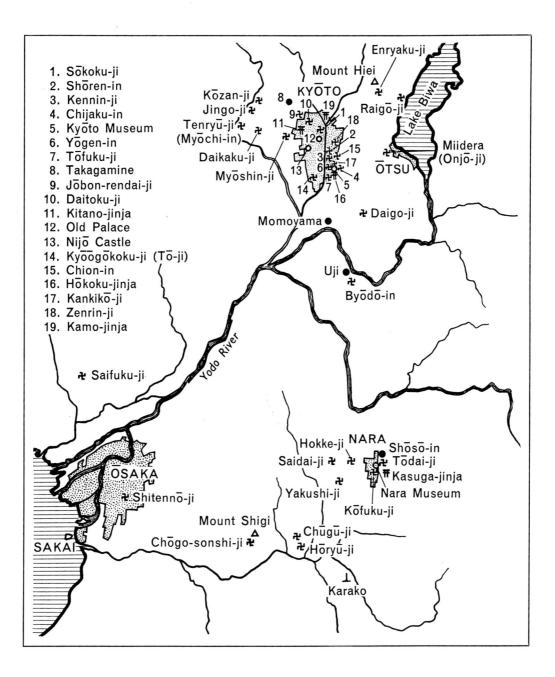

THE KYOTO-NARA REGION

The wealth of art treasures and historic temples and monasteries within this small area testifies to the key part played by this region in the diffusion of Buddhism and the cultural development of the whole country.

Selected Bibliography

of Books and Articles on Japanese Painting in Western Languages

General

Harold G. HENDERSON and Robert T. PAINE Jr., Japanese Art, Oriental Art, Series O, Section III, Newton, Mass., n.d.

Ernest F. FENOLLOSA, Epochs of Chinese and Japanese Art, 2 vols., New York 1913.

Kurt GLASER, Die Kunst Ostasiens, 2nd edition, Leipzig 1920.

René GROUSSET, Les Civilisations de l'Orient, Le Japon, Vol. IV, Paris 1930.

H. MINAMOTO, An Illustrated History of Japanese Art, translated by H. G. Henderson, Kyöto 1935.

Serge ELISSEEFF, Histoire Universelle des Arts, Japon, tome IV, Paris 1938.

Index of Japanese Painters, The Society of Friends of Eastern Art, Tokyo 1941, revised edition 1958.

Laurence BINYON, Painting in the Far East, 4th edition, London 1949.

Jean BUHOT, Histoire des Arts du Japon, Des Origines à 1350, tome I, Paris 1949.

Langdon WARNER, The Enduring Art of Japan, Harvard, 1952.

Kenji MORIYA, Die japanische Malerei, Wiesbaden 1953. Robert Treat PAINE and Alexander Soper, The Art and

Architecture of Japan, London and Baltimore 1955.

Hugo MUNSTERBERG, The Art of Japan, London 1957.

Peter C. SWANN, An Introduction to the Arts of Japan, Oxford 1958.

Yukio YASHIRO, 2000 Years of Japanese Art, London and New York 1958.

Individual Artists and Special Subjects

C. J. HOLMES, Hokusai, New York 1901.

Shiichi TAJIMA, Masterpieces Selected from the Ukiyoe School, 5 vols., Tokyo 1907.

Shiichi TAJIMA, Masterpieces Selected from the Körin School, 4 vols., Tokyo 1913.

Y. NOGUCHI, Hiroshige, New York 1921, London 1934 and 1940.

Laurence BINYON and J. J. O'Brien SEXTON, Japanese Colour Prints, New York 1923.

Henri FOCILLON, Hokusai. Art et Esthétique, Paris 1925. Catalogue of Art Treasures of Ten Great Temples of Nara,

25 vols., Tokyo 1932-1934.

Kenji TODA, Japanese Scroll Painting, Chicago 1935.

Chie HIRANO, Kiyonaga, Harvard 1939.

Robert Treat PAINE, Ten Japanese Paintings in the Boston Museum of Fine Arts, New York 1939.

Yukio YASHIRO, Scroll Painting of the Far East, Transactions and Proceedings of the Japan Society, Vol. XXXIII, London 1939.

Dietrich SECKEL, Das älteste Langrollenbild in Japan (Kako-Genzai-Ingakyō), Bulletin of Eastern Art, No. 37, Tokyo 1943.

Toichiro NAITO, The Wall Paintings of Horyūji, Baltimore 1943.

Terukazu AKIYAMA, L'origine de la peinture profane au Japon, Bulletin of the Vereeniging van Vrieden der Aziatiesche Kunst, new series, No. XXXIV, pp. 104-113, Amsterdam, September 1951.

Uemura ROKURO, Studies on the Ancient Pigments in Japan, Eastern Art, Vol. III, pp. 47-60, Philadelphia 1951.

Pageant of Japanese Art, 6 vols., edited by staff members of the Tokyo National Museum, Tokyo 1952-1954.

Exhibition of Japanese Painting and Sculpture Sponsored by the Government of Japan, catalogue, Washington, New York, Boston, Chicago, Seattle 1953.

Dietrich SECKEL, Buddhistische Kunst Ostasiens, Stuttgart 1957.

L'Art japonais à travers les siècles, catalogue of the exhibition sponsored by the Government of Japan, Paris, Rome, The Hague 1958-1959.

Dietrich SECKEL, *Emaki*, Paris 1959; German edition, Zurich 1959.

- Aizu province (northeastern Honshū) 117. Aizu-Wakamatsu, castle in northern
- Honshū, founded by Gamo Ujisato (1592), with Western equestrian portraits 138.
- Ajanta (India), cave paintings 23.
- Akashi-no-ue, character in the Tale of Genji 148.
- Ama-no-hashidate 115.
- Ami family, art counselors of the Shoguns 116;
- Nō-ami (1397-1471), called Shin-nō, founder 116;
- Gei-ami (1431-1485), called Shin-gei, son of No-ami 116;
- Sō-ami (?-1525), called Shin-sō, grandson of No-ami, paintings on the sliding doors of the Daisen-in, at the Daitoku-ji monastery 116.
- Amida (Amitābhā), Buddha 22, 40, 42-45, 59, 63, 99;
- cult of Amida (Amidism) 40, 42-45, 63, 116, 120;
- Descent of Amida (raigō) 42, 43, 45-47, 63, 68, 78;
- Paradise of Amida 22-24, 27, 86.
- Ando or Ichiyū-sai Hiroshige (1797-1858) 176-170:
 - Tōkaidō-gojū-santsugi (Fifty-three Stages of the Tokaido Highway, 1833)
 - 177-179:
- Toto-meisho (Famous Sites of the Eastern Capital, ten prints, 1831-1832) I77:
- Kiso-kaido (Sixty-nine Stages of the East-West Highway through the Central Mountains, 1837-1842) 179;
- Composition with Three Landscapes (1857) 179.
- An-ei era (1772-1781) 170.
- angry gods, representations of 53-55, 57.
- animal painting 185, 187.
- Annual Court Ceremonies (Nenchū-gyōgi) 60; scrolls painted by Tokiwa Mitsunaga (c. 1158-1179) 80.
- Aoi-no-ue, character in the Tale of Genji 135.
- Aoki Mokubei (1767-1833), painter and potter 192.
- Aoyagi Mizuho Collection: Portrait of Nakamura Kuranosuke by Ogata Korin 156.

- apsaras, flying angels 23, 25, 27. Arashi Wasaburō, actor in the Ichimuraza theater, Edo (1726) 166. architecture, Japanese 42, 65.
- arhat, disciple of the Buddha, hermit in
- meditation 23, 49. Arima (western Kyūshū), college and
- seminary (founded in 1579) 138. aristocratic culture of the Heian period
- 39, 40, 53, 60, 63, 67, 74, 167.
- Ashikaga, leading warrior family and dynasty of Shoguns at Kyoto (1336-1573) 107, 108, 123; Takauji (1305-1358), founder of the shogunal government 107;
 - Yoshimochi (1386-1428), fourth Shōgun
- 110;
- Yoshiteru (1536-1565), thirteenth
- Shōgun 136.
- Asia, Central 22, 23.
- Asukabe-no-Tsunenori, court painter of the emperor Murakami (mid-10th century) 67.
- Atami Museum (Shizuoka-ken), Sekaikyūsei-kyō Collection:
- Anonymous, Six Yuna (Serving Women of the Hot Baths), hanging scroll, 17th century 162, 163;
- Katsushika Hokusai, Gaifu-kaisei (Mount Fuji series, c. 1825) 175-177; Ogata Korin, White and Red Plum Trees, screen paintings 154-156;
- Sotatsu (attribution), Deer Scroll, calligraphy by Hon-ami Kōetsu 151, 152. Avalokitesvara (see Kannon), Bodhi-
- sattva.
- Awa province (Shikoku), lord of 174. Aya-no-nu-kakori, Korean artist at the
- Yamato court (7th century) 20. Azuchi, castle founded by Oda Nobunaga
- and decorated by Kanō Eitoku (1576) 124, 135, 137;
- Christian church and seminary founded by the Jesuits (1580-1581) 137, 138.
- bakufu (Shogunate), military government 60, 132.
- Ban-dainagon, Tomo-no-Yoshio (811-868), secretary of state, called 79, 80.
- Ban-dainagon-ekotoba, three scrolls, 12th century, Sakai Collection, Tokyo 79-81, 87. 100.

- Bashō (family name Matsuo, 1644-1694), haikai poet 182, 190.
- beni-e (or urushi-e), prints hand-colored with rose-red (beni) and other colors (early 18th century) 165.
- beni-zuri-e, painting printed with rose-red and a few other colors 165-167.
- bessho (in Sanskrit, utsada), subsidiary hell 87.
- bijin-ga, pictures of beautiful girls 164. bird and flower compositions 121, 131,
- 153, 157, 159, 177, 179, 184, 187, 188. Bishamon-ten (in Sanskrit, Vaisravana,
- Buddhist deity 75. Bitchū province (western Honshū) III.
- Biwa Lake, near Kyōto 45, 124.
- biwa, a kind of lute 32, 33, 73.
- bodhi, Wisdom of the Buddha 37.
- Bodhidharma (died before 534), Indian monk, introduced Zen Buddhism into China 104, 108, 113.
- Böfu Ryöshin, monk, friend of Sesshū 111. bosatsu (in Sanskrit, Bodhisattva) 18, 20,
- 22, 23, 27, 34, 35, 42, 45, 49, 57, 62, 63. Bosch, Hieronymus (c. 1450-1516) 89.
- Boston, Museum of Fine Arts:
- Attack of the Sanjo Palace, handscroll of the Heiji-monogatari, 3rd quarter of the 13th century 95-99;
- Dai-itoku-myöö (Mahājetas), deity,
- painting on silk, 11th century 53, 54,
- Hokkedō-kompon-mandara (Shaka-muni Preaching), painting on hemp cloth, late 8th century 26, 27, 69.
- Bronze Age in Japan (Yayoi Culture) 11. Buddha 20, 22, 37, 45, 49, 53, 60, 84, 103. Buddhism, Indian 45, 104;
- esoteric Buddhism in Japan 37, 39, 40,
- 42, 45, 84, 87, 89, 92, 102, 106; introduction of Buddhism in Japan (538) 11, 19;
- Buddhist painting 16, 19, 20-25, 28,
- 34, 39, 40, 43, 45, 49, 60, 65, 67, 73, 85; Buddhist sculpture 19, 20, 34, 40;
- Buddhist temples 27, 40, 65.
- bu-gaku, classical dances 148.
- Bunchō, see Tani Bunchō.
- bunjin-ga (in Chinese wen-jen-hua), literati painting 181, 182, 184, 185, 188-190, 192.
- Buson, see Yosa Buson.

byōbu, folding screen 66, 139, 142, 143, 160. Byōdō-in temple at Uji 42, 43;

Hōō-dō (Phoenix Hall, founded in 1053), paintings 42, 43, 45, 49, 68-70, 78; statue of Amida 42.

- Causes and Effects (E-ingakyo), illustrated sūtra of (8th century) 28, 29, 88.
- celestial guardians 23, 63.
- Cézanne, Paul (1839-1906) 113.
- Ch'ang-an, T'ang capital 29, 33, 37, 39; tomb of Hsien-yü-t'ing-hui (died in 723) 34.
- Chê School of Chinese painting 111, 188. Ch'i dynasty (China) 19, 22.
- Northern Ch'i 22.
- Chi-an region (Korea) 16.
- Chijaku-in temple, Kyōto 129;
- decorations by Hasegawa Tohaku 129-132.
- Chikuden, see Tanomura Chikuden.
- Chin Tartars 103.
- China 12, 17, 19, 20, 26, 28, 37, 39, 40, 69, 89;
 - relations and trade of Japan with China 22, 37, 39, 103, 104, 107, 108, 111, 141; Japanese embassies to China (804-806 and 838-840) 37, 65;
 - Chinese costume 33, 34;
- Chinese influence on the art of Japan 27, 28, 33, 34, 37, 39, 49, 54, 65-67, 69, 70, 74, 90, 100, 103, 104, 116, 120, 121, 127, 130, 132, 134, 141, 151, 159, 165, 181, 183, 189, 190, 192; Chinese merchants in Japan 65, 103;
- Chinese poetry, literature 66, 108; polychrome prints 166.
- Ch'ing dynasty of China (1644-1912) 184. Chinkai, painter-monk of the Todai-ji. Nara (1148) 27.
- chin-zō, portrait of a Zen master 105, 106. Chion-in temple, Kyōto, center of the Jodo sect:
 - Hönen-shönin-eden (Life of the Monk Honen), scroll paintings, 14th century 102.
- Chishō-daishi, see Enchin.
- Chōbō-ji temple, Kyōto:
- Shakai-saisei-seppo-zu (Resurrection of the Buddha), scroll, late 11th century 103.
- Chögen, Japanese monk (late 12th century) 104.
- Chōgo-sonshi-ji temple, on Mount Shigi (Nara) 75, 76;
- Shigisan-engi-e-maki, three handscrolls, 12th century 74-78, 90, 100.
- Chōjū-giga (Animal Caricatures), four scrolls of drawings, 12th-13th centuries 83-86.
- Chonen, Japanese monk in China (982) 103.
- Chōshun, see Miyakawa Chōshun.
- Christianity in Japan (16th century) 136-139;
- Christian missionaries 136, 137, 184; Christian paintings 137, 138.
- Chūgū-ji, nunnery near the Horvū-ji. Nara 20.
- Chūjō-hime, princess, Taima-mandara embroidery (woven in 763) 27.
- Chūson-ji temple at Hiraizumi, province of Iwate (northern Japan):

202

large set of Buddhist sūtras (Tripitaka), copied about 1119 88.

- civil wars 42, 45, 86, 123, 136. Construction Bureau, Nara 67.
- Daigo (885-930), Heian emperor 67, 75, 76, 92.
- Daigo-ji temple, south of Kyōto 148; decorations of the five-storey pagoda (built in 951) 38-41, 53;
- Bu-gaku, screen paintings of classical dances by Sotatsu 148;
- fan-shaped leaves mounted on screens (senmen-ga) by Sōtatsu 149; Hoon-in temple:
- Sutra of Causes and Effects, scroll paintings, 8th century 28.
- Dai-itoku-myöö (in Sanskrit, Mahājetas).
- Buddhist deity 53, 54, 57. Daijō-ji, temple at Hyōgo, decorations by Maruyama Ökyo 184.
- Dainichi-Nyorai (in Sanskrit, Vairocana), supreme god of the esoteric pantheon 39, 57.
- Daitoku-ji, Zen monastery, Kyōto: Daisen-in temple, sliding doors attributed to Sō-ami (died 1525) 116;
 - sliding doors by Kano Motonobu (c. 1513) 121;
 - Jukō-in temple, Miyoshi chapel, decorations by Kanō Naonobu and Kanō Eitoku (c. 1566) 123, 125, 126; Yotoku-in temple (mistakenly given as Yōgen-in in the text), screen paintings attributed to Ten-ō Sōtan and Sōkei (finished 1490) 116.
- Dan Ino Collection, Tokyo:
- Jizō-bosatsu (Ksitigarbha), hanging scroll, late 13th century 63, 64.
- Daruma (in Sanskrit, Bodhidharma) 108. Death of Shinzei from the Heiji-monoga-
- tari, Seikado Foundation, Tokyo 95. Degas, Edgar (1834-1917) 179.
- Dejima, islet near Nagasaki 176.
- deva, twelve (in Sanskrit, Juni-ten) 39, 49, 57, 104.
- Diseases, Scrolls of (Yamai-no-soshi), late 12th century 86, 88.
- dogu, clay figurines of the Jomon Culture II.
- Doi Tsuguyoshi, Japanese art historian 126, 134.
- Donchō, Korean painter-monk of Koguryō, came to Japan (in 610) 26.
- dotaku, bronze bells of the Yayoi Culture 12, 13, 15.
- dragons in early Chinese painting 16.
- Dutch traders in Japan (17th-19th centuries) 176; Dutch engravings 176.
- Eagle-headed Mount, picture of 20.
- edakumi, painter 27.
- Edakumi-no-tsukasa, Painters' Bureau at Nara (until 808) 27, 67. Edo (present-day Tokyo), seat of the
- shogunal government founded by
- Tokugawa Ieyasu 132, 133, 141, 156, 157, 162, 166, 170, 171, 174, 175, 177, 179, 181, 182, 184, 193;
- official academy of the Shōgunate 135; Famous Views of the City of Edo 170, 176, 177, 180;
- Edo period (or Tokugawa period) 141.

- E-dokoro, Painting Office of the imperial court (founded before 886) 67, 80, 144. e-goyomi, illustrated almanac 166.
- e-hon, illustrated book 164.
- E-ingakyō, illustrated sūtra of Causes and Effects (8th century) 28, 29, 88.
- Eisai Min'an, Japanese monk (1141-1215), introduced Zen Buddhism in Japan (late 12th century) 104, 106.
- Eisen, see Kikukawa Eisen.
- Eitoku, see Kanō Eitoku.
- e-maki, illuminated handscroll 70, 100, 145.
- e-makimono, illuminated handscroll 28.
- Emman-in temple at Ötsu, on Lake Biwa (in the Onjō-ji or Mii-dera monastery): scrolls painted by Maruyama Ökyo (Fortunes and Misfortunes, Peacock, etc.) 184.
- Enchin (814-891), monk of the Tendai sect 57.
- engi, legend of the origin and miracles of the temples 92, 102.
- En-i, painter, fellow pilgrim of the monk Ippen (13th century):
- Ippen-shonin-eden (Life of the Monk Ippen), twelve scrolls painted on silk (1299) 99-101.
- Enichi-bō-Jōnin, painter monk of the Kōzan-ji (first half of 13th century) 90, 91;

Portrait of Myōe-shōnin 91, 93;

- Kegon-engi-e-maki (attribution) 89-91. Enkaku-ji, Zen monastery at Kamakura (founded in 1282 by Mugaku Sogen) 106, 113;
- Butsunichi-an, mausoleum of Hojo Tokimune (1251-1284) 106.
- Enryaku-ji, monastery of the Tendai sect on Mount Hiei (founded in 805) 37, 40. eshi, master painter 27.
- Eshi-no-soshi (Story of a Painter), scroll paintings, 13th century (Imperial Col-
- lection) 100.
- Eshin-sōzu (942-1017), another name of Genshin, monk of the Enryaku-ji and author of Ojō-yōshū (published in 985) 40, 45.
- e-ya, painting shop 149.

fan painting 144, 149, 150, 152, 164, 190. feudalism in Japan 60, 179.

fighting scenes 95, 98, 101.

- Flemish painting or painters 89, 139.
- Four Divinities, Tomb of the (Chi-an region) 16.
- Four Great Masters, Chinese literati painters 188.
- France, vogue for Japanese prints in 179, 180.
- Freer, Charles (1856-1919), American collector 149.
- Frois, Louis, Christian missionary in Japan (late 16th century) 139.
- Fudai, present-day Õita (Kyūshū), Jesuit seminary (founded in 1580) 138
- Fudō-myōō (in Sanskrit, Acala), Buddhist deity 55, 57. Fugen-bosatsu (in Sanskrit, Samantab-

Fujikake Shizuya, Japanese art historian

hadra, Bodhisattva) 60.

164.

Fuji, Mount 170, 175-177, 190.

- Fujiwara, influential aristocratic family 39, 57, 79, 80, 92, 144;
 - Yoshifusa (804-872), Prime Minister (866) 79;
 - Tokihira (871-909), minister of the emperors Uda and Daigo 92; Michinaga (966-1027), Prime Minister
 - 40, 42; Yorimichi (992-1074), his son, founder
 - of the Byödö-in temple (1052) and the Phoenix Hall (1053) at Uji 42, 68; Narifusa, courtier of the emperor Goshirakawa 83;
 - Mitsuyoshi, courtier of the emperor Go-shirakawa, his portrait at the Jingoji, Kyöto (late 12th century) 83; Nobuyori (1133-1159), ordered attack
 - on the Sanjō Palace 97; Kanezane (1149-1207), minister 81;
 - Takanobu (1142-1205), courtier and portrait painter (*nise-e*), portraits at the Jingo-ji, Kyōto 80-83, 94; Nobuzane (before 1185-after 1265), his
 - son, realistic portrait painter (*nise-e*) 83, 94;
- Kinhira (1264-1315), minister of the left (1309) and donor of the Kasugagongen-kenki scroll paintings 102.
- Fukui Rikichirō, Japanese art historian 88, 117, 141, 149.
- fumi-e, images to be trampled on 138. Funabashi (town south of Tokyo), Kakuōji temple 138.
- fuyō flowers (hibiscus mutabilis) 125.
- Fuyuki family, merchants of Edo (18th century) 156.
- gaki (in Sanskrit, pretas), hungry demons 86, 88.
- gaki-dō, world of hungry demons 88. Gaki-zoshi (Scrolls of Hungry Demons)
- late 12th century 86, 88. Gakuō, wash painter, Shūbun school 116.
- Gamō Ujisato (1556-1595), Christian nobleman, founder of the castle of Aizu-Wakamatsu (1592) 138.
- Ganku (or Kishi Ku, 1756-1838), animal painter 187.
- Gauguin, Paul (1848-1903) 179.
- Gengyō, Korean monk of the Kegon sect (7th century) 89-91.
- Genji, Prince Hikaru 72, 73, 135, 145, 148.
- Genji-monogatari (Tale of Genji), love story, early 11th century 70, 100, 135, 145-148, 167; set of scroll paintings (first half of 12th century), dispersed
- 70, 72-75, 79, 100, 148, 167. genkan, lute with round body 33.
- genre painting 132, 139, 159-180.
- Genroku era (1688-1704) 153, 182.
- Genshin, see Eshin-sozu.
- Gion Nankai (1676-1751), literati painter of Wakayama 190.
- Gishō, Korean monk of the Kegon sect (624-702) 89-91.
- go, game of Chinese origin, similar to checkers 33.
- Go-daigo, emperor, overcame the Hōjō (1333) 107.
- Godaison (in Sanskrit), five raja 57.
- gold leaf applied to mural decorations 124, 125, 129-133, 136, 137, 139, 145-148, 154-157, 188-191.

- Gomes, Pietro, Christian missionary in Japan (late 16th century) 138.
- Go-mizunoo, Japanese emperor (1611-1629) 135, 145, 160.
- Goncourt, Edmond de (1822-1896) 171, 175.
- Good Law, Lotus Sūtra of the 37, 164.
 Go-shirakawa (1127-1192), late Heian emperor 80, 81, 83, 97.
- Goshun (1752-1811), founder of the Shijō school 185;
- landscapes, pair of screens, Tokyo, National Museum 185, 187.
- Grousset, René (1885-1952) 113.
- Gunabhadra (394-468), Indian monk, translator of the *sūtra* of Causes and Effects into Chinese (Kako genzai inga-kyō) 28.
- Gyokudō, see Uragami Gyokudō.
- haboku (in Chinese, p'o mo), cursive style of wash painting 113, 114, 130, 134.
- Hachijō-no-miya Tomohito (1579-1629), imperial prince, younger brother of the
- emperor Go-yōzei and adoptive son of Toyotomi Hideyoshi 125.
- haiga, painting illustrating a haikai poem 192.
- haikai, poem of seventeen syllables 157, 166, 182, 185, 190, 192.
- Hakata (northern Kyūshū), seaport 103.
- Hakuka, Korean painter from Kudara (in Japan from 588) 26.
- Hakuun Egyō (1223-1297), Zen monk 107. Hamachō Kanō, Kanō school of Edo
- (17th-19th centuries) 181. hama-matsu-zu, screen painting of Beach
- with Pines 144. Han dynasty of China (206 B.C.-A.D. 220),
- painting of 22.
- Hanabusa school, founded by Itchō (18th century) 182.
- Hanabusa Itchö (1652-1724) or Taga Shinkö (his real name) or Chökö (his pseudonym), a painter deriving from the Kanö school who worked out a style of his own 182;
- Peasant leading his Horse across the River, hanging scroll, before 1698, Seikadō Foundation, Tokyo 182, 183.
- Hang-chou, Southern Sung capital (from 1138) 103.
- haniwa, terracotta funerary statuettes (Tumulus period, 3rd to 6th centuries A.D.) II, 15, 17.
- Hara Collection 87.
- Hara (Shimabara peninsula, Kyūshū), resistance of the Christians in the castle (1637-1638) 138.
- Harunobu, see Suzuki Harunobu.
- Hasegawa Nobuharu (late 16th century), painter of portraits and Buddhist images, sometimes identified with Hasegawa Tõhaku 126.
- Hasegawa Tōhaku (1539-1610) 126, 127, 132;
- *Pine Wood*, pair of screens, Tokyo, National Museum 127-129;
- sliding doors in the Chijaku-in temple, with his studio pupils (originally in the Shōun-ji) 129-132.
- Hasegawa Kyūzo (1568-1593), Tõhaku's son 127.

- Hasshu Gafu (Eight Albums of Painting), written in China (c. 1620), republished in Japan (1671) 189.
- hatamoto, direct vassal of the Shogun 167.
- Heian period (late 8th century-late 12th century) 28, 37, 39, 60, 63-67, 74, 77, 79, 88, 92, 100, 103, 127, 144, 150, 156, 165, 179.
- Heian-kyō (Peace Capital), present-day Kyōto 37.
- Heiji civil war (1159) 60, 95.
- Heiji-monogatari, war novel (written c. 1220) 95;
- three original scrolls, dispersed (second half of 13th century) 95-99, 101.
- Heijō (present-day Nara), capital from 710 to 794 27.
- Hell, representations of 86, 87.
- Hell of the Iron Mortar 86-88.
- Hell Scrolls (Jigoku-zōshi), 12th-13th centuries 86, 87, 98, 102.
- hemp cloth, painting or drawing on 26-28, 30, 34, 35.
- 30, 34, 35. Henry IV, King of France (1589-1610) 138.
- Hiei, Mount (north of Kyōto) 37, 45.
- Higo province (Kyūshū) 101.
- Himalayas 20.
- hinoki, Japanese cypress or cedar 22, 65, 125.
- Hirano, Shintō shrine of Kyōto 81.
- hirao, strip of precious cloth worn in the
- official dress of the imperial court 83. Hiraoka convent, Kyöto, built by Myöe
- (1223) 90. Hirose Taizan (1751-1813), painter 192.
- Hiroshige, see Andō Hiroshige.
- Hiroshige III (1842-1894), print designer, pupil and successor of Andō Hiroshige 180.
- Hishikawa Moronobu (1618-1694), print designer 164, 165, 167, 182.
- Hitachi province (northeastern Honshū) 117.
- Hiyoshi, Shintō shrine near Kyōto 81. Hoei-dō, publisher of prints (19th century) 178.
- Hoen, print designer (19th century) 180.
- Hōgen civil war (1156) 60, 95.

Hōgen-monogatari, war novel (c. 1220) 95. Hōitsu, see Sakai Hōitsu.

- Hōjō, warrior family, dynasty of shogunal governors at Kamakura (1203-1333) 106, 107;
- Tokimune (1251-1284), his mausoleum at the Enkaku-ji 106.

Descent of Amida (raigo-zu), triptych,

first half of the 11th century 43-45.

Hokke-kyō, Lotus Sūtra of the Good Law

hokkyō, honorary title of Buddhist monks

Hōkoku-jinja, Shintō shrine, mausoleum

Hon-ami Koetsu (1558-1637), art patron,

calligrapher and decorator 150-153.

203

and painters 145, 150, 152, 153.

of Toyotomi Hideyoshi 160.

Hokusai, see Katsushika Hokusai.

- Hokke, Buddhist sect founded by Nichiren (13th century) 120.
- Hokkedō-kompon-mandara (Shaka-muni Preaching) 26, 27, 69.
- Hokke-ji temple, Nara:

Hon-ami family 150.

37, 164.

- Honda Tomimasa (early 17th century), local ruler 145.
- Hönen (1133-1212), founder of the Jodo sect 63, 102.
- Hönen-shönin-eden (Life of the Monk Hōnen), 48 scrolls (1307-c. 1350) in the Chion-in temple 102, 108.
- Hongan-ji, fortified monastery at Ishiyama (present-day Ösaka) 120;
- paintings by Kano Motonobu (1539-1553) 120.
- Honshū, main island of Japan 19, 111, 136, 178.
- Hōō-dō (Phoenix Hall), built in 1053 in the Byodo-in temple at Uji 42, 43, 45, 49, 68-70, 78;
- statue of Amida 42;
- Descent of Amida (raigo-zu), nine versions of 42, 43, 45. hori-shi, block-cutter 167.
- Hōryū-ji, Buddhist temple south of Nara 18-27;
 - Tamamushi-no-zushi, painted Buddhist shrine (mid-7th century) 18, 20-22; Tenjukoku-mandara, dedicated to Prin-
 - ce Shōtoku 20;
 - wall paintings with paradise scenes (late 7th century) 22-26;
 - statues of four celestial guardians (mid-7th century) 22:
- bronze triad of Shaka-Nyorai (623) 19. hosho, paper for prints 171.
- Hosoda (or Chöbun-sai Eishi, 1756-1815) 171.
- Hossō, Buddhist sect 52, 53.
- Hotei (in Chinese, Pu-tai), supernatural being, incarnation of Maitreya 108.
- Hsia Kuei (early 13th century), Southern Sung painter 108, 110, 113.
- Hsiao Ch'ih-mu, Chinese literati painter 190.
- Hsien-yü-t'ing-huei (died 723), tomb in Ch'ang-an 34.
- Huang Kung-wang (1269-1354), Chinese literati painter 188.
- Hui-kuo, Chinese monk of the Shingon sect 39.
- Hui-tsung, Sung emperor (1101-1125) and painter 106.
- Hungry Demons (Gaki-zōshi), scrolls of the 86, 88.
- hyōban-ki, anecdotes of famous actors and courtesans 164.
- Hyōbu-bokkei (Hyōbu Bokkei), wash painter working under the influence of the Zen master Ikkyū Sõjun(mid-15th century) 116.
- Hyōnen-zu (Parable of the Old Fisherman) painted by Josetsu (before 1415) 110.
- Ichikawa Ebizō, actor, painted by Sharaku (1794), 173, 174.
- Ichimuraza theater, Edo 166.
- Ichinojō, see Ogata Kōrin.

204

- Ichizan Ichinei (1247-1317), Chinese monk (I-shan I-ning) 107.
- I Fu-chiu, Chinese painter working at Nagasaki (from 1720) 190.
- Ikeda (province of Bizen), lord of 192. Ike-no-Taiga (1723-1776), Japanese literati painter 190-192;
- Landscape in the Chinese Manner, pair of screens (c. 1760-1770) 190, 191;

- Juben Jugi (Ten Advantages and Ten Pleasures of Country Life), albums with Yosa Buson 190, 192.
- Ikkyū, Zen monk, master of Hyobū Bokkei 116.
- imperial academy of painting 121, 132, 141, 144.
- imperial family 19, 37, 53, 65, 134, 141, 153.
- imperial power, restoration of 107, 179, 193.
- Imperial Collections (preserved in Tokyo and Kvoto):
 - Eshi-no-sōshi (Story of a Painter), scroll paintings, 13th century 100; Kasuga-gongen-kenki (Miracles of the Shinto Deities of Kasuga), 20 scrolls (1309) 102;
 - Moko-shurai-ekotoba (Mongol Inva-
 - sions), two scrolls (c. 1293) 102;
 - fan-shaped leaves mounted on screens (senmen-ga) 149;
 - Saigyō-hōshi-ekotoba (Life of the poetmonk Saigvo), four scrolls painted by
 - Kaida Sukeyasu (1500) 145; Fabulous Lions, screens by Kano Eitoku 125:
 - Natural History by Itō Jakuchū (1758-
 - 1770), 30 pictures from the Sōkoku-ji temple, Kyōto 188.
- Indian influence on Japanese art 23, 33; Indian esoteric divinities 40.
- Inen, seal of the Tawara-ya 152.
- Ingakyō (Causes and Effects) 28, 29.
- ink monochrome painting (in Chinese, pai-hua) 34, 63, 83, 84, 103, 104, 107, 108, 110, 116, 117, 124, 127, 131, 134, 135, 151, 152.
- Ippen (1239-1289), monk, founder of the Ji-shū sect 98-101.
- Ippen-shonin-eden (Life of the Monk Ippen), twelve scrolls painted by En-i (1299) 98-101.
- Ippitsusai Bunchō (18th century), print designer 170.
- Iran under the Sassanians 23; influence of Iranian art on Japan 33, 34.
- Ise-monogatari (Tale of Ise), 10th century 70, 149, 156.
- Ishida Mitsunari (1560-1600), lord favored by the Toyotomi and defeated by the Tokugawa (in 1600) 132.
- Ishida Yūtei (1721-1786), painter of the Kano school of Kyoto, master of Maruyama Ökyo 182.
- Ishii Yūshi Collection, Tokyo: Kozan-shōkei, hanging scroll by Ten-yū Shōkei (mid-15th century) 109.
- Ishikawa Toyonobu (1711-1785), print designer 165-167.
- Ishiyama (present-day Ōsaka) 120.
- Isoda Koryūsai (18th century), ukiyo-e painter, specializing in women 170.
- Itō Jakuchū (1716-1800), bird and flower painter in the realistic style 187; Cocks and Cactus, sliding doors of the Saifuku-ji, Ösaka 188, 189; Natural History, thirty bird and flower pictures (1758-1770) for the Sökoku-ji
- temple, Kyōto 188. Itsukushima, Shintō shrine:
- decorated sūtras presented by the Taira family (1160) 149.

- Itsunen (in Chinese, I-jan), Chinese monk of the Zen sect of Obaku (at Kyōto in 1644), painter of realistic portraits 183, 184.
- Izu province (eastern Japan) 120.
- Izumo-no-okuni, dancing girl who founded the Kabuki theater, Kyōto (early 17th century) 160.
- Jasoku, founder of the Soga school, successor of Hyobū Bokkei 116.
- Jataka, previous lives of the Buddha 20, 21.
- jigoku, Hell 86-88, 92.
- Jigoku-zōshi (Hell Scrolls) 86-88, 98, 102. Jingo-ji temple of the Shingon sect,
- Kvoto:
 - portraits by Fujiwara Takanobu (1142-1205) 81-83, 107;
- pair of mandara with gold outlines on damask (824-833) 39;
- Shaka-Nyorai in a Red Robe (12th century), hanging scroll 58, 60.
- Jion-daishi (632-682), or Kuei-chi, Chinese monk, founder of the Hossō sect 52, 53, 81, 107;
- his portrait in the Yakushi-ji, Nara (11th century) 52, 107.
- Ji-shū, Buddhist sect founded by Ippen (13th century) 99.
- Jizō (in Sanskrit, Ksitigarbha), Bodhisattva 62, 63.
- jobon-josho, Supreme Salvation of Amida 63.
- Jōbon-rendai-ji temple, Kyōto:
- Sūtra of Causes and Effects, 8th-century scroll 28, 29.
- Jōdo (Pure Land), Buddhist sect 63, 99. Jōjin, Japanese monk, journey to China
 - (1072) 103.
- jōkō, emperors in retirement who continued to govern (from the late 11th century) 57.
- Jokyū civil war (1221) 90.
- Jokyū-bon version (1219) of the Kitanotenjin-engi scrolls 92.
- Jomon Culture (7th to 1st millennium B.C.), Neolithic age of Japan 11, 12. jomon, pottery decorated with rope designs II, I2.
- jōruri, popular ballad 164.
- Josetsu Taikō, Zen painter-monk, initiator of monochrome painting in Japan 110, II3:
- Hyönen-zu (Parable of the Old Fisherman, before 1415) 110.
- Josui Sõen, painter-monk of the Enkakuji, disciple of Sesshū 113, 115, 117.
- Jūni-ten, the twelve deva: series of images in the Saidi-ji, Nara (9th century) 39; in
- the Tō-ji, Kyōto (1127) 60; (1119) 104. Jūroku-rakan, sixteen disciples of the Buddha 49-51.
- Kabuki, classical Japanese theater of popular origin 160, 165, 171, 175.

Kagoshima (southern Kyūshu), large sea-

Kabuki dance 160. Kabuki-byobu, screens with girls dancing

port 136.

and making music 160. Kagawa Prefecture (Shikoku) 13.

Kagei, see Tatebayashi Kagei.

- Kaida Sukeyasu, Life of the poet-monk $Saigy\bar{o}$, four scroll paintings, 1500 (Imperial Collections) 145.
- Kaigetsu-dō Ando, ukiyo-e painter (17th century), 165; school of 165.
- Kaiho Yůshö (1533-1615), painter of the Momoyama period 129-132; mural decorations of the Kennin-ji, Zen monastery, Kyöto (1595-1600) 130, 131; three pairs of screens at the Myöshin-ji, Kyöto (1595-1600) 131-133.

Kaiseki, see Noro Kaiseki.

- Kaishi-en-gaden (Mustard Seed Garden), published in China (1679) and in Japan (1748) 190.
- Kajibashi Kanō, Kanō school of Edo (17th-19th centuries) 181.

kakemono, hanging scroll 49.

- Kako genzai inga kyō, Sūtra of Causes and Effects 28, 29.
- Kakuo-ji, Buddhist temple at Funabashi 138.
- Kakutei (†1785), painter-monk of the realist school of Nagasaki 184.
- Kakuyū (1053-1140), great painter-monk of the Tendai sect, known as Toba-sõjõ 84.
- Kamakura (eastern Japan), 60, 104, 106-108, 113, 117.
- Kamakura period (1191-1333) 60, 63, 89, 92, 95, 100, 144, 165.
- Kammu (737-806), emperor, founder of Kyōto 37.
- Kamo, Shintō shrine, Kyōto 160; Kamo festival 135.
- Kamo river 160.
- kana-zōshi, serial stories 164.
- kanbachi, leather plaque on the soundbox of a lute 33.
- Kanchi-in temple, Kyōto, in the Tō-ji monastery:
- Dragons, pair of screens by Maruyama Ökyo 184.
- Kankikō-ji temple, Kyōto:
- Ippen-shönin-eden (Life of the Monk Ippen), twelve scrolls on silk (1299) 98-101.
- Kan-muryōju-kyō, important sūtra of the Amida cult 27, 40.
- Kannon (Avalokitesvara, Bodhisattva) 23, 24, 27, 45, 59, 63, 108.

Kanō, village in Izu province 120.

- Kanō, dynasty and school of painters 120, 126, 127, 129-136, 139, 141, 144, 159, 160, 162, 176, 181, 182, 187, 193; Kanō family of Kyōto, descendants of Sanraku (Kyō-Kanō) 133, 153, 182; Kanō schools of Edo, see Hamachō, Kajibashi, Kobikichō, Nakabashi;
- Einö (1634-1700), Sanraku's grandson, author of the Lives of the Japanese Painters (Honchö-gashi) 181;
- Eitoku (Kuninobu, 1543-1590), Naonobu's son 120, 121, 123-127, 129, 132-135, 159, 160;

Screen paintings:

- Views of Kyöto, 1574, pair of screens (Uesugi Collection) 124, 159; Hinoki-byöbu, 1590, Tokyo, National Museum (from the Palace of Hachijōno-miya Tomohito) 125;
- Fabulous Lions, Imperial Collections 125;

Mural decorations:

Daitoku-ji monastery (Jukō-in temple, Miyoshi chapel), with his father Shōei (c. 1566) 123, 125, 126;

palace of the Konoe, Kyōto (1567-1568) 123;

- castle of Azuchi (1576) 124, 135;
- Juraku Palace, Kyōto (1587) 124;
- castle of Ōsaka (1583) 124; Hideyori (†1557), Motonobu's son 120,
- 159; Looking at the Red Maples on Mount

Looking at the Rea Maples on Mount Takao, screen painting, Tokyo, National Museum 159;

- Kagenobu, first painter of the Kanō family 120;
- Kōi (†1636) 132, 135;
- Kuninobu, called Eitoku, see above;
 Masanobu (1434-1530), Kagenobu's son and founder of the school 120;
- Mitsunobu (1565-1608), Eitoku's eldest son 124, 132;

decorations in the Kangaku-in temple, Miidera monastery at Otsu (1600) 132; Motonobu (1476-1559), Masanobu's son

- 118-121, 123, 125, 129, 134; decorations in the Hongan-ji monastery, Ishiyama (1539-1553) 120; sliding doors of the Daisen-in temple,
- of the Daitoku-ji (c. 1513) 121; sliding doors of the Reiun-in temple, of the Myöshin-ji (1543-1549) 118, 119,
- 121, 125; – Munenobu (1514-1562), Motonobu's son 120:-----
- Naganobu (1577-1654), Eitoku's younger brother 124, 132, 160-162;

Cherry Blossom Festival, screen painting Hara Kunizō Collection, Tokyo 160-162;

murals in the castle of Nagoya (popular scenes, 1614) 132, 162;

- Naizen (1570-1616), screens: Scene with the celebration at the Hōkoku-jinja shrine 160; Namban-byōbu (screens showing the
- arrival of Westerners) 160; – Naonobu, see under Shōei;
- Naonobu (1607-1650), Takanobu's son,
- Tannyū's brother 135; – Sadanobu (1597-1623), Mitsunobu's son
- 132;
- Sanraku (1559-1635), Eitoku's adoptive son 124, 132-135, 181;

Kuruma-Arasoi, scènes from the Tale of Genji, screens from the Kujō Palace (now Tokyo, National Museum) 135; screen paintings on Chinese historical subjects, in the Myōshin-ji, Kyōto 135; partitions of the Daikaku-ji, Kyōto (c. 1620) 134;

sliding doors of the Tenkyū-in temple, Myōshin-ji, Kyōto, with Sansetsu (1631-1635) 3, 4, 134, 135, 137;

- Sansetsu (1590-1651), Sanraku's adoptive son 134;

murals in the Tenkyū-in temple, at the Myōshin-ji, Kyōto (1631-1635), with Sanraku 3, 4, 134, 135, 137;

- Shōei (Naonobu, 1519-1562), Motonobu's son 120, 123, 124;

decoration of the Jukō-in (Miyoshi chapel) at the Daitoku-ji monastery, with his son Eitoku (c. 1566) 123, 125, 126:

- Soshū (1551-1601), Eitoku's younger brother 124;
- Takanobu (1571-1618), Eitoku's son 124, 132, 135;
- Cherry Trees and Pheasants (attribution), castle of Nagoya (1614) 132;
- Tannyū (1602-1674), Eitoku's grandson 125, 135, 136, 181, 182;
- decoration of the castle of Nijō (1626) at Kyōto 135, 136;
- Yasunobu (1613-1685), Takanobu's son 135, 182;
- Yukinobu (1513-1575), Motonobu's vounger brother 120.
- Kaō, Zen monk, precursor of monochrome painting (first half of 14th century) 107.
- Kaoru, character in the Tale of Genji 72, 73.
- kara-e, decorative painting of Chinese inspiration 66, 67, 69.
- kara-jishi, fabulous lion 125.
- Karako (south of Nara), excavated site of the Yayoi Culture, designs on pottery 12.
- kara-oshi, uninked impression, technique of ukiyo-e prints 171.
- Karashar (Central Asia) 23.
- Karasumaru Mitsuhiro (1579-1638), courtier and scholar of Kyōto 145.
- Karigane-ya, business house of the Ogata family, Kyōto 153.
- karma, Sanskrit term for the notion that a man's actions in one of his successive states of existence decide his fate in the next 88.
- Karula (in Sanskrit, Garuda), Buddhist mythical bird 57.
- mythical bird 57. kasen-e, portraits of famous poets 100. Kashiwagi, nephew of Prince Hikaru in the Tale of Genji 72, 73.
- Kasuga shrine, Nara 102.
- Kasuga-gongen-kenki (Miracles of the Shintō Deities of Kasuga), twenty
- scrolls painted by Takashina Takakane (1309), Imperial Collections 102, 108. Katsukawa Shunshō (1726-1792), print
- designer 170, 171, 174, 176.
- Katsushika district of Edo 175.
- Katsushika Hokusai (1760-1849) 175-179:
 - Thirty-six Views of Mount Fuji (1825-1831) and One Hundred Views of Mount Fuji (from 1834) 175-177;
 - Views of the Tōkaidō (from 1804) 176; Views of Edo 176;

Hokusai Manga, pictorial encyclopedia (from 1814 on) 176.

- Kawabata Collection:
- Jüben Jügi (Ten Advantages and Ten Comforts of Country Life), albums by Ike-no-Taiga and Yosa Buson 190, 192. Kawarasaki-za theater, Edo (18th centu-
- ry) 174. kebiishi, police office of the Heian period
- 80.
- Kegon, Buddhist sect 89-91.
- Kegon-engi (or Kegonshū-sōshi-eden), six scrolls by Enichi-bō-Jōnin, early 13th century, in the Kōzan-ji 89-92.
- Keisen-machi, Fukuoka (northern Kyūshū), Ōtsuka Tomb 14, 16.

- Kenchō-ji, Zen monastery at Kamakura, founded by Rankei Doryū (1253) 105. 106:
- portrait of Rankei Döryū (1271) 106. Kennin-ji, Zen monastery at Kyöto 131; murals by Kaiho Yūshō (1595-1600) 130:
- Wind and Thunder Gods, screens by Sõtatsu 148.
- kentō, guide-marks on prints 166.
- kesa, Buddhist stole 107.
- Khotan (Central Asia) 23.
- Kichijo-ten (in Sanskrit, Mahasri), Goddess of Beauty and Fecundity 28, 30.
- Ki-fudō (yellow-bodied Fudō) 57. Kikaku (family name Enomoto, 1661-
- 1707), poet of the Bashō school 182. Kikukawa Eisen (1790-1848), called
- Keisen Eisen, print designer 179. Kimmei, Yamato emperor (6th century)
- TO
- Ki-no-Tsurayuki, poet of the imperial court (early 10th century) 66.
- kirikane, patterning in cut gold leaf 28, 42, 45, 49, 57, 60, 63;
 - in silverfoil 60.
- Kita Genki, portrait painter of Nagasaki (17th century) 184.
- Kitagawa Utamaro (1753-1806), print designer 170-172, 180;
- Kasen-koi-no-bu (Love Poems), set of prints 171, 172.
- Kitano Temman-gū, Shintō shrine in Kyōto dedicated to Tenjin 92, 94, 95, 160;
- Kitano-Tenjin brotherhood 94.
- Kitano-tenjin-engi (Life of Sugawara Michizane and Origin of the Shinto Shrine of Kitano-tenjin): Jokyū-bon (version of the Jokyū era) or
- Kompon-engi (fundamental engi) in eight scrolls plus a supplementary scroll (1219) 92, 94, 97;
- Koan-bon (version of the Koan era), originally three or six scrolls, now only fragments, some mounted in two scrolls in the Kitano shrine, others dispersed (1278, mistakenly dated 1282
- in the text) 95, 146, 148. Kitao Shigemasa (1739-1820), print de-
- signer 170.
- Kitsuzan Minchō (1352-1431), Zen paintermonk of the Tōfuku-ji 110. ko, "based on the idea of..." 167.

- Kōan-bon, Kōan era (1282) 94, 145. Kobayashi Yukio, Japanese archeologist 15.
- Kobe Museum, screens with equestrian portraits of Western princes (1592) 138.
- Köben, see Myöe-shönin.

206

- Kobikichō Kanō, school of Edo (17th-19th centuries) 181.
- kogaku-zu (ancient dances), scroll paintings, 15th century 148.
- Koguryō, ancient kingdom of northern Korea (in Japanese, Kokuri), tomb paintings 16, 17, 26.
- Kohon-setsuwa-shū (Ancient Collections of Legends, c. 1130) 76.
- Kokuri (Koguryō, in Korea) 16, 17, 26. Kokuzo-bosatsu (in Sanskrit, Akasagarbha), God of Wisdom 56, 60.

- Komano-kaseichi, architect of Korean origin at the Yamato court (early 7th century) 20.
- Kōmyō (701-760), wife of the emperor Shōmu 29, 33.
- Komyo-shingon, doctrine of Divine Light 90.
- Kondo Ichitaro, Japanese art historian, print specialist 164, 176.
- Kongara (in Sanskrit, Kinkarah), attendant of Fudō-myōō, divinity represented as a small boy 57.
- Kongō-ji temple, Kauchi (Ōsaka):
- Nichi-getsu-sansui-byobu, pair of screens of the Four Seasons, late 16th century 142-145.
- Kongō-ji temple at Tanba, decorations by Maruyama Ökyo 184.
- Kongō-kai (in Sanskrit, Vajra-dhatu), esoteric pantheon, World of Wisdom 39, 40.
- Kongōbu-ji, monastery of the Shingon sect on Mount Kōya, founded by Kūkai (816) 37, 49;
- Nirvana (Death of the Buddha), hanging scroll (1086) 48, 49.
- Konjaku-monogatari (Buddhist Legends and Folklore), early 12th century 76. Konoe, ministerial family 123.
- Korea 12, 15-17, 19, 20, 22, 26, 89, 110; ancient Korean painting 20; Korean merchants in Japan 65.
- Körin, see Ogata Körin.
- Körin-hyakuzu (One Hundred Master-
- pieces of Korin), woodcut reproductions published by Sakai Hoitsu in 1815 (new series in 1826) 157.
- Koryūsai, see Isoda Koryūsai.
- Kose school of imperial court painters 67:
- Kanaoka, superintendent of the imperial Shinsen-en park (late 9th century) 67; Landscape of the Imperial Park, ordered by Sugawara Michizane (868-872) 67; - Hirotaka (early 11th century) 67, 68;
- Kinmochi, at the court of the emperor
- Murakami, Kintada's brother (mid-10th century) 67;
- Kintada, at the court of the emperor Murakami, probably Kanaoka's grandson (mid-10th century) 67.

kosode, gaudy, short-sleeved kimono 162. koto, horizontal harp 192.

- Kotohira-gū, Shintō temple at Sanuki, decorations by Maruyama Ökyo 184.
- Köya Mount, or Köya-san, sacred mountain at Wakayama 45-47, 81; Eighteen Temples of Yūshi-Hāchi-
- manko: Descent of Amida (Raigo-zu), triptych, early 12th century 45-47.
- Kōzan-ji monastery, northwest of Kyōto, re-established by Köben (1206) 85, 89, 90, 104;
- Portrait of Myoe, by Enichi-bo-Jonin, hanging scroll, first half of 13th century 91, 93;
- Chōjū-giga (Animal Caricatures), four scrolls of drawings, 12th-13th centuries 85, 86;
- Kegonshū-soshi-eden (or Kegon-engi). six scrolls painted by Enichi-bo-Jonin, mid-13th century 89-92.
- Kudara (in Korean, Pekche), ancient kingdom of southern Korea 19, 26.

- Kudara-no-Kawanari (789-853), officer of the imperial guard and a famous painter 67.
- Kuei-chi, see Jion-daishi.
- Kujō family, palace (Kyōto) of the 135. Kūkai (774-835), Japanese monk, founder of the Shingon sect 37, 39, 40;
- his portrait in the pagoda of the Daigoji, near Kyōto 40.
- Kumagai Nobuo, Japanese art historian 110, 113.
- Kumashiro Shukko, called Yühi (1712-1772), Nagasaki painter 184.
- Kundai-kan söchö-ki (Notebook of the Shōgun's Art Secretary), by the Ami family 116.
- Kunisada II, print designer (10th century) 180.
- Kuniteru, print designer (19th century) T80.
- Kurth Dr., art historian (study of Sharaku) 174
- Kushiro Unsen (1759-1811), literati painter 192.
- Kusumi Morikage, pupil of Kanō Tannyū (17th century) 181.
- Kuwayama Gyokushū (1746-1799), pupil of Ike-no-Taiga 192.
- Kyōho era (1716-1736) 165.
- Kyosen, art name of a vassal of the Shōgun Ōkubo Jinshirō (†1777) 167.
- Kyōto (capital of Japan after 794) 37, 39, 42, 60, 65, 68, 69, 83, 89, 91, 92, 103, 106-108, 110, 111, 116, 120, 121, 123, 127, 129, 130, 133, 135, 136, 141,
 - 145, 150, 153, 156, 159, 160, 164, 177, 182, 183, 187;
 - Christian church (built in 1578) 137; Imperial palace (Sheiryo-den) 77, 80, 92, 94, 188;
- Juraku palace, decorated by Kanō Eitoku (1587) 124;
- Muromachi palace 107;
- National Museum 90:
- shogunal painting academy 110, 111, 116, 120, 121;
- ukiyo-e painters of Kyōto 165, 167, 185;
- Views of Kyōto 124, 159, 160.
- Kyōto-Ōsaka region 184, 185.
- Kyūshū, island of southern Japan 10, 11. 14, 15, 19, 92, 101, 103, 111, 136, 138;

Mongol invasions (1274, 1281) 103. Kyzil (Central Asia) 22.

- Lepanto, battle of (1571) 139.
- Liang K'ai, Sung painter (mid-13th century) 107, 130.
- Liao dynasty of the Khitan Tartars in northern China (907-1125) 103.
- Li-chên, painter of the imperial T'ang court 39. Li-shih, Chinese painter 106.

192.

yang-tung 22.

- literati painters, see bunjin-ga.
- literature and poetry in Japan 70, 74,
- 76, 98, 100. Li Yü, Chinese poet of the Ch'ing period

Lotus Sūtra of the Good Law (Myöhö-

renge-kyō or Hokke-kyō), written on fan-

shaped leaves of paper, presented to the

Shitennō-ji temple, Ösaka (c. 1180) 164.

Lung-men (China), central cave of Pin-

machi-eshi, city painters, or popular painters 162.

Magoshi Collection, Tokyo:

- Water Fowl on a Lotus Pond, hanging scroll by Sötatsu 151.
- Mahasattva, Prince, in a previous life of the Buddha (Jataka) 22.
- Makura-no-soshi (The Pillow Book), essays by the lady-in-waiting Seishonagon (early 11th century) 100.
- mandara (in Sanskrit, mandala), representation of the Buddhist pantheon 39, 40. Manet, Edouard (1832-1883) 179, 180.
- Manjušri, see Monju.
- Maruyama-Shijō, realist school from the 18th century on 182.
- Maruyama Ökyo (1733-1795), founder of the Maruyama school of realism 176, 182-185, 187, 188, 190; Scroll paintings:
 - Landscapes of the Yodo River (1765) 182, 183;
- Fortunes and Misfortunes, Peacock, etc. in the Emman-in temple of the Miidera
- monastery, Ötsu 184; Pine Tree in Snow, 1765, Tokyo, National Museum 185, 186;
- Screen paintings:
- Dragons, in the Kanchi-in, Kyöto 184; Pine Trees in Snow, Mitsui Coll. 184; Hotsu River, Nishimura Collection 184; Mural decorations:
- in the Ökyo Pavilion of the Meigen-in temple, 1784 (now National Museum, Tokyo) 185;
- in the Kongō-ji temple, at Tanba; Daijō-ji temple, at Hyōgo; Kotohira-gū, at Sanuki 184;
- megane-e, peep-show pictures (c. 1760) 182:
- sketchbooks (Nishimura Collection and National Museum, Tokyo, 1770-1776) 184.
- Masuda Collection:
- Sutra of Causes and Effects, scroll (8th century) and copy (9th century) 28. Matsugasaki-Tenjin, Shintō shrine at
- Shimonoseki:
- Tenjin-engi scrolls (1311) 95.
- Matsumura Gekkei, see Goshun. Matsumura Keibun, Goshun's brother
- 185. Matsushima (Pine Islands), famous site in northern Honshū 148-151.
- Maya, Shaka-muni's mother 49.
- Ma Yüan, Southern Sung painter (active 1190-1230) 108, 110, 188.
- megane-e, peep-show pictures 182.
- Meigen-in temple, at Aichi 185.
- Meiji era (1868-1912) 193.
- meisho-e, pictures of famous sites 66.
- Meiwa era (1764-1772) 166, 170.
- Miidera monastery, at Ōtsu:
- murals by Kanō Mitsunobu in the Kangaku-in temple (1600) 132. military novel 101.
- Mimana, Japanese protectorate in southern Korea 19.
- Minamoto, court nobles who later became an important warrior family 60, 95, 104, 106;
- Makoto, minister of the left (857-868) 79;

- Yoritomo, founder of the Shögunate at Kamakura (1184) 60, 83, 104; his portrait at the Jingo-ji, Kyōto 83;

Yoshitomo, minister (in 1159) 97. Ming dynasty of China (1368-1644) 108, III.

- Ming painting 111, 184, 187, 188.
- Miroku (in Sanskrit, Maitreya), Buddha 22.
- mitsuda-e, oil painting employing litharge (mitsudaso) as a siccative, special
- technique of ancient painting 20. Mitsui Collection 61;
- Pine Trees in Snow, pair of screens by Maruvama Ökyo 184.
- miya-mandara, bird's-eye view of Shintō shrine 92.
- Miyakawa Chōshun (1683-1753), painter of feminine figures 166.
- Miyake-shima, islet in the Pacific, south of Tokyo 182.
- Miyako, name given by the Jesuits to Kvōto 136.
- Miyamoto Musashi (1584-1685), or Niten, painter and swordsman 136.
- Miyoshi, noble family 123, 125.
- Moko-shurai-ekotoba (Invasions of the Mongols), two handscrolls (c. 1293) in the Imperial Collections 101.
- Mokuan Reien, Zen painter-monk (died in China, 1329) 107.
- Mokuren (in Sanskrit, Mangdalyana), disciple of the Buddha 88.
- Momoyama period (late 16th-early 17th century) 121, 124, 125, 129, 132, 134, 135, 144, 150; castle of Momoyama of Toyotomi
- Hideyoshi, decorated by Kanō Sanraku (1592) among others 124, 133.
- Monet, Claude (1840-1926) 179.
- Mongol invasions 101.
- Monju (in Sanskrit, Mañjuśri), Buddhist divinity, bodhisattva 108.
- monogatari, novel or tale in Japanese literature 70.
- Mori Collection (Tokyo):
- Sansui-chōkan, scroll by Sesshū 113. Mori Sosen (1749-1821), animal painter 187.
- Mori Teijiro, Japanese archeologist 17.
- Morikawa Collection (Tokyo): Saigyō-hōshi-ekotoba (Life of the poetmonk Saigyō), four scrolls by Sōtatsu (1630) 145.
- Moronobu, see Hishikawa Moronobu.
- Motonobu, see Kanō Motonobu.
- Mu-ch'i (pseudonym Fa-ch'ang), Zen Chinese painter (mid 13th century) 106, 107, 120, 127.
- Mugaku Sogen (Wu-hsüeh Tsu-yüan, 1226-1286), Chinese Zen monk, founder of the Enkaku-ji (1282) 106.
- Murakami (926-967), emperor, founder of the Daigo-ji pagoda (951) 39, 67.
- Murasaki-shikibu, lady-in-waiting of the empress, author of the Tale of Genji (1010) 70.
- Murasaki-shikibu-nikki (Diary of the Lady-in-Waiting Murasaki) 100.
- Muromachi or Ashikaga period (1336-1573) 107, 141, 144, 159.
- Muromachi palace, Kyōto 107.
- Musō Soseki (1275-1351), Japanese Zen monk 105-107.

- Muto Shui, Japanese Zen painter-monk 105-107.
- Mutsu province (northern Japan) 100. Myōchi-in, Zen temple, Kyōto:
- Portrait of Muso Soseki (1275-1351) by Muto Shui, hanging scroll on silk 105-107.
- Myōe-shōnin (1173-1232), or Kōben, monk of the Kōzan-ji 89-91;
- My Dreams (1220) 91;
- his portrait in the Kozan-ji by Enichibō-Ĵōnin 91, 93.
- Myöö (in Sanskrit, Raja), angry gods 53-55, 57.
- Myoren, monk of the Chogo-sonshi-ji on Mount Shigi (late 10th century) 75-78.
- Myöshin-ji, Zen monastery, Kyöto: three pairs of screens by Kaiho Yūshō (1595-1600) 131-133; two pairs of screens by Kanō Sanraku
- on Chinese historical subjects 135;
- Reiun-in temple, sliding doors painted by Kanō Motonobu (1543-1549) 118, 119, 121, 125;
- Tenkvū-in temple, decorated by Kanö Sanraku with Sansetsu (1631-1635) 3, 4, 134, 135, 137.
- Nagasaki 138, 176, 183, 184, 190; Jesuit art school 138; Nagasaki school of painting (17th
- century) 184. Nagasena (in Sanskrit, Nagassina), disci-
- ple of the Buddha, symbol of mercy 49, 50.
- Nagoya, Tokugawa Museum:
 - scroll paintings of the Tale of Genji, early 12th century 70, 72, 74, 75, 79; castle of Tokugawa Ieyasu (built in 1614):
 - interior decoration attributed to the Kanō studio, chiefly to Takanobu or Naganobu (popular scenes) 132, 162.
 - Nakabashi Chikudō (1776-1853), literati painter 192.
 - Nakabashi Kanō, Kanō school of Edo (17th-19th centuries) 181.
- Nakamura Kuranosuke, patron of Ogata Korin 156;
- his portrait by Ogata Körin (1704) 156. Nakura (in Sanskrit, Nakula), arhat,
- symbol of Divine Power 49, 51. Namban-byōbu (screens of the "Southern
- Barbarians," representing the arrival of Westerners in Japan 139, 160.
- nan-ga (in Chinese, Nan-hua), Southern School of Chinese painting 188-190, 192, 193.
- Nara, ancient city of central Honshū, capital of Japan in the 8th century 19, 27, 37, 45, 53, 67, 75, 104;

screens of richly dressed ladies (17th

Nara period (late 8th century) 29, 33,

Narasaki Muneshige, art historian, print

Nenchū-gyōji (Annual Court Ceremonies)

207

Yamato-bunka-kan Museum:

Narutaki, suburb of Kyöto 153.

nehan-zu, Nirvana scene 48, 49.

Neolithic period in Japan 11.

century) 162.

34, 39, 65, 67.

specialist 164.

80.

- Nichi-getsu-sansui-byōbu (Screens of the Four Seasons), late 16th century (Tokyo, National Museum and Kongōji at Kauchi, Ōsaka) 142-145.
- Nichiren, Japanese monk, founder of the Hokke sect (13th century) 120.
- Nichizō, monk who visited Hell according to the legend of *Kitano-tenjin-engi* 92.
- Nicolao, Giovanni, Christian missionary, who came to Japan (c. 1583), head of the Jesuit art school of Nagasaki 138. Nihonshoki, first official Japanese annals
- (compiled in 720) 19, 22. Nijō castle, Kyōto (the "Versailles of Japan"), built in 1601-1603, decorated
- by Kanō Tannyū and his studio (1626) 135, 136; visit of the emperor Go-mizunoo (1626)
- 135, 160. Ning-po, port in southern China 111.
- Ning-po, port in southern China III. Ninsei (family name Nonomura), Kyöto
- potter (17th century) 153. Niou-no-miya, grandson of Prince Hikaru
- in the Tale of Genji 73, 75. nirvana (in Sanskrit), death of the Buddha
- 48, 49.
- nise-e, realistic portraits, fashionable in the 13th and 14th centuries 83, 94, 101. Nishikawa Sukenobu (1674-1754), print
- designer of Kyōto 165, 167. nishiki, brocade 167.
- nishiki-e, polychrome print initiated by Harunobu 166, 167, 170, 171.
- Nishimura Collection (Kyōto): sketchbooks of Maruyama Ōkyo (1770-
 - 1776) 184; Hotsu River, screens by Maruyama
- Ökyo 184.
- Nishimura Shigenaga (†1756) 165.
- Niten, see Miyamoto Musashi. Ni Tsan, Chinese literati painter (1301-
- 1374) 188.
- Nō plays and masks 73, 153; Nō actors 174.
- Nobuharu, see Hasegawa Nobuharu.
- Nobukata, painter (late 16th early 17th century) working in the European style 139.
- Nomura Bun-ei Collection, Kyöto: Landscape and Boat in Stormy Weather, hanging scroll by Shūkei Sesson 117, 120.
- Noro Kaiseki (1747-1828), pupil of Ikeno-Taiga at Wakayama 192.
- Noto province (northern Japan) 126.
- novels of the Heian period 70, 164. Nyorai (in Sanskrit, Tathagata), the
- Buddhas 53. Nyosannomiya, wife of Prince Hikaru in
- the Tale of Genji 73.
- Obaku, Zen sect introduced in the 17th century (in Chinese, Huang-po) 183, 184.
- Oda Nobunaga (1534-1582), ruler in power at Kyōto (from 1568) 123, 124, 129, 136.
- Ōei civil war (1467-1477) 111, 123.

208

Ogata Kenzan (1663-1743), Kōrin's brother (pseudonyms Shinsei or Shisui), potter and painter 153, 156, 157; sets of bird and flower pictures of the twelve months 157. Ogata Kōrin (1658-1716) 153-157, 182; designs on ceramics 153; *Irises* (before 1704), screen painting, Tokyo, Nezu Museum 153, 156;

Azaleas, hanging scroll 156; Red and White Plum Trees (c. 1710), pair of screens, Atami Museum 154-156; Wind and Thunder Gods, copy after Sötatsu, Commission for Protection of Cultural Properties 156, 157; Portrait of Nakamura Kuranosuke

- (1704) 156. Ogataryū-inpu, collections of seals of the
- Ogata school, published by Sakai Hõitsu (1815) 157.
- Ogata Sõhaku (1571-1631), Körin's grandfather 153.
- Ogata Söken (1621-1687), Körin's father 153.
- Ogino Isaburō, actor of the Ichimuraza theater, Edo (1726) 166, 168.
- Öhashi Hachirō Collection (Tokyo):

dõtaku (1st century A.D.), from the Kagawa Prefecture (Shikoku) 13, 15. õ-hiroma, audience hall of palace 136.

- oil painting 20, 138; coat of oil protecting the painting 33.
- Oita (Kyūshū) III.
- Okada Beisanjin (1744-1820) 192;
- his eldest son Hankö (1782-1846) 192. Okakura Tenshin (1862-1913), Japanese art critic who formed the nucleus of the Far Eastern Collection of the Boston Museum of Fine Arts 53.
- oku-eshi, studio painters in the service of the shogunal family (17th-19th centuries) 181.
- *ōkubi-e*, painting with the face in close-up 170.
- Okumura Masanobu (1686-1764), painter and publisher of actors' portraits 165, 166.
- Ökyo, see Maruyama Ökyo.
- Ökyo Pavilion, see Maruyama Ökyo.
- Omi province (central Honshū) 129.
- omote-eshi, painter of the shogunal academy (17th-19th centuries) 181.
- Onjō-ji (Mii-dera) monastery at Ōtsu: Ki-fudō (Yellow-bodied Fudō, 9th century) 57.
- onna-e, painting in the feminine manner 74.
- *ōrai-mono*, popular literature of a practical nature describing the itinerary of the main highways 164.
- Osaka 120, 141, 144, 145, 164, 182, 183; castle of Osaka decorated by Kano Eitoku (1583) 124, 132, 133.
- Otogi-zōshi, scrolls of popular novels and tales (15th century) 102.
- Ōtomo (or Tōmo), aristocratic family of Ōita 111.
- Ötsuka Tomb (northern Kyūshū), royal tomb of the Tumulus Period 14-16. Õuchi, aristocratic family of Yamaguchi
- (western Honshů) 111. Owari province (central Honshů) 123.
- pai-hua (in Chinese), ink monochrome
- painting 34.
- Paleolithic Age in Japan 11.
- Paris, Musée Guimet, print collection bequeathed by Dr Gachet 180; World's Fair (1867) 180; (1889) 180.

- Pekche (Korea), see Kudara.
- Peking III;
- National Museum: three-color pottery from Ch'ang-an, tomb of Hsien-yüt'ing-hui (†723) 34.
- Phoenix Hall, see Hoo-do.
- plumes overlaid on paper 31, 33.
- Po Chü-i (772-846), Chinese poet 70.
- Portuguese in Japan 123, 136, 139.
- print, technique and development of the
- 159, 164-167, 170, 174-176, 179, 180. prints (for calligraphy), Chinese polychrome 166.

Raigo-ji temple at Shiga:

- Sixteen Arhat, late 11th century (now National Museum), Tokyo) 49-51.
- raigō-zu, pictorial image of the Descent of Amida 42, 43, 45, 47, 63, 68, 78.
- raja (in Sanskrit, Godaison) 60.
- rakan (in Sanskrit, arhat), disciple of the Buddha 49-51.
- rakuchū-rakugai-zu, views with popular festivals 160.
- Rankei Dōryū (in Chinese, Lan-ch'i Taolung, 1213-1278), great Zen master, founder of the Kenchō-ji temple at Kamakura 106;
- his portrait at the Kenchō-ji (1271) 106. Renge-ō-in, Buddhist temple of Kyōto, known as "Sanjū-san-gen-dō":
- Wind and Thunder Gods, polychrome statues (13th century) 148.
- Resurrection of the Buddha (Shaka-saiseiseppō-zu), in the Chōbō-ji, late 11th century 103.
- rinne, doctrine of the mystical circuit of souls through the Six Spheres 63.
- Rokudō-e, illuminated scrolls of the Six Paths, 13th century 88.
- Rokujo-no-miyasudokoro, character in the Tale of Genji 135.
- ryaku-reki, leaf of an abridged calendar 166.
- Ryōan Keigo, Zen monk and writer (on Sesshū, 1486) 113.
- Ryūmyō (in Sanskrit, Nāgārjuna), Hindu monk and great Buddhist theologian (late 2nd-early 3rd century), mistakenly spelt Ryūmo in the text 40; bis portrait in the Daico ii. 40;

his portrait in the Daigo-ji 40.

- Sadahide, print designer (19th century) 180.
- Saichō (767-822), Buddhist monk, founder of the Tendai sect, of the Enryaku-ji monastery (805) on Mount Hiei 37, 39.
- Saidai-ji temple, Nara: Jūni-ten (twelve deva), polychrome
- painting, 9th century 39.

Saifuku-ji temple, Ösaka:

- Cocks and Cactus, sliding doors by Itō Jakuchū 188, 189.
- Saigyō (1118-1190), poet monk, illustrated life of (Saigyō-hōshi-ekotoba), copy by Sōtatsu (1630), Imperial Collections 145.
- Saiho Jōdo (Pure Land of the West), Paradise of Amida 40.
- Saishōkō-in, Kyōto, wall paintings (1173) in the adjoining palace 80, 81. Saitō Jūrōbei, name of an actor identified

with Tōshūsai Sharaku 174.

Sakai, seaport near Ōsaka 144.

- Sakai, noble family at the Edo court 156. Sakai Hoitsu (1761-1828) 157;
- publications: One Hundred Masterpieces
- of Korin (Korin-hyakuzu), two series (1815, 1826) and Collection of Seals of the Ogata School (Ogataryū-inpu) (1815) 157:
- Autumn Plants, painted on the back of the screens of the Wind and Thunder Gods by Ogata Körin, Commission for Protection of Cultural Properties 157.
- Sakai Tadahiro Collection, Tokyo: Ban-dainagon-ekotoba, 12th-century scrolls 79-81.
- Sakaki Hyakusen (1697-1752), Japanese literati painter 190.
- sake, alcoholic beverage made from rice 102.
- sala, sacred tree 49.
- Sanraku, see Kanō Sanraku.
- Sanshuku (in Sanskrit, Ārdrā), one of the Seven Stars 40, 41.
- Sassanians (Iran) 23. Satake Höhei (1750-1807), pupil of Ike-
- no-Taiga, painter of Shinano 192. sato-eshi, private painter of the Nara
- period (8th century) 27 Seikado Foundation, see Tokyo.
- Seimei (in Korean, Syöng-myöng), emperor
- of Kudara (Pekche) 19. Seishi (in Sanskrit, Mahāsthāmaprāpta), Bodhisattva 45, 63.
- sei-shinden, small private building for the
- emperor's use 134. Seitaka (in Sanskrit, Cetakah), Buddhist divinity, attendant of Fudō-myōō (Acala) 37.
- Sekai-kyūsei-kyō Collection, see Atami Museum.
- senmen-ga, painting on fan paper 144, 149, 150, 152, 164, 190.
- Sen-no-Rikyū (1518-1591), great tea master, founder of the Sen-ke school 127. Senzui-byobu (landscape screen) 69, 71.
- Sesshū school 127, 136. Sesshū Tōyō (1420-1506), Zen painter-
- monk 110-117, 120, 136, 176, 181; journey to China (1467-69) 111; journey through Japan (1481-84) 113; his Tenkai-toga-ro studio 111, 113; Works:
- Four Chinese Landscapes, Tokyo, National Museum (1467-1469) 111;
- Autumn Landscape (Shūkei-sansui), Tokyo, National Museum 112, 113; Sansui-chōkan, landscape scroll, Mori Collection 113;
- Haboku-sansui (Landscape in the Cursive Style), 1495, Tokyo, National
- Museum 113, 114; Huei-k'o cutting off his arm to show his willpower to Bodhidharma (Eka-danpi), 1496, Sainen-in temple 113;
- Landscape of Ama-no-hashidate (Bridge of Heaven), 1502-1506, Commission for Protection of Cultural Properties 115, 116.
- Sesson, see Shūkei Sesson.
- setsu, snow 117.
- Shaka-muni (Śākyamuni, in Sanskrit) or Shaka (nyorai), Buddha 20, 22, 28, 45, 49, 58, 60, 108, 138;

- Shaka-muni Preaching, 8th century, Boston Museum of Fine Arts 26, 27, 69;
- bronze statue in the Hōryū-ji (623) 19, 53, 58, 60.
- Shaka-saisei-seppō-zu, see Resurrection of the Buddha.
- shaku, kind of scepter of high dignitaries 83.
- Sharaku, see Tōshūsai Sharaku.
- Sheirvo-den, imperial palace, Kyoto 77, 92;
 - fires (1176) 79; (1661) 80; Oten-mon, main gate (burnt in 866) 70. 80:
 - Sujaku-mon, outer gate 80;
- Taiken-mon, imperial gate 96.
- Shên Chou (1427-1509), Chinese literati painter 188.
- Shên Nan-p'in (or Shên Ch'üan), Chinese painter (worked in Nagasaki, 1731-
- 1733) 184, 187, 193. Shibui Kiyoshi, Japanese art historian
- and print specialist 164; - Collection:
- Kasen-koi-no-bu (Love Poems), set of
- prints by Utamaro 171, 172. Shichigutei (in Sanskrit, Cundibhagavati), sixteen-armed Bodhisattva 38, 40.
- shigajiku, scroll of painting and poetry (fashionable from the first half of 15th
- century) 108, 110. Shigemasa, see Kitao Shigemasa.
- Shigenaga, see Nishimura Shigenaga.
- Shigi, Mount (southwest of Nara) 74-76. Shigisan-engi-emaki (Origin of the Temple
- of Mount Shigi), three scrolls in the Chōgo-sonshi-ji on Mount Shigi, 12th century 74-80, 90, 100.
- Shijō, entertainment center of Kyōto 160.
- Shijō school, founded by Goshun (1752-1811) 185;
- Maruyama-Shijō school 182.
- shiki-e, painting of the four seasons 66, 69, 113, 125, 142-144, 151.
- Shikoku, island of Japan 13, 15
- Shimada Shūjirō, Japanese art historian 102
- Shimonoseki, town in western Honshū: Shinto shrine of Matsugasaki-Tenjin 95. Shinano province (central Honshū) 75, 192.
- shinden, central building of the shindenzukuri 65.
- shinden-zukuri, construction of noble houses in Japan, Heian period 65.
- Shingon, esoteric Buddhist sect (in Chinese, Chên-yen; in Sanskrit, mantra) 37, 39, 40, 45, 53.
- shinkei, view of an actual place 190.
- Shinran (1173-1262), Japanese monk, revived the Jodo and Shinshū sects 63.
- Shinsei, or Shisui, pseudonyms of Ogata Kōrin 153, 156, 157.
- Shinsen-en, imperial park 67.
- Shinshū, Amidist sect, reformed by Shinran (at the Hongan-ji, Ishiyama) 120. Shintō shrines 81, 92.
- Shintō religion 95, 102.
- Shin-ukiyoe-ruiko (book published in 1869) 174.
- Shiragi (in Korean, Silla), kingdom of ancient Korea 89.

- Shitenno-ji temple, Ösaka:
- ten albums of the Lotus Sūtra of the Good Law (1180) 164.
- Shōei, see Kanō Naonobu.
 - Shōgun, military governor at the head of the bakufu 107, 108, 116, 120, 123, 132, 141;
 - shogunal academy of painting 110, 116, 120, 121.
 - shōji, sliding door 66, 70, 81, 88, 108, 118, 119, 121, 124, 125, 127, 129-131, 134, 150.
 - Shōkadō Shōjō (1584-1639), painter-monk of Otokovama, near Kyōto 136.
 - Shōkai, disciple of the monk Ippen (13th century) 99.
 - Shōkei Ten-yū, painter of the Shūbun school 110.
 - Shokunin-uta-awase, poetry competition between different crafts 101.
 - shokunin-zukushi, illustrations of different occupations 160.
- Shōmu (701-756), emperor of the Nara period 29.
- Shōno, view of (stage on the Tōkaidō highway) 178.
- Shorchuq (Central Asia) 22.
- Shōren-in temple, Kyōto:
 - Fudō-myōō, hanging scroll on silk, mid-11th century 55, 57.
- Shōsō-in, imperial collection of Nara 29, 31-34, 65;
- paintings on musical instruments (genre scenes and landscapes), 8th century 32-34, 69;
- landscapes on maps in the T'ang style, 8th century 34;
- Beauties beneath a Tree (Chōmōryūjobyobu), screen painting, 8th century 31, 33;
- Bodhisattva seated on a Cloud, drawing on hemp cloth, 8th century 34, 35.
- Shōtoku (572-622), Prince, the emperor Yomei's son and regent of the empress Suiko at the Yamato court 19, 20, 26.
- Shōun-ji temple, Kyōto, built by Hideyoshi in 1592 (now destroyed) 129. Shoun-ji temple, Sakai:
- Matsushima (Pine Islands), screen paintings by Sōtatsu (now in the Freer Gallery, Washington) 148-151.
- Shubun Tensho or Ekkei (second quarter of 15th century), Zen painter-monk of the Sōkoku-ji 109-111, 113, 116, 120; journey to Korea (1423-1424) 110; Kozan-shōkei, landscape scroll traditionally attributed to Shubun, Tokyo, Ishii Yūshi Collection 109, 110.
- Shūkei Sesson (c. 1504-after 1589), wash painter 117, 120;
- Landscape and Boat in Stormy Weather, hanging scroll, Nomura Bun-ei Collection, Kyōto 117, 120.
- shukuba, relay stations along the road 178.
- Shumiyoshi school, deriving from the Tosa school (from 17th century on) 176.
- Shunkō, print designer, pupil of Katsukawa Shunshō 176. Shunrin Shūtō, monk of the Sōkoku-ji,

209

Zen master of Sesshū III.

- Shunrō, pseudonym of Hokusai while working in the studio of Katsukawa Shunshō (1778-1792) 176.
- Shunshō, see Katsukawa Shunshō.
- Six Dynasties period (China, A.D. 220-589) 20.
- Six Paths, doctrine of the 88, 92, 94; Scrolls of the Six Paths (Rokudo-e) 88.
- Sō Shiseki (1712-1786), painter of the realist school of Edo 184.
- Soen Josui, monk of the Enkaku-ji, disciple of Sesshū 113, 115, 117.
- Soga Chokuan (early 17th century), monochrome painter 136.
- Soga school, founded by Jasoku 116.
- Sōkei, see Ten-ō Sōkei.
- Sōkoku-ji, Zen monastery of Kvōto 110. 111, 136, 187, 188.
- Sosen, see Mori Sosen.

Sösetsu, Sötatsu's brother or son 152. sōshi, book in the form of an album 70. Sotan, see Ten-o Sotan.

- Sotatsu (active c. 1630) 102, 141, 144-153, 156, 176;
 - Scroll paintings:
 - Saigyō-hōshi-ekotoba (Life of the poetmonk Saigyō), 1630, Morikawa Collection 145;
 - Flowers of the Four Seasons, Deer, Lotus Flowers (attributions), with Hon-ami Kōetsu 151, 152;
 - Water Fowl on a Lotus Pond, Magoshi Collection 151;
 - Screen paintings:
- three pairs on gold background for the emperor Go-mizunoo (1630) 145;
- Scenes from the Tale of Genji, Seikado Foundation, Tokyo 145-148; Bu-gaku (Classical Dances), in the
- Daigo-ji 148; Wind and Thunder Gods, in the Kennin-
- ji, Kyōto 148, 156, 157 Matsushima (Pine Islands), Washing-
- ton, Freer Gallery 148-151; Sliding doors:
- in the Yōgen-in, Kyōto (1621) 149, 150. Sotatsu-Korin school 141-157, 176, 181, 190.
- Starving Tigress, Legend of the 21, 22. Sugawara, noble family of scholars, Heian period 92;
- Koreyoshi, Michizane's father 94-96;
- Michizane (845-903), minister and poet at the court of the emperor Uda 67, 92, 94;
- Life of Sugawara Michizane and the Origins of the Shinto shrine of Kitano, see Kitano-tenjin-engi.
- Suhō province (western Honshū) 113, 136. Sui dynasty of China (589-618) 22.
- suiboku-ga, wash painting 107, 108, 111, 115, 116, 120, 127, 130, 134, 136, 151, 188, 192.
- Sukenobu, see Nishikawa Sukenobu.
- Sumeru, Mount (symbolic image of the world in Buddhist mythology) 20.
- Sumiyoshi, Shintō shrine of 148.
- Sung dynasty of China (960-1279) 53, 103, 104, 106; Southern Sung 103, 110;

210

painting of the Sung dynasty 90, 100, 103, 104, 106-108, 110, 111, 113, 121, 127, 130, 187, 188.

Sung dynasty, ancient (429-479) 19.

- Sung-kao-seng-chuan (Lives of the Great Monks), compiled in the Sung period, in Chinese 90, 91.
- surimono, print in a limited edition for distribution among friends 167.
- suri-shi, painter 167.
- sūtra 19, 27, 28, 37, 45, 49, 74, 87, 88, 102, 149, 164.
- Suzuki Harunobu (1725-1770), print designer specializing in feminine figures 167, 170, 171, 176, 180;
- Girl on her Way to the Shinto Shrine, Tokyo, National Museum 167, 169. Suzuki Keizō, Japanese historian, specia-
- list in ancient costumes 80.
- Syöng-myöng, emperor of Pekche (523-554), Korea 19.
- Taga Shinkō, see Hanabusa Itchō.
- Taihō-ryō law (promulgated in 701) 27. Taika reform (645) 22.
- Taikō Josetsu, Zen painter-monk, founder of the new school of monochrome painting 110, 113;
- Hyonen-zu (Parable of the Old Fisherman, before 1415) 110.
- Taima-dera temple (south of Nara) 27: Taima-mandara (763), silk tapestry representing the Paradise of Amida and stories from the Kan-muryoju-kyo sūtra 27.
- Taira (Heike), court nobles who became a powerful warrior family (in power, 1167-1184) 60, 95, 104, 149;
- Kiyomori, dictator of the Taira family 83, 103, 104;
- Shigemori, Kiyomori's son, courtier of the emperor Go-shirakawa (1138-1179) 83; his portrait at the Jingo-ji, Kyōto 82, 83, 87, 107.
- Taizō-kai (in Sanskrit, Garbha-dhatu), World of Reason 38-40.
- Takagamine, art colony (founded by Honami Kōetsu) 150, 151, 153.
- Takao, Mount 159.
- Takashina Takakane, head of the court atelier at Kamakura (early 14th centu- \mathbf{rv}):
- Kasuga-gongen-kenki (Miracles of the Shinto Deities of Kasuga), twenty scrolls ordered by Fujiwara Kinhira (1309) 102.
- Takehara-kofun Tomb, Wakamiya-machi, Fukuoka (Tumulus Period) 10, 15-17.
- Taketori-monogatari, novel (early 10th century) 70.
- Takezaki Suenaga (late 13th century),
- warrior of Higo (Kyūshū) 101. Takuma school of painting (from 12th century on) 104;
- Shōga (active between 1168-1209), Twelve Deva, pair of screens, 1191, in the Tō-ji, Kyōto 104.
- tamamushi, kind of beetle 20.
- Tamamushi-no-zushi, Buddhist shrine with paintings on lacquered panels, in the Horyū-ji temple, Nara (mid 7thcentury) 18, 20-22.
- Tanaka Collection, Tokyo:
- Annual Court Ceremonies, seventeen illuminated scrolls, copy after Tokiwa Mitsunaga 80.

- Tanaka Ichimatsu, Japanese art historian 141.
- Tanba province 182.
- tancho, or tancho-zuru, red-headed crane 121, 125.
- tan-e, prints hand-colored with orange-red (tan), early 18th century 165.
- T'ang dynasty of China (618-906) 29, 33, 53, 104;
 - T'ang art 19, 23, 27, 34, 65, 69, 75, 77, 103:
 - T'ang influence on Japanese art 22, 23, 27, 40, 53, 103;
- T'ang fashions and costumes 28, 33, 60.
- Tani Bunchō (1763-1840), favorite painter of the military caste of the Shogunate 102.
- Tani Nobukazu, Japanese art historian 116, 141.
- Tanomura Chikuden (1777-1835), literati painter 192.
- tarashikomi, print technique for obtaining shadings on uniform surfaces 151.
- Tatebayashi Kagei (18th century), painter of the Sōtatsu-Kōrin school 157
- Tawara-ya, name of the firm of fanpainters headed by Sotatsu 149, 152.
- Tawaraya Sori, pseudonym of Hokusai (Sōtatsu-Kōrin style) 176.
- tea masters 127.
- Temmei era (1781-1789) 170.
- ten, heaven 88, 92.
- Tendai, Buddhist sect 37, 39, 40, 53, 57, 98.
- Tenjin (God of Heaven), Shintō divinity, patron of scholars and men of letters (see also Sugawara Michizane) 92, 94; Kitano-tenjin-engi, 1194, oldest text 92:
 - idem, Jokyū-bon or Kompon-engi (1219)
 - 92, 94, 97; idem, Kōan-bon (1278, mistakenly dated 1282 in the text) 95, 146, 148;
- Tenjin-engi, in the Matsugasaki-Tenjin shrine, Shimonoseki (1311) 95.
- Tenjukoku-mandara (Paradise scene), panels of embroideries dedicated to Prince Shōtoku (c. 622), in the Hōryū-ji, Nara 20.
- Tenkai-toga-rō, name of Sesshū's studio 111, 113.
- Ten-ō Sōkei, Sōtan's son, screen paintings for the Yotoku-in temple (not Yogen-in) at the Daitoku-ji, c. 1490, initiated by his father 116.
- Ten-ō Sōtan (1413-1481), disciple of Shūbun 116, 120.
- Ten-yū Shōkei (mid-15th century), painter of the Shubun school:
- Kozan-shökei, landscape scroll, Ishii Yūshi Collection, Tokyo 109-111.
- Tetsugai-sho, Hell of the Iron Mortar 86-88.
- Toba-sojō, see Kakuyū.
- Tōdai-ji, temple of the Great Buddha at Nara (erected in 752) 27, 29, 34, 75, 76. 89:
- Hokkedō-kompon-mandara, late 8th century 26, 27.
- Todoki Baigai (1749-1804), painter 192. Tōfuku-ji, Zen monastery of Kyōto 110, 129.

- Tō-ji (or Kyōō-gōkoku-ji), temple of the Shingon sect at Kyōto, under the monk Kūkai (823) 37, 39;
 - Twelve Deva and Five Raja series (1127) 57, 60;
- Twelve Deva, pair of screen paintings by Takuma Shōga (1191) 104; Senzui-byobu, landscape screen, 11th century (now owned by the Commission
- for Protection of Cultural Properties) 69, 71;
- Kanchi-in temple:
- Dragons, pair of screens painted by Maruyama Ökyo 184.
- Tōkaidō, main highway from Kyōto to Edo 164, 176-179.
- Tokiwa Mitsunaga (active 1158-1179), painter of the imperial court 80, 81; wall paintings in the Saishōkō-in temple (1173) 80, 81;
 - attributions:

Ban-dainagon-ekotoba, three illuminated scrolls, Sakai Collection, Tokyo 79-81, 87. 100:

Annual Court Ceremonies, sixty illuminated scrolls (destroyed) 80.

- toko-no-ma, niche in the main room of a house (lay or clerical) for holding a painting or a vase of flowers 108.
- Tokugawa, shogunal family, succeeded the Toyotomi (1615-1868) 125, 132, 135, 138, 141, 153, 164, 176, 179; Ieyasu (1542-1616), first Shögun at Edo (1603-1605) 129, 132, 135, 150; Hidetada, second Shōgun (1621) 150; Iemitsu (1604-1651), third Shögun at Edo (1623-1651) 135; Yoshimune (1684-1751), eighth Shōgun
- at Edo (1716-1745) 176. Tokyo 132, 135 (see also Edo);
- Tokyo Bay 193. Tokyo, Commission for Protection of Cultural Properties:

Jigoku-zōshi (Hell Scroll), late 12th century, formerly Hara Collection 86-88; Senzui-byobu (Landscape Screen) from the Tō-ji, 11th century 69, 71;

Gaki-zōshi (Scroll of Hungry Demons), 12th century 88;

Wind and Thunder Gods, screen paintings by Ogata Körin after Sötatsu (on the back, painting by Sakai Hoitsu) 156, 157:

Landscape of Ama-no-hashidate (Bridge of Heaven), hanging scroll by Sesshū Tōyō (1502-1506) 115, 116.

- Tokyo, Goto Museum:
 - Scroll of the Tale of Genji, 12th century 70:
 - Landscape on hemp cloth, from the Shōsō-in, Nara, 8th century 34.
- Tokyo, National Library 180.
- Tokyo, National Museum:
- Anonymous works:
- Sixteen Rakan (Disciples of the Buddha), from the Raigo-ji, Shiga, late 12th century 49-51;
- Fugen-bosatsu on a White Elephant and Kokuzō-bosatsu, hanging scrolls on silk, formerly Mitsui Collection, 12th century 56, 60;
- Gaki-zōshi (Scroll of Hungry Demons), late 12th century 88;

Escape of the Young Emperor (Rokuhara-gyōkō), handscroll from the Heijimonogatari, 13th century 95;

Nichi-getsu-sansui-byobu (Screens of the Four Seasons), late 16th century 144, 145;

- Other works:
- Ando Hiroshige, Landscape of Shono, print (1833) 177, 178;
- Goshun, Landscapes, pair of screens 185, 187;
- Hasegawa Tohaku, Pine Wood, pair of screens 127-129;
- Ike-no-Taiga, Screens in the Chinese Style (c. 1760-1770) 190, 191;
- Kano Eitoku (attribution), Hinokibyobu (screen with hinoki), c. 1590, from the palace of Hachijo-no-miya Tomohito 125;
- Kano Hideyori, Looking at the Red Maples on Mount Takao, screen painting 159:
- Kanō Sanraku, Kuruma-Arasoi, scene from the Tale of Genji, screen from the palace of the Kujo family 135;
- Maruyama Ökyo, Pine Tree in Snow,
- hanging scroll (1765) 185, 186;
- sketchbooks (1770-1776) 184;
- paintings in the "Okyo Pavilion," formerly at the Meigen-in, at Aichi (c. 1784) 185); Sharaku, Portrait of Ichikawa Ebizō,
- color print (1794) 173, 174;
- Suzuki Harunobu, Girl on her Way to the Shinto Shrine on a Stormy Night, color print 167, 168;
- Sesshū Tōyō, Shūkei-sansui (Autumn and Winter Landscape), hanging scroll
- 112, 113; - Haboku-sansui (Landscape in the Cursive Style), hanging scroll (1495) 113, 114;
- Four Chinese Landscapes (1467-1469) III:
- Torii Kiyonobu II, The Actor Ogino Isaburō on Stage, hand-colored print 166, 168.
- Tokyo, Nezu Museum:
- Irises, screens by Ogata Korin (before 1704) 153, 156.
- Tokvo, Seikado Foundation:
- Death of Shinzei, scene from the Heijimonogatari, handscroll, 13th century 95;
- Peasant leading his Horse across a River, hanging scroll on silk by Hanabusa Itchō (before 1698) 182, 183;
- pair of screens with scenes from the Tale of Genji, by Sotatsu 145-148.
- Tokyo, Hara Kunizo Collection: Cherry Blossom Festival, screen painting
- by Kanō Naganobu 160-162. Tokyo, Sakai Tadahiro Collection: Ban-dainagon-ekotoba, scroll paintings attributed to Tokiwa Mitsunaga, second
- half of 12th century 79-81, 87. Tokyo, Reimeikai Collection (on deposit
- at the Nagoya Museum): Scroll paintings of the Tale of Genji, 12th century 72, 73, 75, 80.
- Tokyo, Fine Arts University: Sūtra of Causes and Effects, scroll, 8th century 28.

- Tomo (Otomo), aristocratic family of the Nara and Heian periods (8th-9th centuries) 79, 111;
- Yoshio (811-868), secretary of state (dainagon) 76.
- Torii Kiyonaga (1752-1815), portraits of actors and women 170-171, 176;
- Kiyomitsu (1735-1785) 170;
- Kiyonobu II (1702-1752) 165, 166; Portrait of the Actor Ogino Isaburō (1726) 166, 168;
- Kiyonobu (1664-1729) 165;
- Kiyomasu (1694-1716?), Kiyonobu's son 165.
- Tosa family, court painters descending from one of the oldest military clans (from late 14th century on) 102, 135, 144, 162, 164, 176, 190, 193;
- Mitsunobu (†1522) 120, 144;
- Mitsuoki (1617-1691), Mitsuyoshi's grandson 144;
- Mitsuyoshi (16th century) 144;
- Yukimitsu (active 1352-1389), founder of the family 144;
- Yukihiro (early 15th century, then still called Fujiwara), Yukimitsu's son or grandson who began using the name Tosa 144.
- Toshūsai Sharaku (active 1794-1795), print designer, actor portraits 171, 174;
- first set (May 1794), 28 portraits; second set (July 1794), then November 1794 and February 1795 171;
- Portrait of the Actor Ichikawa Ebizo (1794), Tokyo, National Museum 173, 174.
- Toulouse-Lautrec (1864-1901), 162.
- Toyonobu, see Ishikawa Toyonobu.
- Toyotomi family (exterminated 1615) 125, 129, 132, 133;
- Hideyoshi (1536-1598), dictator, succeeded Nobunaga (1582-1598) 124, 125, 127, 129, 132, 133, 138; memorial ceremony (1604) 160;
- Sutemaru (†1592), Hideyoshi's son 129.
- tree and bird compositions 121, 124-126, 130, 134-137.
- tribhanga posture, with triple curves 23. Tun-huang (China), cave paintings (5th-8th centuries) 22, 23, 27.
- Turfan (Central Asia), painting from the Astāna cemetery (8th century) 33.
- tsukinami-e, paintings of the landscapes and occupations of the twelve months 66, 157.

tsuta, ivy leaf 170.

- Tsuta-ya Jūzaburō publisher of prints, notably of Utamaro's and Sharaku's 170, 174.
- tsuzuki-mono, several prints assembled to form a whole 170.

tsuzure-ori, silk tapestry 27.

- Tumulus Period (3rd-6th centuries A.D.) 15, 25
- Tung Ch'i-ch'ang (1555-1636), Chinese painter and theorist of literati painting 188.
- Uda, Japanese emperor (867-931) 92. U-daijin, minister of the right (10th century) 92.

- Uesugi Kenshin (1530-1578), northern chieftain 124.
- Uji, Princess, character in the Tale of Genji 73, 75.
- Uji, Byōdō-in temple (see Byōdō-in).
- uki-e, painting in depth 176.
- Ukifune, Princess, character in the Tale of Genji 73.
- ukiyo-e (literally, painting of the floating world), genre pictures with a popular appeal (17th-19th centuries) 102, 164, 165, 171, 174-176, 179-182.
- Umezu Jirō, of the National Museum, Kyōto 90.
- Unkoku school, in western Japan 192. Unkoku Tõgan (1547-1618), monochrome painter, self-styled successor of Sesshū
- in western Japan 136. Uragami Gyokudō (1745-1820), literati
- painter 192; Autumn Landscape, album leaf 192.
- urushi, lacquer 165.
- urushi-e (or beni-e), prints colored with rose-red (beni) and other colors (fashionable c. 1716-1736) 165, 166, 176.
- Usuki (Kyūshū), Christian seminary built by the Jesuits (1580) 138.
- uta-e, poetic painting of the Heian period 157.
- uta-awase, poetry competition 100.
- Utagawa Kunisada (1786-1864), known as Toyokuni III 179;
- Toyohiro (1773-1828) 177;
- Toyoharu (1735-1814), founder of the Utagawa school 176;
- Toyokuni I (1769-1825), portraits of actors and women 171, 177, 179;
- Kuniyoshi (1797-1861) 179;
- Kunisada II (19th century) 180;
- Kuniteru (19th century) 180.
- Utamaro, see Kitagawa Utamaro.
- Utsusemi, character in the Tale of Genji 145.
- Valignano, Alessandro, Jesuit father in Japan (1579) 138.
- Van Gogh, Vincent (1853-1890) 180. Venice, view of 176.
- Vilela, Father Gaspar, Jesuit missionary (1560) 136.
- waka, Japanese poem of thirty-six syllables 66, 80, 81.
- Wakamiya-machi, Fukuoka (Kyūshū), Takehara-kofun Tomb 10, 16, 17.
- Wakasa, port near Kyōto 103.
- Wakayama (southern Honshū) 190, 192; province 46, 48.
- Wang Meng (c. 1309-1385), Chinese literati painter, 188.
- warrior class (in power from the late 12th century) 60, 61, 76, 83, 84, 91, 95, 100, 104, 106-108, 120.

- wash painting (suiboku-ga) 107, 108, 110, 113, 116, 120, 130, 134, 136, 151, 188, 102.
- Washington, Freer Gallery:
- Matsushima (Pine Islands), pair of screens by Sotatsu 148-151.
- Watanabe Kazan (1793-1841), painter 193;
- Shikō (1683-1755), painter of the Sōtatsu-Kōrin school 157.
- Wei dynasty of China 22.
- wen-jen-hua, literati painting (in Chinese), see bunjin-ga.
- Western art 33, 179, 182, 183, 193; contact of the Japanese with Western
- art 136-139, 176, 184, 190, 193; Western painting in Japan 100, 137, 138, 183, 193.
- Westerners in Japan 160.
- Whistler, James Abbott McNeill (1834-1903) 179.
- Wu Chen (1280-1354), Chinese literati painter 188.
- Wu Tao-tzu, Chinese painter (8th century) 34.
- Xavier, St Francis (1506-1552), introduced Christianity in Japan (1549) 136, 138.
- Yadorigi chapter in the Tale of Genji 73, 75.
- yagō, commercial name 149.
- yakusha-e, portraits of Kabuki actors 165. Yakushi (in Sanskrit, Bhaisajya-guru),
- Buddha 22.
- Yakushi-ji temple, Nara 28, 52; Portrait of Jion Daishi (11th century) 52, 53, 107;
- Kichijō-ten, Goddess of Beauty and Fecundity, 8th century 28, 30.
- Yamagoshi-amida (Descent of Amida across the Mountains) 59, 61, 63.
- Yamaguchi, Suhō province (western Honshū) 111, 113.
- Yamai-no-sōshi (Scrolls of Diseases) 86, 88.
- Yamamoto Baiitsu (1783-1856), literati painter 192.
- Yamamoto Soken, painter of the Kanö school of Kyöto, master of Ogata Körin 153.
- Yamane Yūzō, Japanese art historian 141, 149, 150 153, 156.

Yamato province (now Nara Prefecture, central Honshů) 19.

- Yamato-aya-no-maken, Chinese painter at the Yamato court (early 7th century) 20.
- yamato-e, painting in the Japanese manner 66, 67, 165, 179.

yamato-eshi, Japanese painter 165, 167.

- Yamazaki Kazuo, chemist, his analysis of the pigments in ancient paintings 15, 23.
- Yanagisawa Kien (1704-1758), or Ryū Rikyō, Japanese literati painter 190. Yashiro Yukio, Japanese art historian 27.
- Yayoi Culture (Bronze Age in Japan, 3rd century B.C.-2nd century A.D.) 11, 12, 15.
- yayoi pottery 12.
- Yodo river, connecting Kyöto and Ösaka 183.
- Yōgen-in temple, Kyōto:
- sliding doors painted by Sōtatsu (1621) 149, 150.
- Yoshida Tsunefusa, courtier at the imperial court of Kyōto (1173), in charge of the mural paintings of the Saishōko-in 80.
- Yoshiwara, gay quarter of Kyōto 165, 171.
- Yosa Buson (1716-1783), *haikai* poet and literati painter 185, 190;
- Jūben Jūgi (Ten Advantages and Ten Comforts of Country Life), albums illustrated with Ike-no-Taiga (Kawabata Collection) 190, 192.
- Yüan dynasty of China (1260-1368) 103, 188;
- Yüan painting 107, 108, 111, 121, 188; ink monochrome landscape 108.
- Yü-chien, Sung painter, excelled in the p'o-mo technique 113, 120.
- Yūjo (1723-1773), painter-monk, superior of the Emman-in (Mii-dera monastery, Ōtsu) and patron of Maruyama Ōkyo 184.
- Yukimitsu, court painter at Kyōto (14th century) 94;
- attribution, *Kitano-tenjin-engi*, 3 illuminated scrolls (1278, *mistakenly dated* 1282 in the text) 94.
- yuna, serving woman in the hot baths 162, 163.
- Yūzū-nen Lutsu-engi (Origin and Development of the Yūzū sect), two scrolls with black and white engravings (1391) 164.
- Zen (in Chinese *ch'an*; in Sanskrit, *dhyana*) Buddhist doctrine 104.
- Zen Buddhism in Japan (introduced in the late 12th century) 63, 104, 106-108, 111, 116, 183;
- Zen monks 106-108, 116, 120, 127, 130; Zen monasteries 104, 106, 108, 116, 120, 121, 129, 130, 134.
- zenki-zu, scene of illumination 108.
- Zenrin-ji temple, Kyōto:
- Descent of Amida across the Mountains, first half of 13th century 59, 61, 63.
- zushi, shrine holding the image of a Buddhist god 20.

List of Colorplates

Atami (Shizuoka-ken), Museum, Sekai-kyūsei-kyō Collection:
Attributed to Sōtatsu (early 17th century): Deer, detail. Handscroll, with calligraphy by Hon-ami Kōetsu (1558-1637). Gold- and silver-tinted ink on paper. (Height 13%")
Anonymous: Serving Women of the Hot Baths (yuna), detail. 17th century. Hanging scroll, colors on paper. $(28\frac{5}{8}\times 31\frac{5}{8}")$
Ogata Kōrin (1658-1716): White and Red Plum Trees. Pair of screen paintings, colors on gold paper. (Each screen 61¼×68″)
Katsushika Hokusai (1760-1849): Mount Fuji in Fine Weather (Gaifū-kaisei), called the "Red Fuji." About 1825. Color print. (10¼×13%")
Boston, Museum of Fine Arts:
Shaka-muni Preaching in the Mountains (Hokkedō-kompon-mandara). Late 8th century. Painting on hemp cloth, mounted on a frame. $(42\frac{1}{8} \times 56\frac{5}{8}")$ 26
Dai-itoku-myöö (Mahājetas), Esoteric Divinity. 11th century. Painting on silk mounted on a frame. (76%×46½") 54
Story of the Heiji Insurrection (Heiji-monogatari): The Burning of the Sanjō Palace, detail. Third quarter of the 13th century. Handscroll, colors on paper. (Height 1614")
Kauchi (Ōsaka Prefecture), Kongō-ji:
Winter Landscape by Moonlight (Nichi-getsu-sansui-byōbu), detail of a screen painting. Late 16th century, Colors on paper. (Each panel 58×18%")
Spring Landscape in Sunlight (Nichi-getsu-sansui-byōbu), detail of a screen painting. Late 16th century. Colors on paper. (Each panel $58 \times 18\%$ ")
Keisen-machi, Fukuoka Prefecture (Kyūshū):
Painting in the Otsuka Tomb: Decoration of the so-called "Lamp Stone." 5th or 6th century A.D. 14
Kōya-san (Wakayama), Eighteen Temples of the Yūshi-Hāchimankō:
Descent of Amida with Divine Attendants (Raigō). Triptych of three hanging scrolls. Early 12th century. Painting on silk. (Central scroll $8_3 \times 827_8''$, side scrolls $8_3 \times 413_4''$ and $8_3 \times 415_8''$) 46-47
Kōya-san (Wakayama), Kongōbū-ji:
Death of the Buddha (Nirvana). 1086. Hanging scroll, painting on silk. $(105\frac{1}{4} \times 106\frac{3}{4}")$. 48
Kyōto, Chijaku-in:
Hasegawa Tōhaku (1539-1610) and his school: Maple Tree and Autumn Plants, detail. 1592. Painting originally on sliding doors in the Shōun-ji temple. Colors on gold paper. (Entire panel 69¾×218¼″)

Ōsaka, Saifuku-ji:

	Itō Jakuchū (1716-1800): Cocks and Cactus, detail of a painting on sliding doors. Colors on gold paper. (Each panel $69\frac{1}{2}\times36^{\prime\prime}$)	189
Tol	kyo, National Museum:	
	Nagasena, One of the Sixteen Disciples of the Buddha (Jūroku-rakan). Late 11th century. Hanging scroll, painting on silk. (37¾×20½″) From the Raigō-ji, Shiga	50
	Nakura, One of the Sixteen Disciples of the Buddha (Jūroku-rakan). Late 11th century. Hanging scroll, painting on silk. $(37^{3}_{4} \times 20^{1}_{2})''$ From the Raigō-ji, Shiga	51
	Kokuzō-bosatsu (Akasagarbha), God of Wisdom. 12th century. Central part of a hanging scroll, painting on silk. (Entire scroll 51%×33%")	56
	Sesshū Tōyō (1420-1506): Autumn Landscape. (Shūkei-sansui). Hanging scroll, ink on paper. $(18\frac{1}{3}\times11\frac{1}{2}")$	112
	Sesshū Tōyō (1420-1506): Landscape in the Cursive Style (Haboku-sansui). 1495. Hanging scroll, ink on paper. $(58\frac{3}{4} \times 12\frac{7}{8}")$	114
	Hasegawa Tōhaku (1539-1610): Pine Wood, detail of a screen painting. Ink on paper. (Entire screen $61\frac{3}{4} \times 136\frac{1}{2}$ ")	128
	Torii Kiyonobu II (1702-1752): The Actor Ogino Isaburō on Stage. Hand-colored print (urushi-e). $(12 \times 6\frac{14}{7})$	168
	Suzuki Harunobu (1725-1770): Girl on her Way to the Shintō Shrine on a Stormy Night. Color print. $(10\frac{3}{4} \times 8\frac{1}{8}")$	169
	Tōshūsai Sharaku (18th century): Portrait of the Actor Ichikawa Ebizō. 1794. Color print. $(14\% \times 9\%'')$	173
	Andō or Ichiyū-sai Hiroshige (1797-1858): Landscape at Shōno, from the Fifty-three Stages of the Tōkaidō Highway (Tōkaidō-gojū-santsugi). 1833. Color print. (85%×13%")	178
	Maruyama Ōkyo (1733-1795): Pine Tree in Snow. 1765. Hanging scroll, ink and gold on silk. $(48\frac{1}{2}\times21\frac{1}{4}'')$	186
	Goshun (Matsumura Gekkei, 1752-1811): Landscape in the Rain, detail of a screen painting. Ink and colors on paper. (Entire screen $49\frac{5}{8} \times 150^{"}$)	187
	Ike-no-Taiga (1723-1776): Landscape in the Chinese Manner, detail of a screen painting. About 1760-1770. Colors on gold paper. (Entire screen $66\frac{1}{4} \times 140^{"}$)	191
Γok	xyo, Commission for Protection of Cultural Properties:	
	Landscape Screen (Senzui-byōbu), detail: The Cabin of the Poet-Hermit. 11th century. Colors on silk. (Entire panel $57\frac{1}{5}\times16\frac{3}{4}$ ") From the Tō-ji, Kyōto	71
	Hell Scrolls (Jigoku-zōshi): Demons crushing the Damned (scene from the Hell of the Iron Mortar). Late 12th century. Handscroll, colors on paper. (Height 10%")	86
	Idem, The Giant Cock	87
	Sesshū Tōyō (1420-1506): Landscape of Ama-no-hashidate (The Bridge of Heaven), detail. 1502-1506. Hanging scroll, ink and light colors on paper. (Entire scroll 35½×66¾")	115
ſok	yo, Reimeikai Foundation:	
	The Tale of Genji (Genji-monogatari): Prince Genji holding in his Arms the Newborn Babe Kaoru (detail of the third scene of the Kashiwagi chapter). First half of the 12th century. Handscroll, colors on paper. (Height 8% ") Preserved in the Tokugawa Museum, Nagoya	72
	Idem, Prince Niou-no-miya soothing his Wife, Princess Uji (third scene of the Yadorigi chapter). (Height 8 [*] / ₈ ") Preserved in the Tokugawa Museum, Nagoya	72

216

Tol	kyo, Seikadō Foundation:	
	Sōtatsu (early 17th century): Sekiya Scene from the Tale of Genji. Screen painting, colors on gold paper. $(59^{3}_{4} \times 139^{1}_{2})^{"}$	46-147
	Hanabusa Itchō (1652-1724): Peasant leading his Horse across a River. Before 1698. Hanging scroll, colors on silk. $(11\% \times 19\%)$	183
Tol	kyo, Private Collections:	
	Dan Inō:	
	Jizō-bosatsu (Ksitigarbha). Late 13th century. Hanging scroll, painting on silk. (39¾×14¼″)	62
	Hara Kunizō:	
	Kanō Naganobu (1577-1654): Cherry Blossom Festival, detail of the Dancers. Screen painting, colors on paper. (Entire screen $58\frac{3}{4} \times 140^{"}$)	161
	Ishii Yūshi:	
	Ten-yū Shōkei: Landscape (Kozan-shōkei), traditionally attributed to Tenshō Shūbun. Mid-15th century. Hanging scroll, ink and light colors on paper. $(48\% \times 13\%')$	109
	Ohashi Hachirō:	
2	Line Relief on a Bronze Bell (dōtaku): Man winding Thread and Two Men husking Rice. First century A.D. (Height of the bell $167_8"$) From the Kagawa Prefecture (Shikoku)	13
	Sakai Tadahiro:	
v	The Story of Ban-dainagon (Ban-dainagon-ekotoba), attributed to Tokiwa Mitsunaga: Excited Crowd watching a Fire at the Imperial Palace (scene from the first scroll). Second half of the 12th century. Handscroll, colors on paper. (Height $12^{3}/_{8}$ ")	81
	Shibui Kiyoshi:	
	Kitagawa Utamaro (1753-1806): Melancholy Love (mono-omou-koi). Color print from the "Love Poems" series. $(14\frac{1}{4} \times 9\frac{1}{2}")$	172
Uji,	, Byōdō-in:	
	Descent of Amida with Divine Attendants (Raigō), detail of the south door of the Phoenix Hall (Hōō-dō). 1053. Painting on a wooden panel. (Entire panel $89 \times 26 \frac{1}{2}$)	43
	Early Spring Landscape, detail of the north door of the Phoenix Hall (Hoō-dō). 1053. Painting on a wooden panel. (Entire panel $147\frac{1}{2}\times54\frac{1}{2}$ ")	68
Wa	kamiya-machi, Fukuoka Prefecture (Kyūshū):	
	Wall Painting in the Takehara-kofun Tomb: Composition on the Back Wall of the Funerary Chamber. 5th or 6th century A.D.	10
Was	shington, Freer Gallery of Art:	
	Sōtatsu (early 17th century): Pine Islands (Matsushima). Screen painting, colors on paper. Left side. $(65\frac{3}{8} \times 144\frac{3}{4}'')$	150
	Idem, Right side. $(65\frac{3}{4} \times 144\frac{3}{4})$	151

PRINTED BY IMPRIMERIES RÉUNIES SA LAUSANNE

BINDING BY GROSSBUCHBINDEREI H.+J. SCHUMACHER AG SCHMITTEN (FRIBOURG)

PHOTOGRAPHS BY

Henry B. Beville, Washington (pages 3, 10, 13, 14, 25, 29, 30, 38, 41, 43, 44, 47, 48, 52, 55, 56, 68, 71, 72, 75, 77, 81, 82, 84, 105, 109, 112, 114, 117, 119, 126, 131, 133, 137, 142, 143, 147, 150, 151, 155, 161, 163, 168, 169, 172, 173, 175, 178, 183, 186, 187, 189, 191), Hans Hinz, Basel (pages 50, 58, 59, 61, 62, 85, 86, 87, 90, 91, 95, 96, 97, 101, 128, 152), Louis Laniepce, Paris (pages 51, 93, 115), Sandak, Boston (pages 26, 54, 99), and the photographic services of the Benridō, Tokyo (pages 18, 21, 24, 31, 32, 35).

PRINTED IN SWITZERLAND